# 50 Years

## of Amateur Radio Innovation

TRANSMITTERS, RECEIVERS AND TRANSCEIVERS: 1930-1980

Published by Pediment Publishing, a division of The Pediment Group, Inc. www.pediment.com Printed in Canada

# About the Author

Joe Veras, K9OCO, grew up in a ham household and has been licensed for more than 50 years. During high school, it was assumed that he would follow the family trade and become an electronics engineer. His interests and academic path seemed headed in that direction until he discovered photography while working on the school newspaper. Developing film and printing pictures struck him as pure magic. He spent his adult years behind a camera doing advertising photography for print media. Along the way, Joe has also photographed the Radio Classics calendars and written a column on vintage radio for *CQ* magazine.

The magic of Amateur Radio remains an important part of Joe's life. Contesting, DXing and talking with friends fill his on-air hours. He enjoys the workbench side of the hobby too, building equipment from scratch and restoring gear that "follows him home" from hamfests.

The photographs you'll see in this book combine Joe's profession and lifelong hobby. Work on the project began in 1993 and Joe took the last photograph just before Christmas, 2006. The images presented here are the product of more than 200 photo sessions and nearly half-a-million miles of travel.

Joe has been privileged to meet dozens of collectors and to see an incredible array of ham equipment. The nature of the subject matter required that he leave the studio to go where the equipment was. The collectors he visited were universally gracious in their hospitality and generous in sharing both their equipment and knowledge. One outstanding collector deserves special mention: Herman Cone, N4CH. More than 60% of the images you'll see in this book are of radios from his collection.

Joe's greatest source of strength and support has been his wife Gwen. She realized that his book project was a marathon, and not a footrace to the finish line.

Joe dedicates this book to his father, Norm Amundsen, K9NA. "He was the first ham I met, and the finest man I have ever known." ∎

**More vintage radio photography by Joe Veras, K9OCO, is available on CD-ROM. See www.jveras.com/vintagebook.htm for complete details.**

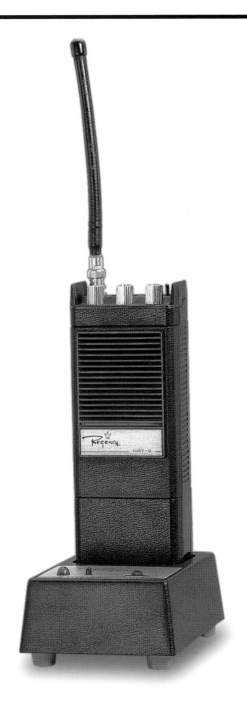

**RIGHT ◊ REGENCY HRT-2** Regency, the company that brought the first solid-state product to the amateur market (the ATC-1 converter, in 1956), introduced its HRT-2 handie-talkie in 1974. It was a 5 channel, crystal-controlled 2 meter FM transceiver with a power output of 2.2 watts. Its HI/LO switch reduced power to 1 watt ; $179.00, 1974. (1)

# Foreword

As much as Amateur Radio is about looking forward, we must never forget our rich history. As a sage once observed, we can best appreciate where we are today by understanding the path that brought us here. When this book was created, the American Radio Relay League was a mere 6 years from its centennial. Amateur Radio itself is only a few years older. That is a century of tradition and progress.

Joe Veras, K9OCO, is a renowned photographer whose work is familiar to most Amateur Radio operators, even if they don't recognize his name or call sign. They have seen his photographs in books, magazines and other venues for decades. We're grateful that Joe has allowed us to publish a portion of his vast collection of professional equipment photography in *50 Years of Amateur Radio Innovation--Transmitters, Receivers and Transceivers: 1930-1980*. As you read this book, Joe's photos will take you on a journey of historical discovery. Perhaps you own, or have owned, some of this equipment yourself. Many of these items are quite rare; this book may be the only place you will see them!

Whether you've been licensed for many years, or just beginning your Amateur Radio career, *50 Years of Amateur Radio Innovation--Transmitters, Receivers and Transceivers: 1930-1980* offers you a fascinating visual travelogue of Amateur Radio technology. ∎

David Sumner, K1ZZ
ARRL Chief Executive Officer
Newington, Connecticut
August 1, 2008

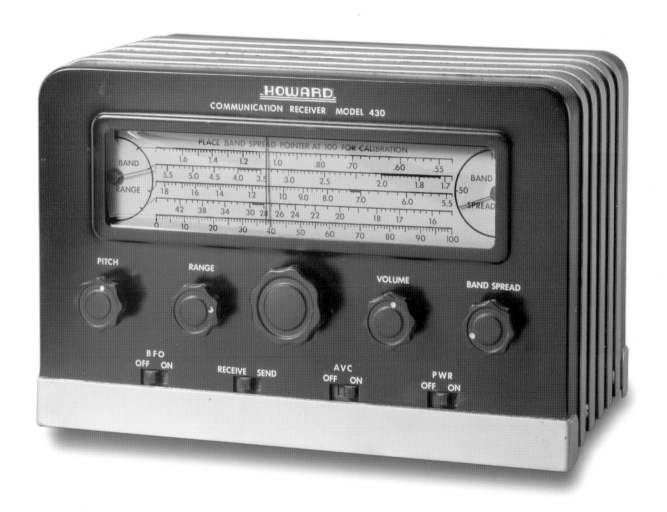

**ABOVE** ◊ **HOWARD 430** Chicago's Howard Radio Company billed itself as "America's Oldest Radio Manufacturer" and made radios for a number of different companies. In the 1930s and early '40s they sold a line of communication receivers under the Howard name. The model 430 had six tubes and tuned .54–40 MHz in four bands; $29.95, 1938. (51).

# How to Use this Book

The photography of *50 Years of Amateur Radio Innovation--Transmitters, Receivers and Transceivers: 1930-1980* is organized into "Eras," each one illustrating a different stage in the evolution of Amateur Radio equipment. Most photos are captioned as follows:

• Model number and manufacturer in bold type
• A brief description
• The year of introduction and the price at that time
• The photo contributor index number

# Photo Contributor Index

| No. | Name | Call | No. | Name | Call | No. | Name | Call |
|---|---|---|---|---|---|---|---|---|
| 1 | Herman Cone | N4CH | 26 | Michael Hopkins | AB5L (SK) | 51 | Harry Snyder | W7HC (SK) |
| 2 | Jim Allen | NU6AM | 27 | Andy Howard | WA4KCY | 52 | Dave Stewart` | NI5M |
| 3 | Dick Bean | K1HC | 28 | Jonathan Jesse | W1JHJ | 53 | Bill Strangfeld | W8FIX |
| 4 | Ron Beaver | WB4OQL | 29 | Billy Johnson | WB5RYB | 54 | John Suker | W1TX |
| 5 | Steve Berg | KB4IRB | 30 | Edmond Johnson | N8HJY | 55 | Joel Thurtell | K8PSV |
| 6 | Mick Brafford | W4YV | 31 | Jim Jorgensen | K9RJ (SK) | 56 | Jack Tiggleman | KA8FQS |
| 7 | John Brewer | K5MO | 32 | Paul Katz | W5NTQ | 57 | Frank Vanderhoof | KT4NU |
| 8 | Peter Brickey | K6DGH | 33 | Tom Koch | W4UOC | 58 | Joe Veras | K9OCO |
| 9 | George Carsner | WØPPF | 34 | Bill Kuning | W3BY | 59 | Tim Walker | W1GIG |
| 10 | Dave Cisco | W4AXL | 35 | Jim Long | W4ZRZ | 60 | Jon Weiner | K1VVC |
| 11 | Rockwell Collins Museum | KØDAS | 36 | Kirk Mc Gill | N4WYC | 61 | Niel Wiegand | WØVLZ |
| 12 | Fred Cross | W4EZY | 37 | Don Merz | N3RHT | 62 | Barry Wiseman | N6CSW |
| 13 | Al Culbert | KØAL | 38 | George Misic | KE8RN | 63 | Don Zielinski | KØPV |
| 14 | John Curtis | WØCAR | 39 | John Nowacki | AD1E | 64 | Don Buska | N9OO |
| 15 | Chuck Dachis | WD5EOG | 40 | Pavek Museum | | 65 | George Maier | W1LSB |
| 16 | Dennis Day | WØECK | 41 | Ron Payne | WA6YOU | 66 | Joe Myers | KD4A |
| 17 | Alan Douglas | | 42 | R. L. Drake Museum | | 67 | Dave Mayfield | W9WRL |
| 18 | Bob Enemark | W1EC | 43 | Dave Rawley | N4XO | 68 | Martin Jue | K5FLU |
| 19 | Nick England | KD4CPL | 44 | Marty Reynolds | AA4RM | 69 | Hop Hays | K4TQR |
| 20 | Scott Freeberg | WA9WFA | 45 | Earl Ridolphi | | 70 | Brian Wingard | N4DKD |
| 21 | Alan Fryer | N3BJ | 46 | Brian Roberts | K9VKY | 71 | Rod Blocksome | KØDAS |
| 22 | Hal Guretzky | K6DPZ | 47 | Dick Ross | K2MGA | | | |
| 23 | Bruce Hall | KE4VHO | 48 | Tom Rousseau | K7PJT | | | |
| 24 | Brian Harris | WA5UEK | 49 | Bill Shepherd | W4YEG | | | |
| 25 | Gerald Higgins | W7ES | 50 | Harold Smith | W4PQW | | | |

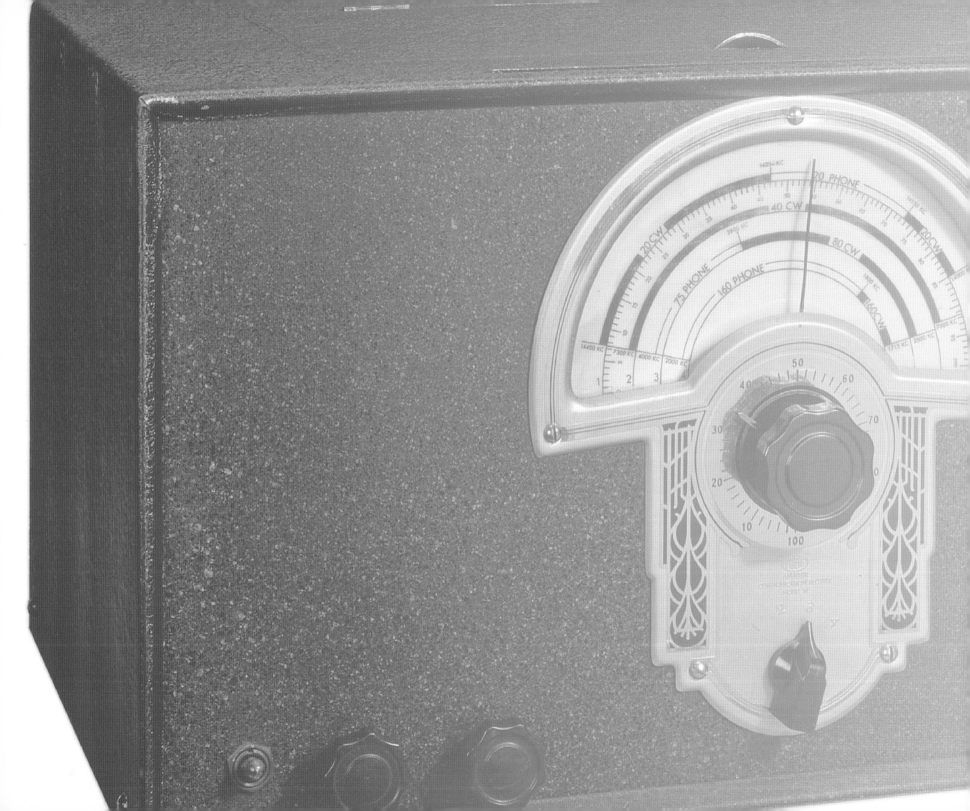

# Table of Contents

# The Birth of the American Amateur Radio Equipment Industry

The early 1930s was not the best period in which to begin a new business. With the nation's economy still caught in the stranglehold of the Great Depression, even established firms gasped for air, struggling to survive. The American Amateur Radio equipment industry was born into these troubled times.

A few far-sighted companies, surveying the bleak economic terrain, discovered not despair but opportunity. East Coast firms such as National and Hammarlund, already engaged in other manufacturing enterprises, marketed their first Amateur Radio products. In Chicago, Bill Halligan began producing communications receivers under the Hallicrafters name. Farther west, in Cedar Rapids, Iowa, Art Collins built amateur transmitters in his basement. During the next 40 years, each of these companies became hamshack, if not household, names. They produced significant amateur product lines and made notable contributions to the state of the art. By their half-century mark, each of them had withdrawn from the amateur market or disappeared entirely.

The prior decade, the 1920s, closed with events having serious implications for Amateur Radio. After much complaining by military and commercial interests regarding interference from out-of-band amateur operation, the US government issued stringent new regulations for the hobby. Amateur Radio had the choice of either meeting the new standards, which took effect in January of 1929, or surrendering its privileges and frequency allocations.

Amateur Radio's organizational body, the American Radio Relay League, took note of the new proposals in early 1928 and made every effort to prepare amateurs for the changed regulations. Its president, Hiram Percy Maxim, declared frequency precision to be the outstanding problem facing the hobby. The League appointed Ross Hull, an Australian renaissance man, as the associate technical editor of *QST*, its monthly magazine. A series of articles by Hull and others, which encouraged amateurs to improve their equipment and operating practices, followed. Driven by the persuasion of the League and the regulatory stick of the government, Amateur Radio operators began to make the necessary adjustments. As a new decade opened, the hobby changed in another way.

Since its inception, when the first amateurs took to the airwaves with spark transmitters, the hobby had been the province of the tinkerer, the experimenter. Nearly all of the equipment was home-built. Commercial activity to a large degree was limited to supplying component parts used in the construction of transmitting and receiving apparatus. In the early 1930s, new commercially made gear appeared on the amateur market, joining those products made by the few companies already in the business. ∎

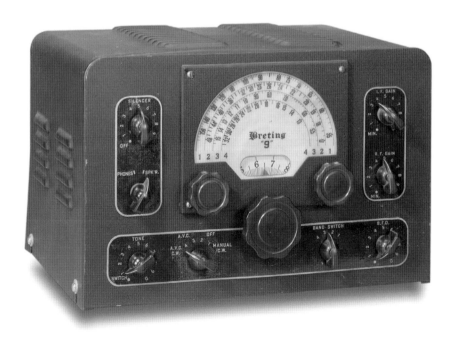

**LEFT ◊ BRETING 9** Breting's nine-tube receiver was a Ray Gudie design. It tuned from .54 to 33 MHz and had a regenerative detector. It featured a noise silencer and AVC; $54.00, 1938. (2)

**OPPOSITE ◊ MEISSNER SIGNAL SHIFTER** The original Signal Shifter was introduced by Meissner at the Pittsburgh hamfest in February 1938. Meissner described it as a "variable-frequency, electron-coupled exciter unit with oscillator and buffer circuits ganged together for single dial control." The Signal Shifter had an internal AC supply and used plug-in coils to cover 160–10 meters. It sold for $39.95 with one set of coils but minus tubes. A less-expensive version without a power supply sold for $31.95. (1)

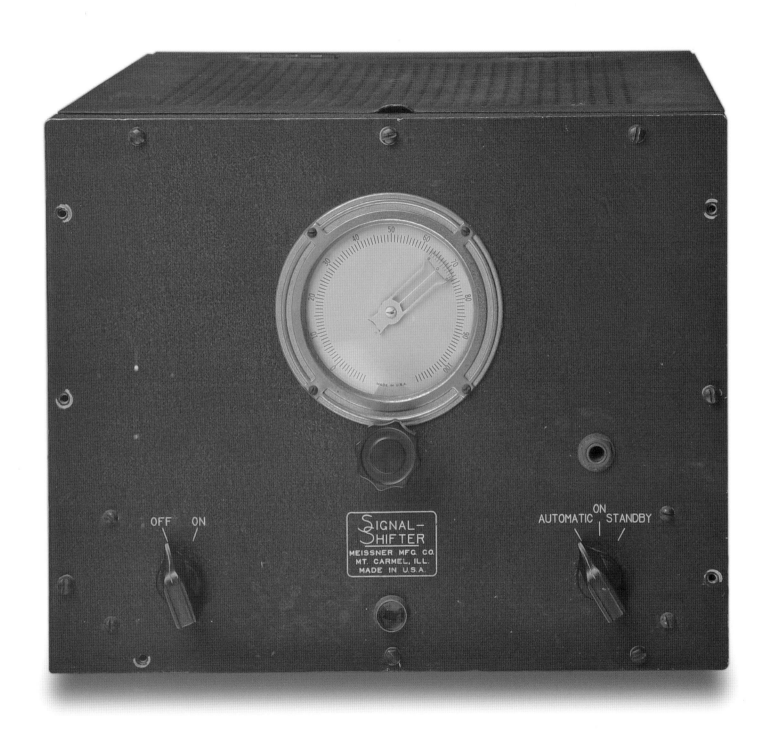

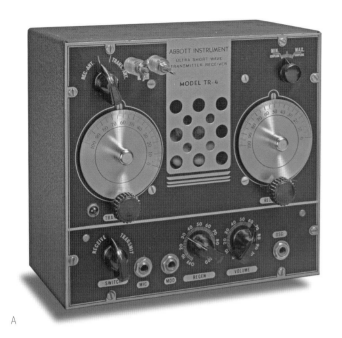

A

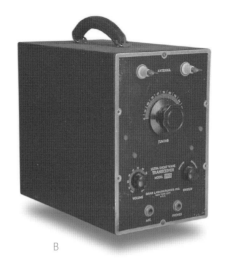

B

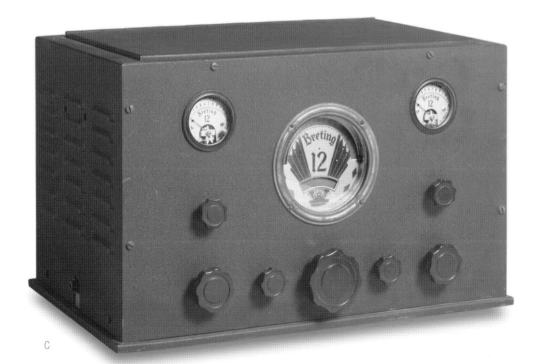

C

D

G

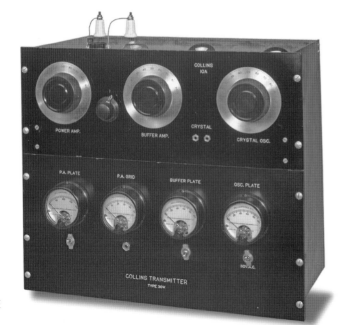

E

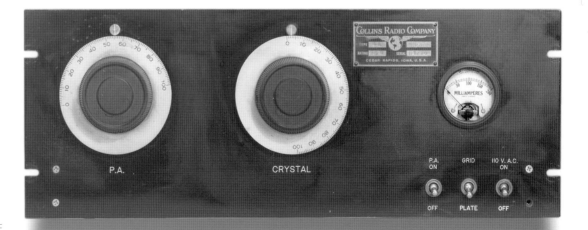

F

**A** ◊ **ABBOTT TR-4** The TR-4 was designed for both fixed-station and mobile use on the 2-1/2 meter band. A super-regenerative receiver was paired with a modulated oscillator transmitter in the four-tube set. The TR-4 sold for $38.22 without tubes or power supply; 1941. (1)

**B** ◊ **BARR LABORATORIES DB-3** Barr's three-tube, 5 meter transceiver used Class B modulation and had a power output of 2 watts. Its self-contained power supply consisted of three 45 volt batteries, two 6 volt dry cells, and a 7½ volt C battery; $27.50, 1935. (1)

**C** ◊ **BRETING 12** Breting receivers were manufactured at the Gilfillan Brothers' Los Angeles plant, taking advantage of their RCA license. The Breting 12 used a dozen tubes, one of which was a second RF stage employed only above 7 MHz. It had both signal strength and percentage-of-modulation meters. A crystal filter in the 432 kHz IF provided selectivity. The Breting 12's audio stages could be used to drive a transmitter's modulator. Frequency coverage was .55–30 MHz in five bands; $93.00, 1935. (44)

**D** ◊ **COLLINS 150B** The 150B was famous for its trip to the Antarctic with Admiral Richard Byrd in 1934. Its 150 watt Class B modulated AM signal relayed a running account of Byrd's adventure and ordeal to the folks back home; $350.00,1932. (11)

**E** ◊ **COLLINS 30W** The 30W was the first transmitter sold by Art Collins. Its 10A RF deck used a 510 final for 30 watts output on 160–10 meters; $95.60, 1932. (24)

**F** ◊ **COLLINS 4A** The 4A was a basic CW transmitter with 20 watts output and onboard low- and high-voltage power supplies; $58.50 (with one set of coils), 1933. (11)

**G** ◊ **TOBE DEUTCSHMANN MODEL H** The Model H was sold as a partially assembled kit. The tuning unit was pre-wired and aligned. The purchaser finished assembling and wiring the 7-tube receiver. It covered the 160, 80, 40, and 20 meter amateur bands; $41.40, 1935. (2)

**A ◊ GROSS CB-80** Gross Radio Company's 100-watt CW and phone transmitter covered 160 through 10 meters; 1937. (37)

**B ◊ GROSS CP-100** The CP-100 combined Gross's CW-100 exciter, a power supply, and a meter panel in the same rack. A pair of T-20s in the final supplied 100–150 watts CW input on 160 through 20 meters; $76.00, 1934. (20)

**C ◊ GROSS CW-25 KIT** The kit builder received a handsome, pre-punched and drilled, wrinkle-finish (shrivel-finished as Gross put it) chassis, all parts (except tubes), a crystal holder, and one set of coils for $13.95. Extra coils for the 160 through 20 meter bands were 75 cents each (three required per band). A '47 crystal oscillator drove a '46 buffer/doubler, which, in turn, drove a pair of '46 final amplifiers. Jacks in each stage allowed a milliammeter to be inserted for tuning. A companion power-supply kit was offered for $8.75; 1934. (44)

**D ◊ HALLICRAFTERS 5-T SKY BUDDY** Hallicrafters' budget communications receiver tuned from .55–16 MHz in three bands. The five-tube superhet contained a built-in speaker and power supply; $29.50, 1936. (15)

**E ◊ HALLICRAFTERS DD-1** Hallicrafters' elaborate 25-tube set was designed for diversity reception using two widely spaced antennas to combat fading on shortwave signals. The wooden cabinet contained a 15 inch speaker as well as the power supply and audio amplifier. The RF deck on top housed the RF, IF, mixer, detector, and noise-limiter circuits for two separate receivers. The oscillator and BFO were common to both receivers; $550.00, 1938. (8)

**F ◊ HALLICRAFTERS HT-1** Hallicrafters' entry into the amateur transmitter market was rated at 100 watts out CW, 50 watts phone with an RK-47 final. Any three bands between 160 and 10 meters could be switch selected, as could one crystal frequency per band; $195.00, 1938. (15)

**G ◊ HALLICRAFTERS HT-6** The HT-6 could switch select any three bands between 160 and 5 meters with 25 watts out on phone and CW. Optional electron-coupled oscillator modules were available for all bands except 5 meters, which was crystal-control only; $99.00, 1939. (15)

**H ◊ HALLICRAFTERS S-1** The S-1 Skyrider was introduced in 1933, beginning Hallicrafters' long amateur product line. Both the metal tag on its front panel and magazine ads noted that the receiver was manufactured by the Silver-Marshall Company. The five-tube, four-band Skyrider had a tuned RF stage and a regenerative detector. It covered 1.5 to 22 MHz and included a built-in speaker; $39.95. (15)

**I ◊ HALLICRAFTERS S-3** The S-3 Skyrider followed closely on the heels of the S-1 (an S-1 variant carried the S-2 designation) and was similar electrically to the basic circuitry of its predecessor. It added a fifth band to include the standard broadcast band in its coverage. Also new to the S-3 were band-spread tuning and a send-receive switch. Gone was the Silver-Marshall nameplate. The name Skyrider appeared on the band-spread dial; $49.95, 1933. (15)

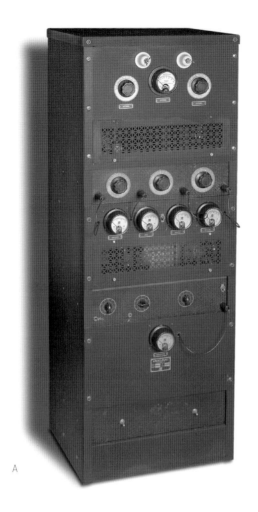

A

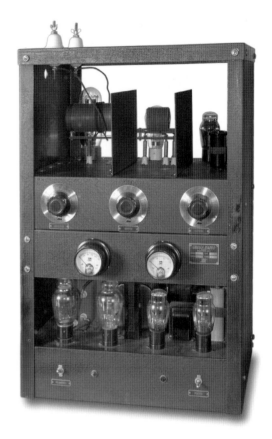

B

C

D

E

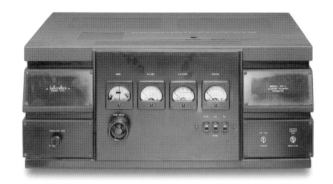

F

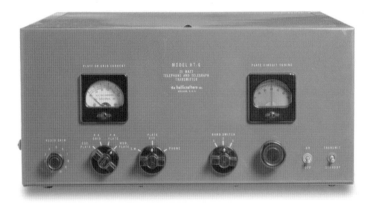

G

H

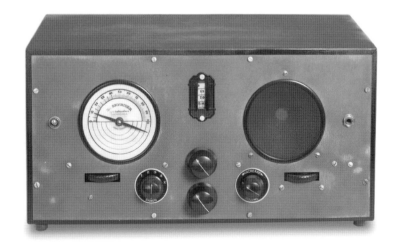

I

**A** ◊ **HALLICRAFTERS S-6** The S-6 was part of the original Super Skyrider series and differed from the S-4 and S-5 in frequency coverage. Its four bands tuned from 1.3–21 MHz, and 28–30 MHz. The S-4 covered 1.3–21 MHz in three bands. The S-5 added a fourth range to cover the standard broadcast band. When equipped with the optional crystal filter, an S-6 became the SX-6; $69.95 ($78.95 with filter), 1935. (18)

**B** ◊ **HALLICRAFTERS S-19R SKY BUDDY** The 1939 model of the Sky Buddy improved upon its predecessor with the addition of coverage up to 10 meters, band-spread tuning, and a separate BFO tube. The earlier S-19 covered .545–18.5 MHz; $29.50, 1939. (51)

**C** ◊ **HALLICRAFTERS S-20** The Sky Champion had 8 tubes and covered .54–44 MHz in 4 bands. It had a built-in speaker but no band spread; $49.50, 1938. (15)

**D** ◊ **HALLICRAFTERS S-20R** The 1939 version of the Sky Champion added an additional IF stage, a noise limiter, and electrical band spread to the features offered by its predecessor but retained the $49.50 price. (56)

**E** ◊ **HALLICRAFTERS S-21** The S-21 was also known as the Skyrider 5-10, operating on what then were known as Ultra High Frequencies. One of its eight tubes was the newly developed RK 1851 RF amplifier. The receiver tuned from 27 to 68 MHz; $69.50, 1938. (1)

**F** ◊ **HALLICRAFTERS S-22R** The S-22R Skyrider Marine tuned from .11 to 18 MHz, covering aircraft, commercial, police, and marine as well as amateur frequencies. The eight-tube circuit's 1600 kHz IF helped with image rejection; $64.50, 1940. (63)

**G** ◊ **HALLICRAFTERS SX-10** The Ultra Skyrider covered 5.5–79 MHz but primarily was designed to deliver performance on the 5 and 10 meter amateur bands. The 10-tube set incorporated a Lamb Noise Silencer circuit and featured variable BFO injection; $114.50, 1936. (15)

**H** ◊ **HALLICRAFTERS SX-15 SKY CHALLENGER** The Sky Challenger offered a lower-cost alternative to Hallicrafters' Super Skyrider series. The nine-tube, general-coverage receiver tuned from .535 to 38 MHz in five bands; $81.95, 1937. (18)

**I** ◊ **HALLICRAFTERS SX-23** The Skyrider 23's venetian-blind-style tuning dial highlights the receiver's Art Deco look. Its four general-coverage bands tuned from .54–34 MHz. Four band-spread ranges covered the 80 through 10 meter ham bands. The SX-23 had a crystal filter and used 11 tubes; $127.50, 1939. (18)

**J** ◊ **HALLICRAFTERS SX-28** The SX-28 was the final and most elaborate of the Super Skyrider line. Its 15-tube lineup included a pair of push-pull 6V6s in the audio output capable of driving a large speaker to room-filling volume. The SX-28's six-band, .55–43 MHz tuning range included a calibrated band-spread dial for the 80 through 10 meter amateur bands. Other features included variable IF selectivity, a crystal filter, and an adjustable noise limiter. The SX-28A, also carrying the Signal Corps Designation AN/GRR-2, appeared in 1944 and was produced for the post-war amateur market through 1946. Outward and electrical differences between the SX-28A and the earlier model were minor, chiefly consisting of the use of Micro Set inductors in the front end; $159.50, 1940. (58)

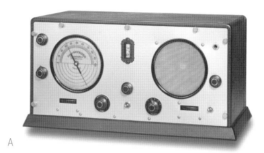

A

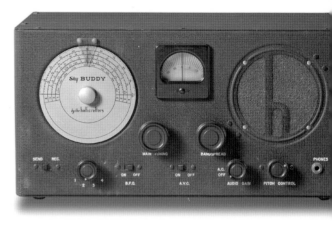

B

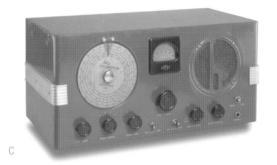

C

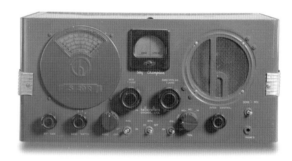

D

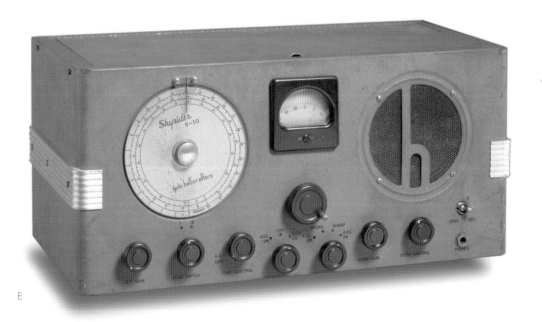

E

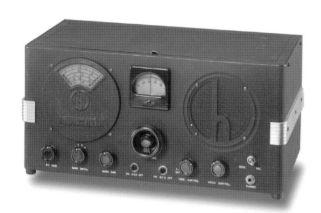

F

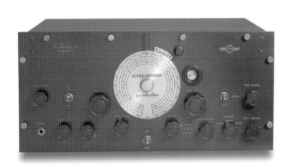

G

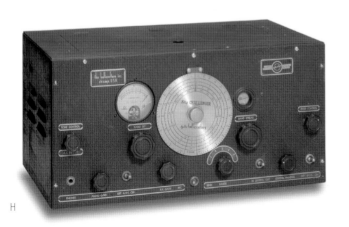

H

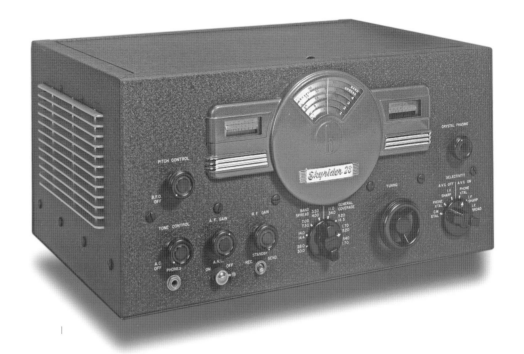

I

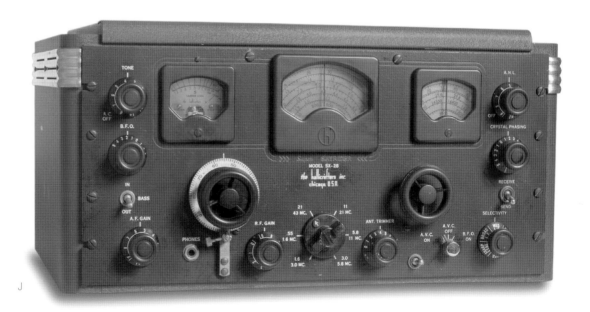

J

17

A

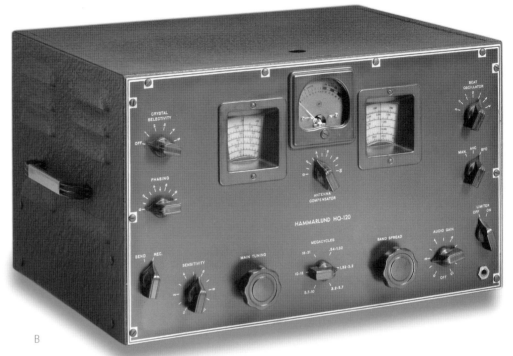

B

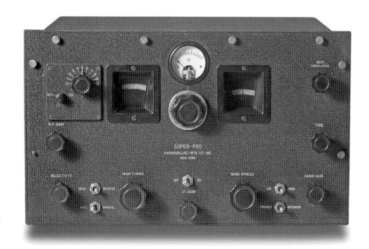

C

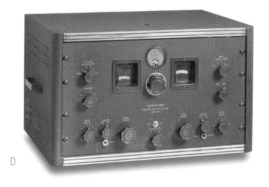

D

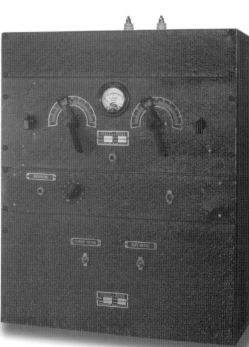

E

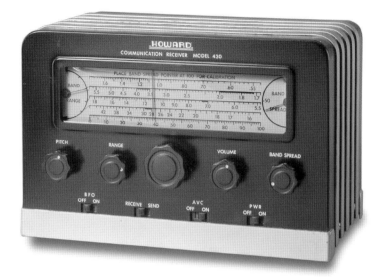

G

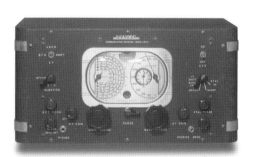

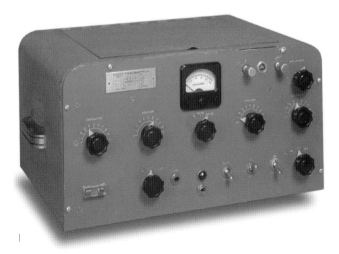

I

**A ◊ HAMMARLUND COMET PRO V.2** A wooden cabinet housed the Original Comet Pro. It tuned from 1.5–21 MHz using plug-in coils. Subsequent versions had metal cabinets. The eight-tube receiver continued to evolve with the addition of improved IF transformers, a front-panel BFO control, a crystal filter, and a 9th tube for an AVC circuit. A version two receiver is pictured; $162.00, 1932. (46)

**B ◊ HAMMARLUND HQ-120** The 120 was the first of Hammarlund's HQ series. Its basic appearance and circuit features would be repeated in many of the company's post-war receivers. The twin dials carried main tuning and electrical band-spread scales. It had a regulated power supply and a noise limiter, and a variable-bandwidth crystal filter was offered as an option. The 12-tube set tuned from .54 to 31 MHz; $117.00 ($129.00 with filter), 1938. (46)

**C ◊ HAMMARLUND SUPER-PRO SP-10** Hammarlund used ad space to apologize for delays in the introduction of their entrant in the receiver supremacy race. The SP-10 Super Pro finally debuted early in 1936, touted as a "receiver worth waiting for" and "the finest receiver ever to bear the Hammarlund name." Among the features incorporated were an input coil designed to use either balanced or single-wire antennas, a make-before-break band switch, a 12-gang main-tuning capacitor, and backlash-free tuning dials. Four air-tuned IF transformers and a variable crystal filter provided selectivity (SP-10X model). Frequency coverage was .54–20 MHz. The 16-tube Super-Pro's power supply was on a separate chassis. It was followed by 100- and 200-series Super-Pros, the latter having 18 tubes, with 2 RF and 3 IF stages; $194.00. (51)

**D ◊ HAMMARLUND SP-210X** The SP-210X's 18-tube circuit included two RF and three IF stages. It covered .54–20 MHz with calibrated band spread for amateur frequencies and had a crystal filter. The power supply was external; $279.00, 1939. (46)

**E ◊ HARVEY RADIO LABORATORIES 60-T** Harvey Radio Labs of Brookline, Massachusetts produced the 60-T transmitter in 1936. Output from the RK-20 final was 50 watts CW, 15 watts grid-modulated AM. The transmitter pictured is a model A, which covered 160, 80, and 40 meters. The B model covered 80, 40, and 20; $88.20. (39)

**F ◊ HOWARD 430** Chicago's Howard Radio Company billed itself as "America's Oldest Radio Manufacturer" and made radios for a number of different companies. In the 1930s and early '40s they sold a line of communication receivers under the Howard name. The model 430 had six tubes and tuned .54–40 MHz in four bands; $29.95, 1938. (51)

**G ◊ HOWARD 436** The seven-tube Model 436 included a noise limiter and built-in speaker. Howard offered an optional R-meter. Four bands covered .54–43 MHz; $39.95, 1939. (1)

**H ◊ HOWARD 450-A** The 450-A had 12 tubes and tuned from .54–65 MHz in six bands. It featured a direct-reading dial with 47 inches of electrical band spread. An R-meter was included, but the crystal filter was a ten-dollar option; $95.45, 1939. (8)

**I ◊ KAAR 10-Z** KAAR Engineering of Palo Alto, California made a handful of ham products. Among them was the 10-Z AM and CW transmitter. Its power output was 15 watts on 160–10 meters. The 10-Z featured band switching, internal 110 VAC/6 VDC power supplies, and an antenna coupler; $105.75, 1938. (26)

A

B

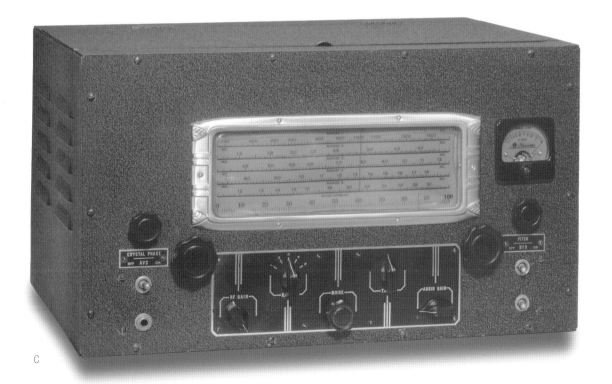

C

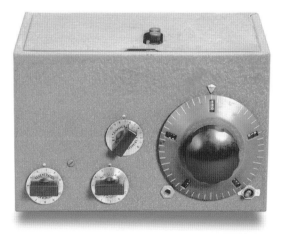

D

E

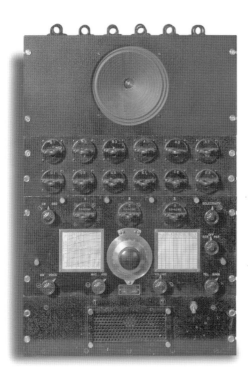

F

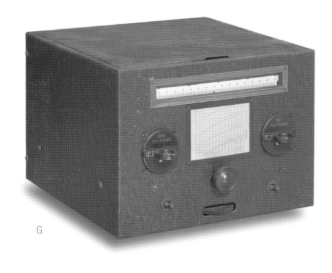

G

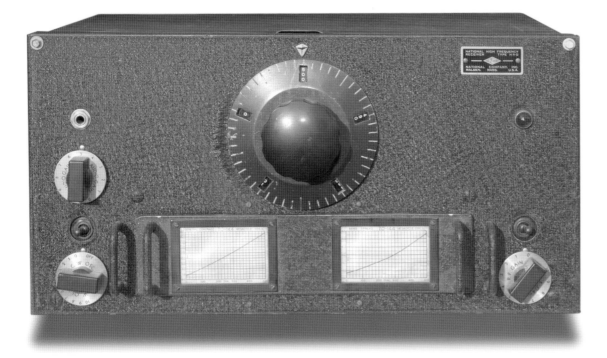

H

**A ◊ LAFAYETTE PROFESSIONAL 9** The nine-tube receiver covered .55–30 MHz in four bands. The kit version came with a pre-assembled tuning unit; $36.75 (kit)/$44.35 (wired), 1935. (1)

**B ◊ MCMURDO SILVER 5C** Known as the "Single Signal Super," the 5C tuned from 1.5–23 MHz in three bands. The eight-tube set sold for $74.70 ($83.50 with crystal filter) in 1934. (8)

**C ◊ MEISSNER TRAFFIC MASTER** Meissner's 14-tube, five-band communications receiver was supplied in kit form, but the tuning unit came pre-assembled and aligned. It had a crystal filter and covered .54–31 MHz; $81.90 (less tubes and speaker), 1938. (18)

**D ◊ MILLEN HETROFIL** James Millen left the National Company in May of 1939 to form his own company, the James Millen Manufacturing Company. The Hetrofil, Millen's first ham product, was introduced in October 1939. The unit connected to the audio output of a receiver and was used to reject or suppress an interfering signal or audio beat note. It used no tubes or other active devices; $3.50. (1)

**E ◊ NATIONAL ONE-TEN** In 1936, National introduced the One-Ten as a tool for exploring the amateur spectrum above 10 meters. The four-tube set tuned wavelengths from 10 meters to 1 meter. It sold for $85.00, including six sets of coils, but minus tubes, speaker, and power supply. (1)

**F ◊ NATIONAL AGS-X** National developed the AGS series of receivers for the Airways Division of the U.S. Department of Commerce for use in their Air-Ground stations. It was marketed to the Amateur Radio Service as well. The "X" version denotes a crystal filter. The nine-tube set used three coils per band to cover 1.5–20 MHz. They plugged in through the front panel. The rack-mount version shown here has a power supply, speaker, and storage space for the coils not in use; $295.00, 1933. (2)

**G ◊ NATIONAL FB-X** The FB-7 and FB-X were identical seven-tube receivers, except that the X model included a crystal filter in the 500 kHz IF. Standard plug-in coils provided continuous coverage from 1.5–20 MHz, and band spread coils were available for the 160, 80, 40, and 20 meter amateur bands. The "A" version of the receivers used air-variable capacitors versus mica-compression trimmers to tune the IF transformers; $38.22, 1933. (18)

**H ◊ NATIONAL HRO JUNIOR** In early 1936, National offered a simplified version of their HRO receiver. The Junior was electrically identical to the senior model except for having no crystal filter or S-meter. Its plug-in coils were general coverage only and did not offer band spread for the amateur bands. It sold for $99.00 complete with tubes and one coil set. The 5897 external power supply was $15.90. (4)

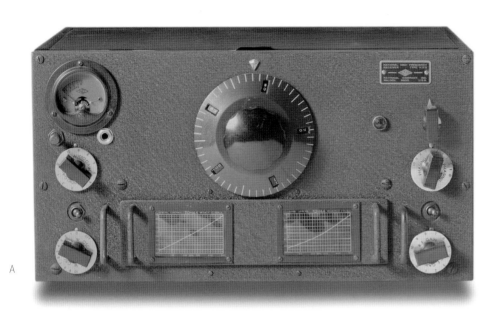

A

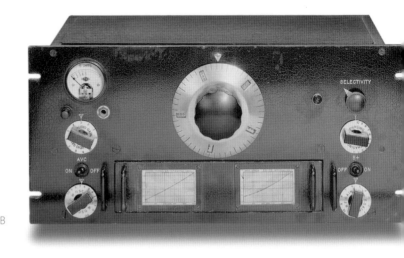

B

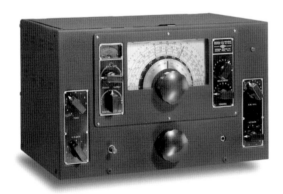

D

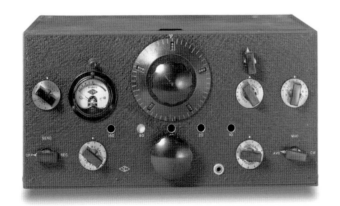

E

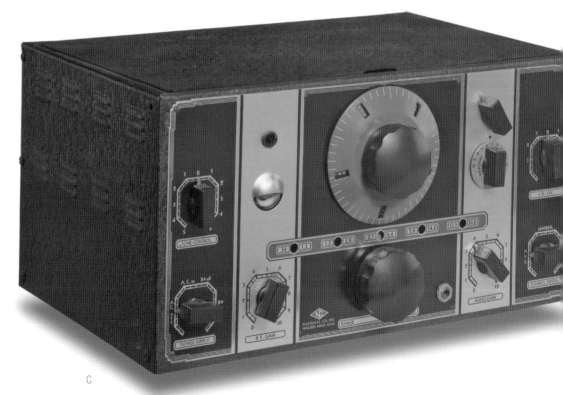

C

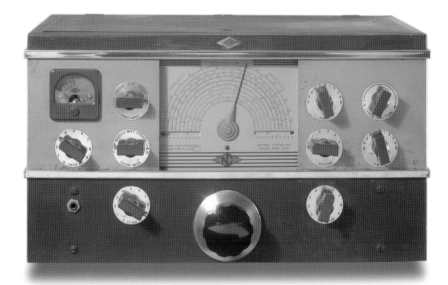

F

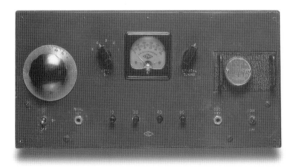

G

H

I

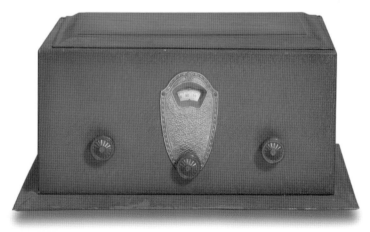

J

**A ◊ NATIONAL HRO SR.** The HRO debuted in March 1935 and remained a signature product of National for 30 years, undergoing a continual evolution and model changes. The version pictured here is a standard HRO, also known as the HRO Senior, following the introduction of the HRO Junior in 1936; $233.00. (39)

**B ◊ NATIONAL HRO V.2** Variation 2 of the HRO added a power lamp to the front panel and changed the S-meter switch to a push/pull type. A rack-mount model was also available; $166.70,1935. (18)

**C ◊ NATIONAL NC-100X** National advertised the NC-100 as the Perfected Superhet. The 12-tube receiver covered .54–30 MHz in five ranges using a moving coil catacomb and had a built-in power supply. With the addition of the optional crystal filter, it became the 100X; $127.50, 1936. (24)

**D ◊ NATIONAL NC-100XA** National restyled the NC-100X to create the 100XA. Changes included a new direct-reading dial, a tone control, and an S-meter to replace the "magic eye" indicator. The chassis inside the 11-tube receiver's new cabinet remained essentially the same as that of its predecessor, including moving-coil band switching; $142.50, 1938. (60)

**E ◊ NATIONAL NC-101X** National's ham-band-only version of the NC-100X had band-spread coverage of 160, 80, 40, 20, and 10 meters. The 12-tube receiver sold for $125.00, including tubes, crystal filter, and 10 inch external speaker; 1936. (1)

**F ◊ NATIONAL NC-200** The NC-200 covered .49–30 MHz in six general-coverage bands. Four more bands were dedicated to band spreading the 80, 40, 20, and 10 meter amateur bands. The 12-tube receiver had a crystal filter; $147.50, 1940. (1)

**G ◊ NATIONAL NTX-30** The NTX-30 provided 30 watts of crystal-controlled output on the 80 through 10 meter bands. A 6L6 oscillator operating on 80 meters drove a series of doubler 6L6s on the higher bands. A pair of 6L6Gs in parallel served as the final amplifier. It was a stand-alone CW transmitter that could be put into AM phone service with the addition of an external speech amplifier/modulator. The table model NTX-30 sold for $195.00, the rack-mount model was $10.00 more; 1938. (61)

**H ◊ NATIONAL SW-2** National entered the shortwave receiver market with the SW-2. The two-tube (untuned RF amp, regenerative detector) set sold in basic panel and chassis form as pictured here; 1928. (18)

**I ◊ NATIONAL SW-3** National designed the SW-3 for the Great Depression market. Its circuit was similar to that of the SW-5, but lacked that model's push-pull audio output stage. It was eliminated in an effort to keep the selling price low enough to attract customers when it was introduced in 1931. The three-tube regenerative set was still capable of good performance and remained part of National's product line for more than 15 years. (10)

**J ◊ NATIONAL SW-4** After adding a third tube to the SW-2, National brought out the four-tube SW-4. Unlike the earlier receiver, it was manufactured using custom-made tooling and included a cabinet. The fourth tube functioned as an audio power amplifier; 1929. (18)

**A ◊ PATTERSON PR-10** The PR-10 was another Ray Gudie design and the receivers were manufactured at the Gilfillan Brothers' Los Angeles plant. Patterson Radio was owned and founded by Emmitt Patterson. The PR-10 covered .54–21 MHz; $70.00; 1933. (45)

**B ◊ PIERSON-DELANE PR-15** Originally known as the Patterson PR-15, it was rechristened the Pierson-Delane PR-15 in 1937 when Patterson's chief engineer, Karl Pierson, formed a new company with a man named De LaPlane. The 15-tube receiver's circuit was the same as its Patterson cousin. There were minor cosmetic differences; $109.50, 1937. (60)

**C ◊ POSTAL MODEL 35** New York City's Postal Radio manufactured communication receivers and accessories such as pre-selectors in the mid-1930s. The 10-tube Model 35 covered .55–23 MHz using three-gang plug-in coils. The coils could be switched to provide either band spread or general coverage; 1934. (2)

**D ◊ RCA ACR-111** The ACR-111 covered .54–32 MHz in five bands and had what RCA called Constant-Percentage electrical band spread. The 16-tube circuit had two tuned RF stages, two IF stages, and a crystal filter; $189.50, 1937. (2)

**E ◊ RCA ACR-136** The RCA Victor Company entered the amateur communications receiver market with the ACR-136 in 1934. It had seven tubes and covered .54 to 18 MHz in three bands. The band-switching set had AVC and mechanical band spread; $69.50. (18)

**F ◊ RCA ACT-150** The Radio Corporation of America's 150-watt output phone and CW transmitter had a pair of 808s in the final amplifier. A pair of 808s served as modulators on phone. Plug-in coils were used to cover 160–10 meters. The transmitter's circuits were fully metered; $625.00 (with one set of coils, but minus tubes), 1937. (59)

**G ◊ RCA ACT-40** The complete 40-watt phone and CW transmitter consisted of four separate units in a rack. The units could also be purchased separately, and the basic transmitter could evolve into a higher-power rig by adding to the original components. It used plug-in coils to cover the 160 through 20 meter bands; $235.00, 1936. (37)

**H ◊ RME-9D** When Radio Manufacturing Engineers of Peoria, Illinois introduced the RME-9 in late 1933, it created the prototype for pre-war communication receivers. If RME was not the first to incorporate any one of the benchmark features in a receiver, the company led the pack by presenting all of them in one box. Only a handful of RME-9s were made, with most of them going to the Press Wireless company before a new set, christened the RME-9D, arrived. Added to the older model's nine-tube, band-switching circuit and internal AC supply were a second airplane-type dial and signal-level meter. Other new features included a front-panel peaking control for the RF and mixer stages, as well as a cast-aluminum chassis. Both the RME-9 and 9D had an IF crystal filter. The five-band tuning range went from .55 to 23 MHz. An optional model in the 9D series dropped broadcast-band coverage in favor of extending the tuning range up to 32 MHz; $112.50, 1934. (34)

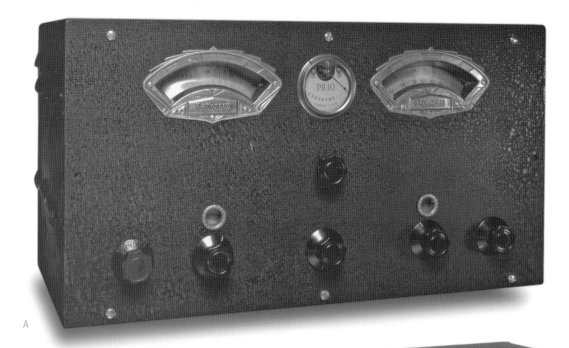

A

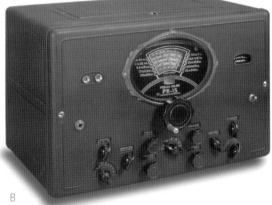

B

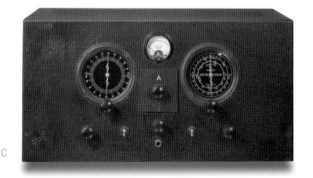

C

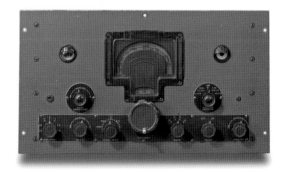

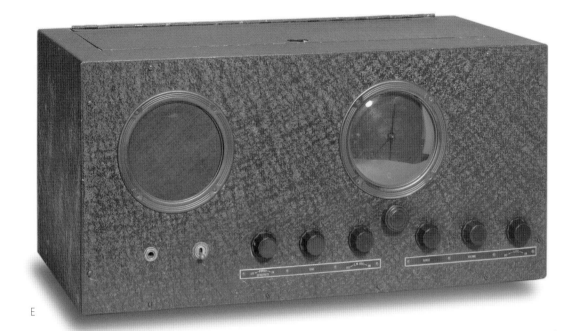

E

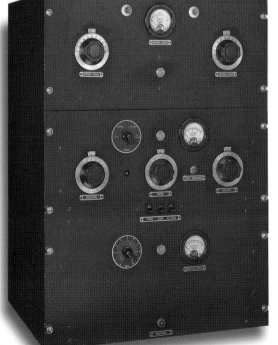

G

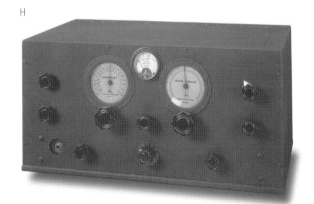

H

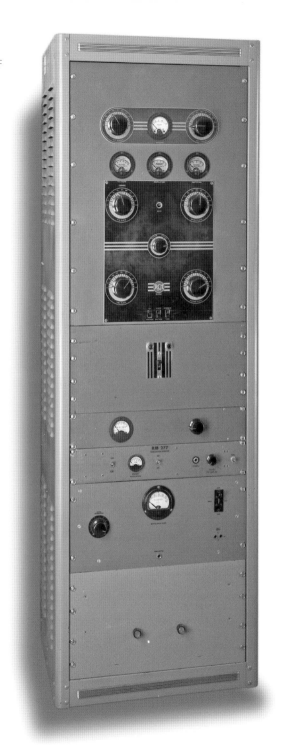

F

25

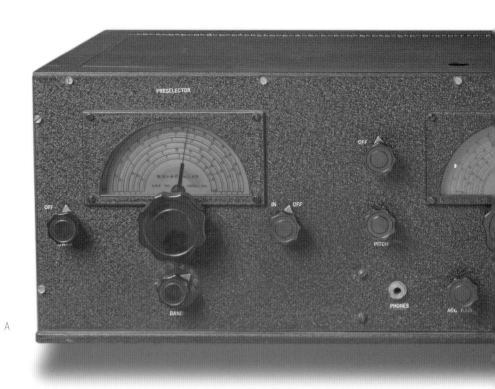

A

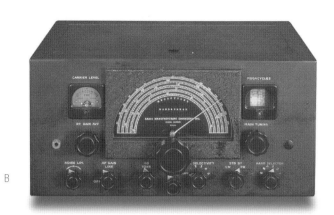

B

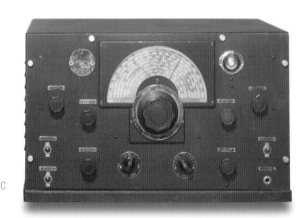

C

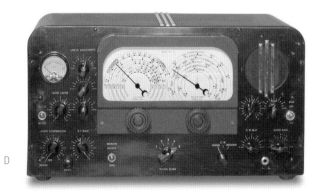

D

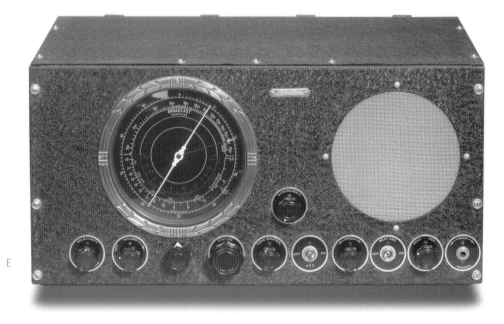

E

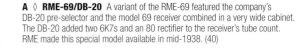

G

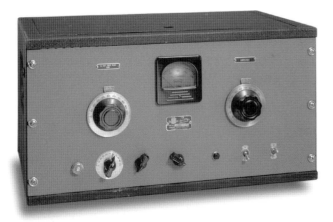

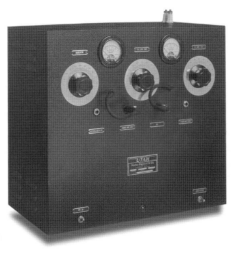

H

**A** ◊ **RME-69/DB-20** A variant of the RME-69 featured the company's DB-20 pre-selector and the model 69 receiver combined in a very wide cabinet. The DB-20 added two 6K7s and an 80 rectifier to the receiver's tube count. RME made this special model available in mid-1938. (40)

**B** ◊ **RME-99** RME touted the model 99 as being suitable for both amateur and commercial duty. The large, semi-circular dial was calibrated for the receiver's six-band, .54–33 MHz general coverage. The window to the right of the main-tuning dial showed calibrated amateur band spread. The 99 used 10 Loktal tubes along with a VR tube and rectifier. A noise limiter and five-position crystal filter were included; 139.20, 1940. (1)

**C** ◊ **SARGENT 21-AA** E. M. Sargent's Model 21 receiver used 12 metal tubes and had a regenerative RF stage. The amateur-band 21-AA tuned .55 to 30 MHz, while the commercial 21-MA covered from 80 kHz to 30 MHz; $139.00, 1936. (8)

**D** ◊ **SARGENT WAC-44** Sargent's 11-tube WAC-44 tuned from .54– 31 MHz in five bands. It had a crystal filter and built-in speaker. The three controls to the left of the tuning dial were used to peak the mixer and two RF stages; $139.00, 1940. (8)

**E** ◊ **SILVERTONE 5656A** The Silvertone 5656A was manufactured for Sears, Roebuck & Co. by Howard Radio. It covered .55 to 18 MHz in three bands. The seven-tube set had a BFO and an internal 8-inch Jensen speaker; 1936. (18)

**F** ◊ **STANCOR 40-P** Sold as a kit in 1940, the 40-P was a self-contained phone and CW transmitter running 40 watts to a TZ-20 modulated by push-pull 6L6s. It covered 160–10 meters using plug-in coils; $42.50. (64)

**G** ◊ **THORDARSON TK17K22** Thordarson's 100 watt transmitter featured band switching on any three bands between 160 and 10 meters depending upon which coils were installed. The upper unit in the rack housed the RF deck and its power supply, while the lower unit contained the modulator and power supply; $165.00, 1940. (61)

**H** ◊ **UTAH ADD-A-UNIT TRANSMITTER** Additional modules could be added to Utah's basic 80 watt CW transmitter to progressively build a half-kilowatt phone rig. The basic unit included a built-in power supply and covered 160–20 meters; $49.75, 1937. (28)

# The War Years

When the Federal Communications Commission issued Order Number Eighty-Seven on December 9, 1941, US ham operation ceased entirely as America entered World War II. The number of amateurs tripled between 1930 and the onset of the war, the ranks swelling from about 17,000 licensees to more than 50,000. More than half of these licensees did wartime duty. Some served in uniform in the armed services, while others were civilian radio operators at military bases or members of Civilian Defense. A number of amateurs participated in the War Emergency Radio Service, operating with portable equipment on the 2½ meter band.

Companies manufacturing commercial and ham communications gear shifted to military equipment, stepping up production to meet the wartime demand. Prior to the United States' entry into the conflict, many of these companies had been supplying equipment to future allies as the war raged in Europe.

The war's end brought with it tons of electronic surplus. Much of it found a home in amateur stations, either as equipment or parts for construction projects. Technology developed during the war for the military made its mark on post-war ham radio. New tube designs made more compact, higher performance equipment possible. Wartime research on radar and VHF/UHF communication yielded benefits in the upper reaches of the amateur spectrum. The SO-239 connector became commonplace on transmitters and receiver, as did the use of coaxial cable as an antenna feedline. ∎

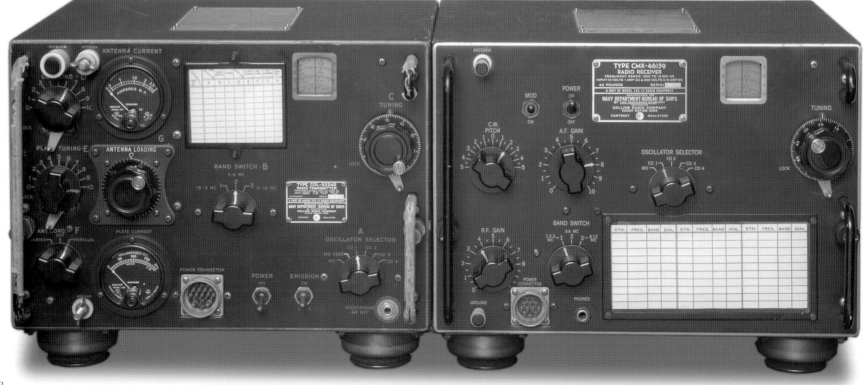

A

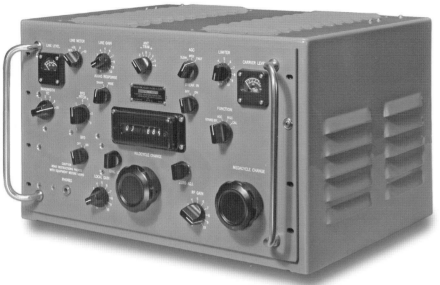

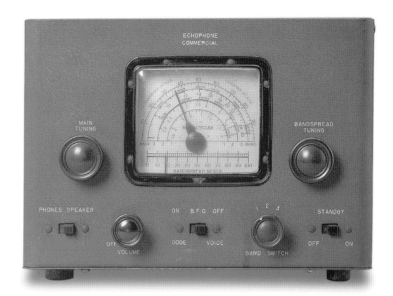

C

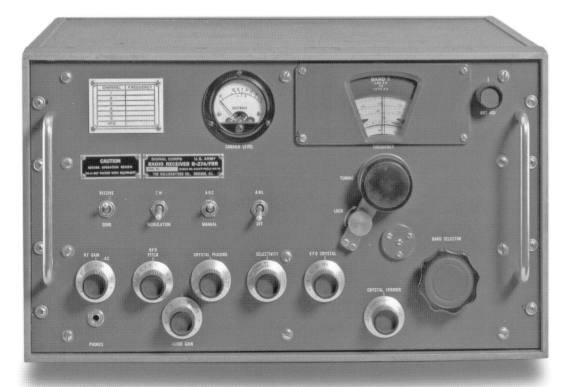

D

**A ◊ COLLINS TCS** The TCS consisted of a transmitter and receiver, along with associated power supply and control circuits. It was designed by Collins Radio for the U.S. Navy during WW II. Collins manufactured more than 35,000 units, and companies such as Magnavox, Stewart-Warner, King Radio, and others manufactured them under license from Collins. The set was used aboard small naval craft as well as for mobile and portable operation ashore. The transmitter covered 1.5–12 MHz, either VFO or crystal controlled. Power output was 40 watts CW and 20 watts AM. The seven-tube superhet receiver covered the same range as the transmitter. (11)

**B ◊ COLLINS R-390A** The 390A shared design similarities with its predecessor, the R-390. The 26-tube set offered a selection of crystal and mechanical filters in its 455 kHz IF. It was introduced in 1954 as a lower cost alternative to the R-390 and remained in production for 30 years. A dozen other companies joined Collins in manufacturing the R-390A under contract. (32)

**C ◊ ECHOPHONE EC-1** The Echophone company got its start in the 1920s manufacturing home broadcast sets but became a casualty of the Great Depression in 1936. Hallicrafters acquired the company's plant and RCA license that same year. In 1940, Hallicrafters revived the Echophone name for use in a line of inexpensive communication receivers. The EC-1 was sold throughout World War II, with many serving as "morale" sets for service personnel. The AC/DC receiver had six tubes and covered .545–30 MHz in three bands. It had a built-in speaker; $19.95, 1940. (1)

**D ◊ HALLICRAFTERS SX-73** The SX-73 was known as the R-274/FRR when it was in military uniform. The 20-tube receiver tuned from .54 to 54 MHz and was double-conversion above 7 MHz. It also offered six crystal-controlled channels with vernier tuning. Its R-274 nomenclature was also used on the Hammarlund SP-600 (R-274C). Although the two receivers shared certain features, they were different design solutions to a common military specification; 1952. (27)

**A ◊ KAAR KE-23AT** Kaar Engineering's nine-tube receiver covered .54–42 MHz in four bands. It had mechanical band spread and an S-meter. A "universal" power transformer allowed operation from line voltages of 110, 120, 150, 210, and 230 VAC at 40–60 Hz; 1944. (1)

**B ◊ MEISSNER 150-B** Meissner built this 150 watt AM and CW transmitter for the Signal Corps. It used the company's Signal Shifter VFO as an exciter and had an 813 final amplifier. Frequency coverage was 1.5 to 16 MHz using plug-in coils. It was popular with amateurs when it hit the surplus market; WW II. (60)

**C ◊ MEISSNER 9-1077 SIGNAL SHIFTER** Meissner advertised their new model Signal Shifter as the answer to wartime crystal procurement problems. The five-tube circuit had 7.5 watts output on 1–16.5 MHz using plug-in coils. The tuning dial, which could directly be hand-calibrated by the user, replaced the logging scale of previous models. It had an internal voltage-regulated power supply; 1943. (1)

**D ◊ MILITARY AN/ART-13** Collins designed the ART-13 for U.S. Navy aircraft; the transmitter went on to fly with other service branches during and after WW II. Collins produced about 26,000 ART-13s; more than twice that number were manufactured by other companies. The 100 watt CW and AM transmitter covered 2–18 MHz and some were equipped with a low-frequency module that tuned from .2–1.5 MHz. The ART-13's significant feature was its Autotune circuitry, a Collins innovation. The operator could preset the oscillator, buffer, PA, and antenna tuning to 10 different frequencies and later select any of them with a single knob. The transmitter changed frequency, retuning itself as required without further attention from the radioman or pilot. (5)

**E ◊ MILITARY BC-221 FREQUENCY METER** The three-tube, heterodyne-type frequency meter was used as a calibrated signal source to accurately set transmitters and receivers. It contained a 1 MHz crystal oscillator and a dual-range VFO covering 125–250 kHz and 2–4 MHz. Using harmonics of the three oscillators, the BC-221 supplied signals from 125 kHz through 20 MHz. Each unit came with its own calibration book stamped with the frequency meter's serial number. (53)

A

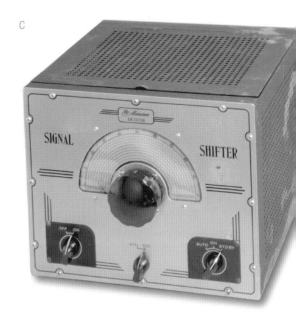

C

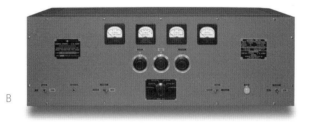

B

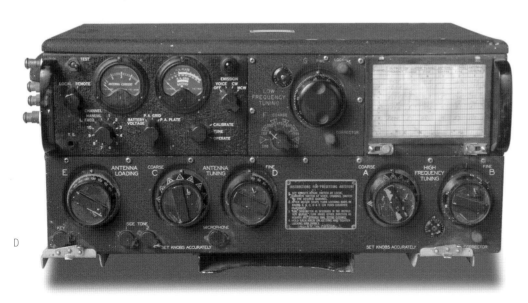

D

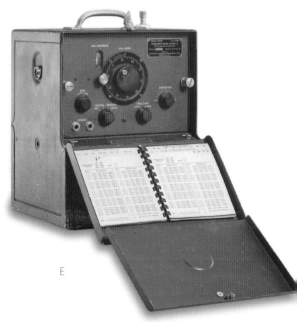

E

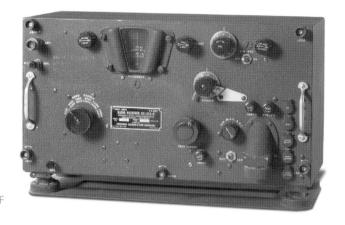

F

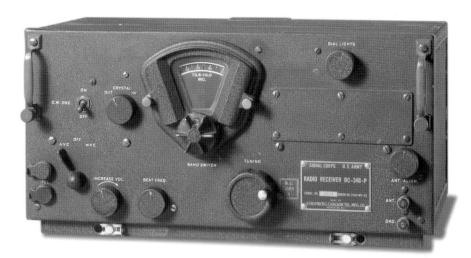

H

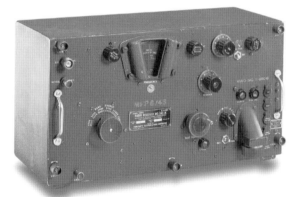

G

I

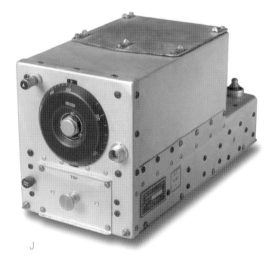

J

**F ◊ MILITARY BC-312-N** The Signal Corps adopted the BC-312 in 1938 and it was manufactured by a number of companies during the war. The nine-tube receiver covered 1.5 to 18 MHz and operated from 12 VDC with a dynamotor power supply; WW II. (51)

**G ◊ MILITARY BC-342-N** The BC-342 tuned from 1.5–18 MHz in six bands. The 10-tube set was made to operate directly from AC power. It had a crystal filter in its 470 kHz IF. Except for the power supply and its rectifier tube, the circuit is the same as that of the BC-312; WW II. (51)

**H ◊ Military BC-348-P** The BC-348 and its similar BC-224 predecessor were designed in the mid-1930s. The '348 was a mainstay receiver in WW II, serving mostly in heavy bombers and multi-engine transport aircraft. RCA did the original design and produced early models but shared production with a number of other manufacturers during the war. More than 100,000 receivers were produced, and the specific manufacturer is indicated by the letter at the end of the nomenclature. The BC-348-P pictured was made by Stromberg-Carlson. Specific circuit details, tube lineups, and even the number of tubes changed with time and company of manufacture. Early models had nine tubes; later receivers eight. All BC-348s tuned from 1.5 to 18 MHz in six bands, but after the C model also covered 200 to 500 kHz without adding an additional band-switch position. Popular with post-war amateurs, the BC-348 was the subject of many conversion articles in the late 1940s and early '50s. (51)

**I ◊ MILITARY BC-375-E** The BC-375 transmitter had its roots in a 1932 General Electric set designed for commercial aviation. Its MOPA circuit used four type VT-4C (211) tubes. One VT-4C was used as the master oscillator, another as the power amplifier, and a pair served as Class B modulators. A VT-25 (210) did duty as either a speech amp or tone oscillator. The BC-375 covered 200–500 kHz and 1.5–12.5 MHz using a series of plug-in tuning units. The transmitter was used in B-17s and other bombers; WW II. (5)

**J ◊ MILITARY BC-453-B** The six-tube BC-453 (R-23) receiver tuned from 190 to 550 kHz and had an 85 kHz IF. It was popular among post-war amateurs for use as an outboard IF to improve a communication receiver's selectivity. In this application, the BC-453 was known as the "Q5-er"; WW II. (5)

A

B

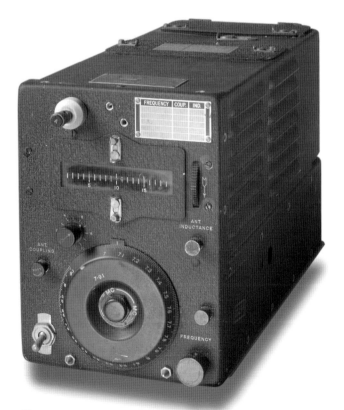

C

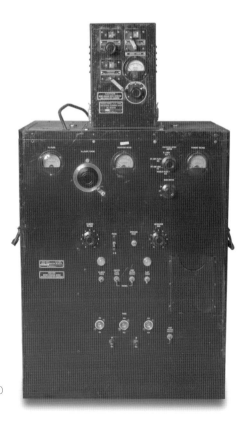

D

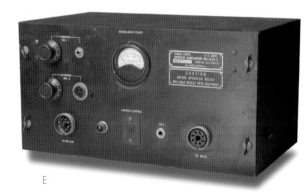

E

**A ◊ MILITARY BC-456-E** The BC-456 was the modulator for SCR-274N transmitters. It used a single 1625 as a screen modulator. The BC-456 included a tone oscillator for the modulated CW mode, and its dynamotor also furnished high voltages to the companion transmitter; WW II. (5)

**B ◊ MILITARY BC-458-A** Known collectively as Command Sets, WW II military surplus ARC-5 and SCR-274N equipment reached the civilian market in 1947, remaining a plentiful source of inexpensive gear for more than 30 years. The equipment was used by both the U.S. Army Air Corps and U.S. Navy for air-to-air and air-to-ground communication as well as navigation, and more than a million sets were manufactured. The backbone of the system was a series of five receivers (covering different frequency ranges from 190 kHz to 9.1 MHz) and eight transmitters (ranging from .5 to 9.1 MHz). Transmitters and receivers for additional ranges and revisions of existing designs were added during the course of the war. Accessories such as modulators, power supplies, and control boxes rounded out the system. The BC-458 transmitter, when converted, was popular as a VFO for the 9 MHz exciters common during the early days of single-sideband operation. The BC-458-A pictured was made for the U.S. Army Signal Corps and was part of the SCR-274N equipment. (65)

**C ◊ MILITARY BC-459** The T-22/BC-459 was the 7.0–9.1 MHz transmitter in the ARC-5 system. Modes were CW, MCW, and plate-modulated AM (with the external MD-7 modulator), unlike the SCR-274N transmitters, which were screen modulated. The T-22/ARC-5 had a "magic eye" tube resonance indicator and a pair of 1625 finals; WW II. (5)

**D ◊ MILITARY BC-610-I** The BC-610 was the military version of Hallicrafters' HT-4 transmitter. The '610 was manufactured from 1940 until 1954. Suffix letters A–F indicate production during the war years; G through I from '46 to '54. The transmitter covered 1.5–18 MHz; power out from the 250TH final was 325 watts AM, 450 watts CW. The unit here is shown with the BC-939-B antenna tuner. AM operation required the use of the BC-614 speech amp. (5)

**E ◊ MILITARY BC-614-I** BC-610 transmitters required an outboard speech amplifier for phone operation. The speech amps were designated BC-614 with a suffix letter to match that of the transmitter. The BC-614 used six tubes, including the power-supply rectifier and a tone oscillator for MCW. (5)

F

G

H

I

**F ◊ MILITARY FT-220-A** The FT-220-A mounting rack was part of the SCR-274N system and provided power, audio, and control connections for three receivers. Shown here (left to right) are a BC-453, BC-946, and BC-454; WW II. (5)

**G ◊ MILITARY R-26** This ARC-5 receiver also carried the Navy's CBY-46105 designation. The six-tube superhet tuned from 3 to 6 MHz. It was similar to the SCR-274N BC-454 except for the plug connections that mated with its mounting rack; WW II. (5)

**H ◊ MILITARY R-27/ARC-5** The BC-455-A receiver was part of the SCR-274N aircraft radio equipment system, also collectively known as ARC-5s. The BC-455-A was a six-tube superhet with a 2830 kHz IF and tuned from 6 to 9.1 MHz. The DY-2A/ARR-2 dynamotor power supply on the rear of the unit furnished operating voltages when connected to a 28 VDC source; WW II. (5)

**I ◊ MILITARY R-274C/FRR** The R-274 series was the military version of Hammarlund's SP-600 receiver. It was built in various models for both the Army Signal Corps and the Navy. The full model number for the receiver pictured is SP-600-JX-26. The 20-tube general-coverage receiver tuned from .54 to 54 MHz and had provision for six crystal-controlled channels between 1.35 and 29.7 MHz. It had an IF and crystal filter at 455 kHz, and a second IF at 3.955 MHz was used on the three highest bands; 1950. (5)

**J ◊ MILITARY R-389/URR** Collins designed and manufactured this 36-tube low-frequency/medium-frequency receiver for the U.S. Army Signal Corps. It covered 15 kHz to 1.5 MHz and had motor-assisted tuning; 1951. (27)

**K ◊ MILITARY R-390** Many consider the Collins R-390 to be the ultimate receiver from the vacuum-tube era. In ways it still surpasses anything made since. The 32-tube, 65 lb. set tuned from .5 to 32 MHz in 32 bands. The receiver's PTO was linked to a mechanical counter, providing a digital readout in an era when that was uncommon. It employed a crystal filter and L/C circuits in the IF to provide a range of selectivity from .1 to 16 kHz. The R-390 was triple conversion below 8 MHz and double conversion above that; 1950. (51)

**L ◊ MILITARY R-391** The R-391/URR was an R-390 with an eight-channel Collins Autotune circuit built in; 1950. (27)

J

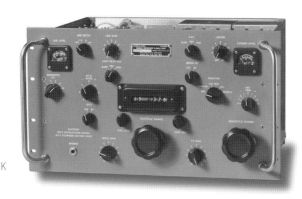

K

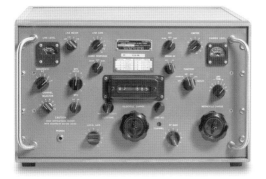

L

33

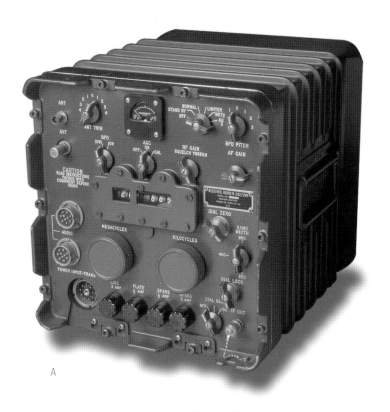

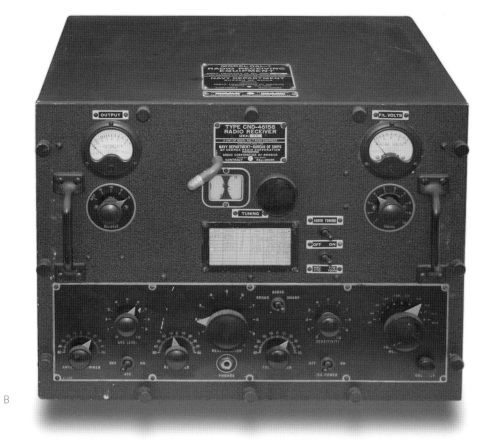

A

B

**A ◊ MILITARY R-392** The R-392/URR was a re-packaged, more rugged version of Collins' R-390. It was intended for mobile duty as part of the GRC-19 system and operated from 24–28 VDC. The 25-tube receiver weighed 55 lbs. and had a water-resistant case; 1950. (1)

**B ◊ MILITARY RAL-7** The RAL series of receivers dates from 1935. They were used by the U.S. Navy through WW II and remained aboard ship as backup receivers for another quarter century. The RAL was a regenerative receiver whose detector entered oscillation so gradually that the receiver had an Oscillator Test button to confirm regeneration. Although they were TRF (Tuned Radio Frequency) sets, the RAL receivers featured uni-knob tuning and also had audio filtering, enabling the operator to select 20 peak response frequencies ranging from 450 Hz to 1300 Hz. The six-tube (plus power supply) set tuned from .3 to 23 MHz in nine bands. The sister RAK series covered 15 kHz to 600 kHz. One detail about the radio in the photograph is not original equipment: The little silver-and-gold device mounted on the lower left-hand corner of the nameplate houses a small lamp which served to illuminate the tuning dial. (21)

**C ◊ MILITARY RAK-7** The Navy's RAK receivers were low-frequency companion pieces to the RAL series MF/HF receivers. The RAK tuned 15–600 kHz in six bands. The eight-tube TRF set had a regenerative detector and audio filters. It ran on 117 VAC or battery power; WW II. (5)

**D ◊ MILITARY RBC-2** The Navy's RBC receivers were 19-tube superhets covering 4–27 MHz in four bands. The sets featured both IF and audio filtering. A separate power supply was required; WW II. (5)

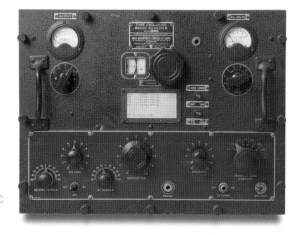

C

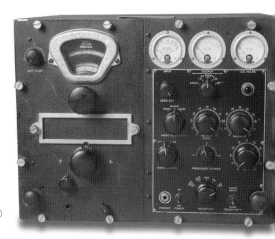

D

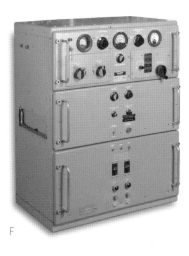

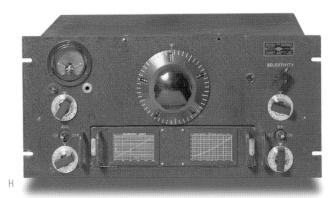

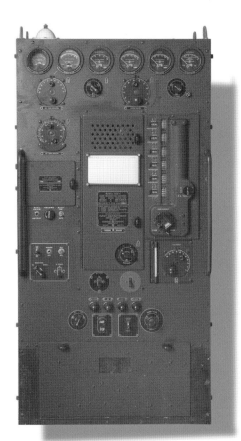

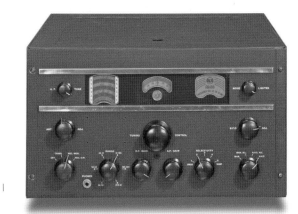

**E ◊ MILITARY SCR-522** The SCR-522 was a VHF (100–156 MHz) air-to-ground and air-to-air communication system consisting of a BC-624 receiver and a BC-625 transmitter in an FT-244 rack housed in a CS-80 case. It was derived from the British TR-1134 set used by many of their aircraft during the Battle of Britain. The transmitter and receiver each had four crystal-controlled channels. Power for the SCR-522 came from a dynamotor supply. The transmitter's AM output was in the 8–10 watt range. SCR-522 conversions provided an inexpensive way for post-war amateurs to get on VHF. The left-hand photo shows the set buttoned up, ready for use; the view on the right has the covers open, revealing some of the '522's inner workings. (5)

**F ◊ MILITARY T-368** Barker & Williamson designed an AM, CW, and RTTY transmitter for the military in the early 1950s. B&W, as well as a number of other companies, manufactured the T-368 for the next decade. The 700 lb. transmitter had 450 watts of carrier power with a 4-400A final. A pair of 4-125s (4D21) served as modulators. It covered 1.5–20 MHz. (27)

**G ◊ MILITARY TCK-4** The TCK transmitters were introduced midway through the war. Using a pair of parallel 813s in the final, power output on 2–18.1 MHz was 400 watts; 200 watts AM. The master oscillator was housed in a temperature-controlled box. Tuning for the TCK's driver and final-amplifier circuits tracked the master-oscillator frequency; WW II. (5)

**H ◊ NATIONAL HRO-M** The HRO-M was similar to the HRO Senior series but came with general-coverage coils rather than the band-spread versions. The M model was a wartime version of the civilian receiver with much of the production going to England. The unit pictured is an HRO-M-RR rack-mount version. The coil set shown is for another model HRO and has bandspread coverage. Many of the coils supplied with the M substituted a logging chart for the bands spread scale in the right hand frame; WW II. (1)

**I ◊ RCA AR-88** RCA introduced the AR-88 in 1941, on the eve of World War II. The 14-tube receiver continued to be produced throughout the war with much of the production going to England and other allies. It covered .54–32 MHz and had a crystal filter but no phasing control. A low-frequency model, the AR-88LF, was also made. (48)

# Era Three

# Post War

Prior to World War II, Amateur Radio frequently moved in lockstep with technology. Then, while technology marched off to war, Amateur Radio was relegated to a state of suspension. When peacetime once again breathed life back into the hobby, most hams returned to the air with equipment from the previous decade.

Even the new offerings from companies that survived the war years were largely throwbacks to the late 1930s and early '40s. Collins, not surprisingly, was a leader in applying wartime innovation to their ham gear, but for another year or two many other manufacturers sold products that were extensions of their pre-war designs.

This era can be characterized as one in which amplitude-modulated radio telephony reigned supreme. Heavyweight gear sat upon the throne during the AM years. Big iron was the guiding principle in both transmitters and receivers. Nearly every manufacturer featured, near the top end of their product line, a rig large and heavy enough to render lifting by one man difficult or impossible.

The decade following World War II found Amateur Radio concerned with more than AM operation, though. For a few years after wartime restrictions

ended, the American Radio Relay League encouraged the use of narrow-band frequency modulation (FM) in areas of the HF spectrum where it was permitted. A number of manufacturers made equipment that included the mode, but the idea was one whose time had not yet arrived. ∎

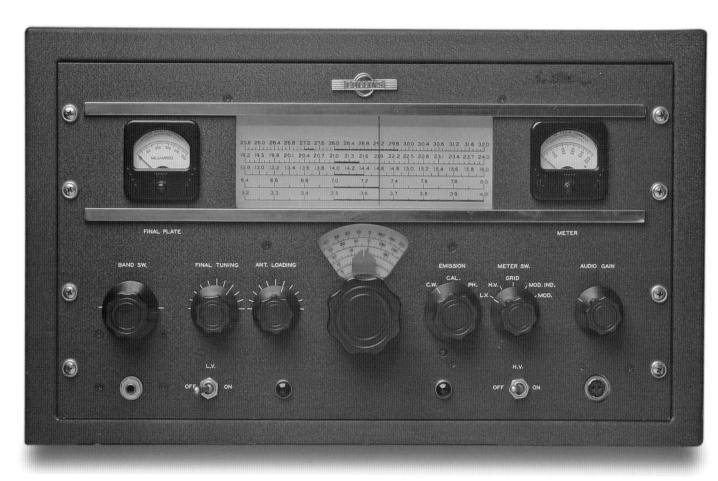

**ABOVE ◊ COLLINS 32V-1** The 32V-1 incorporated a PTO, band-switching transmitter, speech amplifier, power amplifier, modulator, and power supply in a tabletop cabinet. Power input to the 4D32 final was 150 watts CW, 120 watts phone on the 80–10 meter bands. The output circuit was a pi-network. In 1949, the transmitter was superseded by the 32V-2. Differences included TVI measures such as improved shielding, both coarse and fine loading controlled by a single front-panel knob, an L-section added to the V-1's pi-net output, a coaxial connector on the rear panel, and a $100.00 price increase; $475.00, 1946. (31)

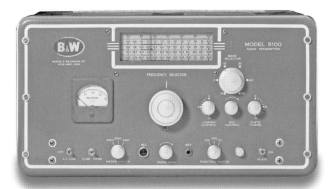

A

B

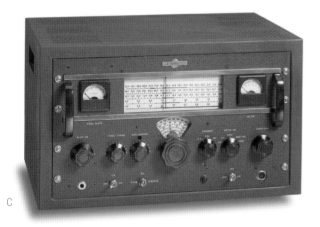

C

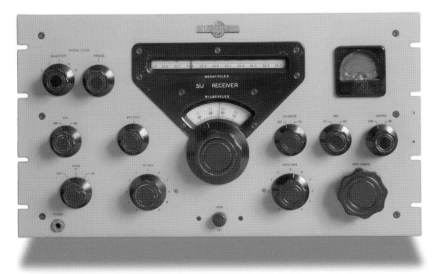

D

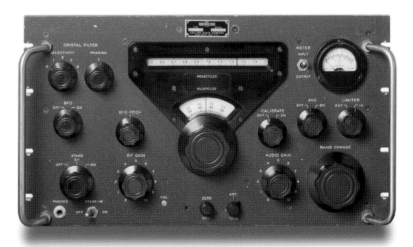

E

**A ◊ B&W 5100** Barker & Williamson's 5100 ran 150 watts CW on 80–10 meters. Power input on AM phone was 135 watts using a pair of 6146s in Class B to modulate its two 6146 finals. It had a pi-network output and a built-in low-pass filter; $442.50, 1954. (63)

**B ◊ COLLINS 30K-1** Collins entered the post-war amateur market with a high-power transmitter. The 30K-1 stood 5½ feet tall, weighed 600 pounds, and delivered 500 watts CW or 375 watts AM phone on the 80–10 meter bands. Its 4-125A final was modulated by a pair of 75THs in Class B. The 30K-1 was made to be used (and often sold) with the Collins 310A exciter; $1450.00, 1946. (32)

**C ◊ COLLINS 32V-3** Collins' 32V-3 continued the company's TVI campaign, with alterations of the 32V-2 design. The new transmitter was installed in a lidless cabinet having different-style ventilation holes. An additional shield for the RF section was added to that already present in the 32V-2, and bypassing was improved for external connections. The CW sidetone and muting circuits were eliminated; $775.00, 1951. (46)

**D ◊ COLLINS 51J-1** The 51J-1 was introduced by Collins as a superior receiver at a premium price. The 16-tube, double-conversion superhet tuned from .5 to 30.5 MHz in 30 bands, each spanning 1 MHz. Frequencies in the lower-dial window were marked in 1 kHz increments. It had an IF crystal filter and selectivity from 200 Hz to 3 kHz. Its 51J-2 successor was identical except for the addition of an "Input/Output" switch next to the S-meter and a front-panel adjustment screw for the 100 kHz calibrator; $875.00, 1949. (40)

**E ◊ COLLINS 51J-3/R-388** 51J-3s built for the military were also known as the R-388. The 18-tube receiver tuned from .5 to 30.5 MHz in 30 bands and was triple conversion below 3.5 MHz; $1000.00, 1952. (31)

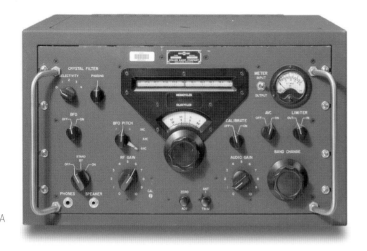

A

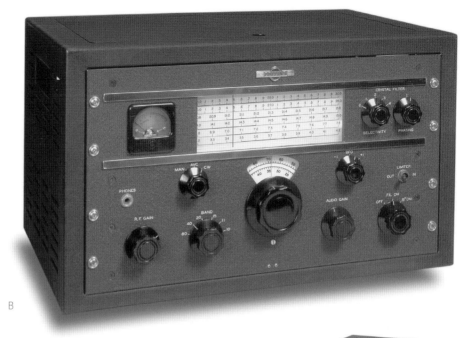

B

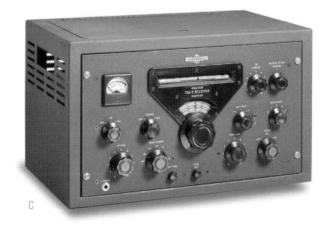

C

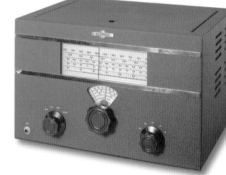

D

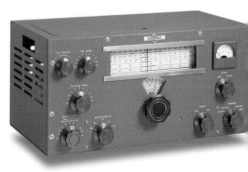

E

**A ◊ COLLINS 51J-4** The 19-tube 51J-4 was the final receiver in Collins' 51J series. It was similar to the 51J-3 but used the company's mechanical filters in its 500 kHz IF; $1200.00, 1957. (31)

**B ◊ COLLINS 75A-1** The first amateur-band receiver from Collins was christened the 75A when it was announced in 1946 and advertised as such until mid-1948. An on/off noise-limiter switch was added and the first production models became the 75A-1. The new Collins receiver brought astonishing technology to the post-WW II ham market. It incorporated the Permeability Tuned Oscillator developed by the company during the war, had a linear tuning dial calibrated in 1 kHz increments (2 kHz on 10 and 11 meters), and was extremely stable. Another unusual practice for its time was the use of a crystal-controlled HF oscillator followed by a tunable first IF. The 14-tube, double-conversion set covered the 80 through 10 meter bands; $375.00. (46)

**C ◊ COLLINS 75A-3** The 75A-2 (1950) had introduced the dial escutcheon that would remain throughout the rest of the A-line receiver series. It covered 160–10 meters, and used the new 70E12 PTO. The optional 148C-1 adapter enabled NBFM reception. Collins' 75A-3 added mechanical filters to the 75A-2 design, ushering in a new era of selectivity for amateur receivers. It retained the previous model's crystal filter, included a 3.1 kHz mechanical filter, and offered an 800 Hz filter as an option. The mechanical filters were selected by a lever switch concentric with the BFO knob; $530.00, 1952. (46)

**D ◊ COLLINS 310A** Collins developed the 310A as an exciter for their 30K transmitter or homebrew high-power rigs. The band-switched exciter covered 80–10 meters and frequency was controlled by a 70E-8 PTO. Its output tube was an 807 and it had an internal power supply; $100.00, 1946. (32)

**E ◊ COLLINS 310B-3** Collins created the 310B-3 by adding a universal antenna coupler to the 310B-1's output circuit. The rigs are otherwise-identical, self-contained 15 watt exciters with band-switching 6AG7 buffer/multiplier stages, and a plug-in coil 2E26 final; $215.00, 1947. (46)

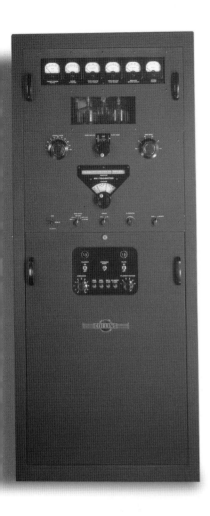

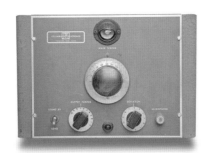

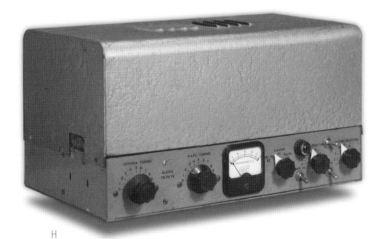

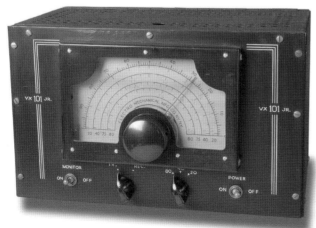

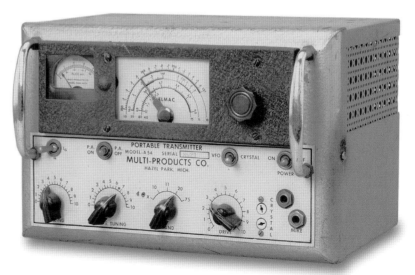

**F** ◊ **COLLINS KW-1** The transmitter was designed with everything—exciter, amplifier, modulator, and power supplies—in one 5½ foot rack, although the exciter could be removed for desktop operation. Input to the 4-250A finals on CW, AM, and NBFM was 1 kilowatt on the 160 through 10 meter bands; $3850.00, 1950. (32)

**G** ◊ **COLUMBUS ELECTRONICS FMO-28** The FMO-28 was an NBFM VFO/exciter for the 80–10 meter bands. The "Magic Eye" tube indicated frequency deviation. It had a self-contained power supply; $79.50, 1947. (58)

**H** ◊ **ELDICO TR-75-TV** In 1949, Eldico introduced the TR-75, a 6L6/807 CW transmitter kit. The following year, the Long Island, New York company added onboard filtering, improved the shielding, and changed the tube lineup to a 6AG7 driving a 1625. The anti-TVI measures included adding a "-TV" to the 60 watt transmitter's name. It had a pi-net output and covered 80 through 10 meters; $44.95, 1950. (13)

**I** ◊ **ELECTRO-MECHANICAL VX-101 JR.** The VX-101 Jr. exciter provided band-switching coverage of 80, 40, and 20 meters but had no provision for crystal operation. It was made by the Electro-Mechanical Mfg. company of Long Island City, New York; $54.50, 1946. (1)

**J** ◊ **ELMAC A-54** Elmac was a division of the Multi-Products company. The name was changed to Multi-Elmac after legal persuasion by the Eitel-McCullough tube people (who felt Elmac was too similar to their own Eimac brand name). The A-54 mobile transmitter ran 50 watts input, phone or CW, on 75, 20, and, 10/11 meters. Its band switch had a position for an optional fourth band; $139.00, 1952. (1)

**A ◊ ELMAC AF-67 & PMR-7** This receiver and transmitter frequently were paired in mobile installations, although the receiver arrived on the market two years later (1955). The PMR-7 receiver covered 160–10 meters plus the broadcast band. It had a 10-tube, double-conversion circuit and both external DC and 115 VAC power supplies available as options. It sold for $159.00. Elmac called its AF-67 transmitter a "Trans-Citer," hinting that it would be equally suited for use on a desktop as well as under an automobile dash. The 60-watt CW, AM, and NBFM rig had VFO coverage of 160–10 meters. It cost $177.00 when introduced in 1953. (1)

**B ◊ ELMAC PMR-6A** Elmac's PMR-6A 10-tube, double-conversion mobile receiver covered 80–10 meters as well as the standard broadcast band. It had a BFO and a noise limiter. A choice of external power supplies made it useful in the home station as well as on the road; $134.50, 1953. (1)

**C ◊ GON-SET 10/11 CONVERTER** In the company's early days, Gonset was spelled "Gon-Set." The 10/11 tuned both those bands in one continuous range. Similar models covered the 20 and 6 meter bands. They were the first in long line of converters produced by the company; $39.95, 1948. (1)

**D ◊ GONSET COMMANDER** The Commander covered 160–6 meters using plug-in coils. The crystal-controlled transmitter ran 35 watts phone, 50 watts CW. A tubeless VFO was available as an accessory; $124.50, 1952. (1)

**E ◊ GONSET G-77A & G-66B** Gonset's chrome-plated mobile pair evoke the era of the automobile in which they were used. The G-66B receiver covered the broadcast band plus 80–10 meters in six bands. The double-conversion set's first IF was at 2050 kHz. Selectivity came from eight L/C circuits in the 262 kHz second IF. The G-77A transmitter ran 60 watts AM to a 6146 final on 80 through 10 meters. Its 6/12 VDC power supply and modulator were on a separate chassis; G-66B, $124.50, 1957; G-77A, $299.00, 1958. (1)

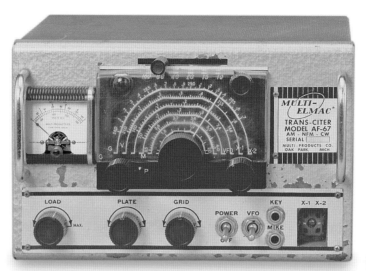

A

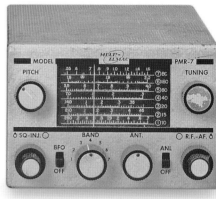

C

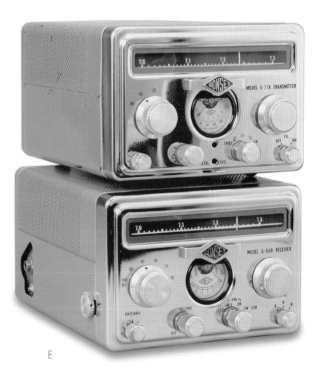

E

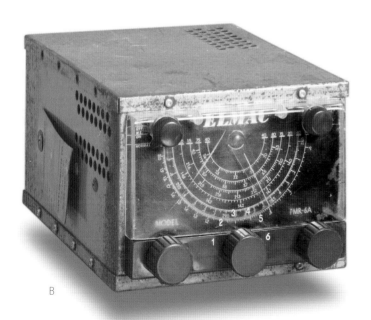

B

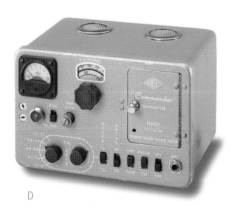

D

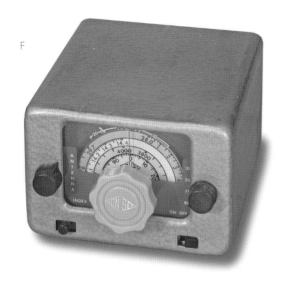

F

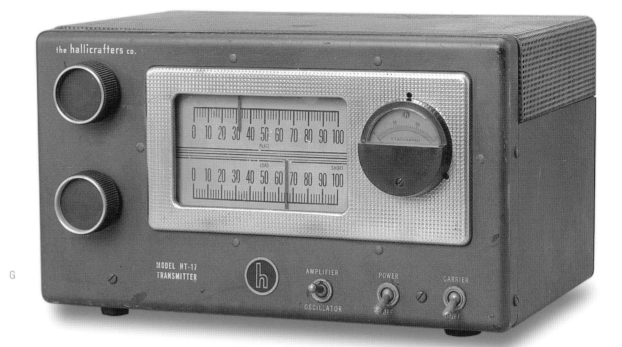

G

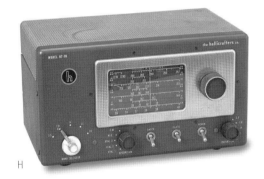

H

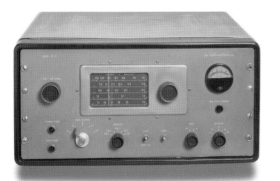

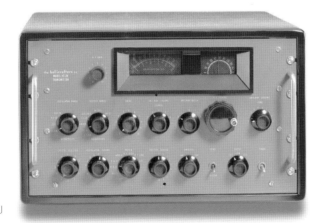

J

**F** ◊ **GONSET TRI-BAND CONVERTER** Gonset's model 3005 Tri-Band Converter covered 20 meters and the phone portions of 10, 11, and 75 meters; $42.50, 1950. (1)

**G** ◊ **HALLICRAFTERS HT-17** The HT-17 covered 3.5 to 30 MHz with plug-in coils. The crystal-controlled transmitter's CW output was 15 watts on the 80 and 40 meter bands; 10 watts on 20, 15, and 10. The VFO-style slide-rule dials were actually scales for the tank circuit's plate and load capacitors. A jeweled pilot lamp served as a visual output indicator and the milliammeter in the unit pictured was offered as an option; $69.50, 1947. (1)

**H** ◊ **HALLICRAFTERS HT-18** In addition to CW, the HT-18 offered narrow-band FM phone. The unit was intended as a VFO/exciter for a higher-powered transmitter. Output was 2.5 watts on 3.5–29.7 MHz; $110.00, 1947. (1)

**I** ◊ **HALLICRAFTERS HT-19** The CW and NBFM transmitter delivered 125 watts output on the 80 through 10 meter bands. It had a self-contained VFO and all stages were band-switched except for the plug-in coil 4-65A final amplifier. It could be used on AM with an external modulator driven by the HT-19's speech amplifier; $298.00, 1948. (15)

**J** ◊ **HALLICRAFTERS HT-20** Hallicrafters paid strict attention to the TVI problem in designing and constructing the HT-20. Even the meter and plate tuning dial on the front panel were covered with an RF-proof screen. The transmitter had 100 watts output on AM and 115 watts on CW. Its 4D32 final amplifier was modulated by push-pull 807s on AM. The HT-20 covered 160–10 meters; $298.00, 1948. (27)

A
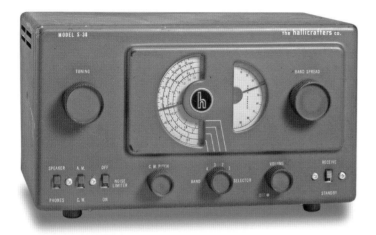

C
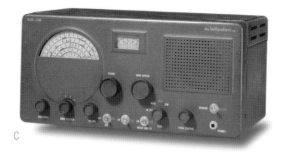

D
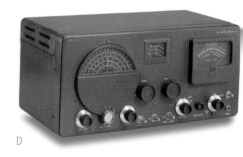

E
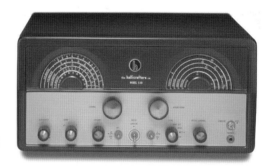

F
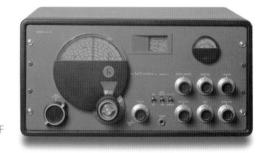

B
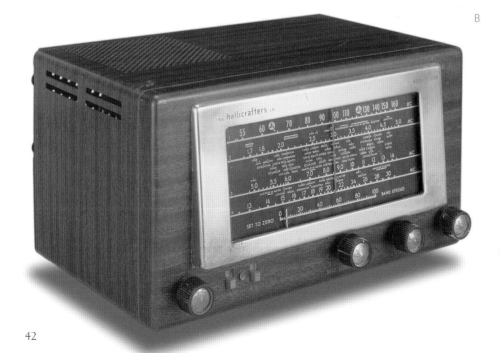

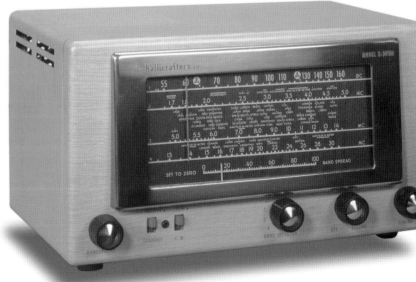

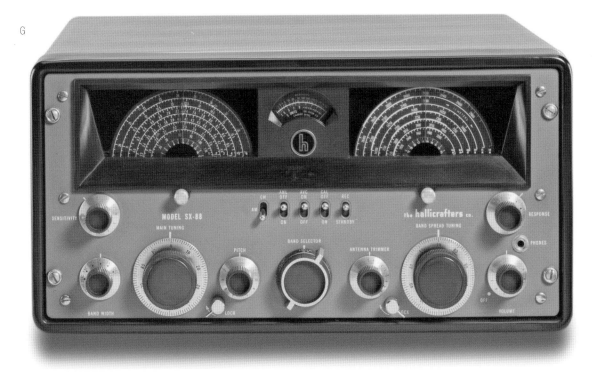

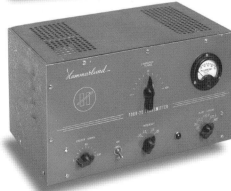

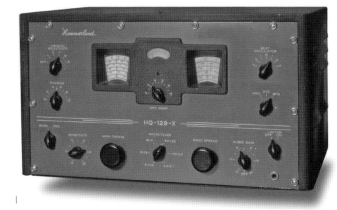

**A ◊ HALLICRAFTERS S-38** The S-38 became Hallicrafters' entry-level receiver following the S-41's short production run. It was dressed up in what the company called its post-war style but was electrically similar to the S-41 and Echophone models preceding it. The AC/DC set used four tubes and covered .54–32 MHz in four bands. It had an adjustable BFO, a noise limiter, and an internal speaker; $39.50, 1946. (1)

**B ◊ HALLICRAFTERS S-38D** Hallicrafters gave the S-38D a facelift and new cabinet style. Its front panel was dominated by a slide-rule dial. The IF tube, which had been a 12SK7 in previous models, was changed to a 12SG7. In addition to the standard gray steel cabinet, the receiver was available in optional blond and mahogany finishes. Both of those are shown here and were designated the S-38DB and S-38DM, respectively; $49.50, 1954. (1) & (66)

**C ◊ HALLICRAFTERS S-40B** The tuning range of the S-40B was the same as earlier models, but it had eight tubes rather than nine and a new, one-piece cabinet; $89.95, 1950. (1)

**D ◊ HALLICRAFTERS S-76** The S-76 was double conversion with IFs at 1650 and 50 kHz. It was difficult to miss the 11-tube set's giant 4-inch S-meter. Frequency coverage was 538–1580 kHz and 1720 kHz–32 MHz. Selectivity was provided by L/C circuits in the second IF; $169.50, 1951. (1)

**E ◊ HALLICRAFTERS S-85** The S-85 had eight tubes and covered .538–34 MHz in four bands. Its band-spread dial carried calibration for the 80 through 10 meter amateur bands; $119.95, 1954. (29)

**F ◊ HALLICRAFTERS SX-42** The SX-42 covered .54 to 110 MHz continuously in six bands. The 15-tube set received AM and CW signals on the bands covering .54 to 30 MHz, and AM, CW, and FM on the bands covering 27–110 MHz. The audio section could be used as a high-fidelity phonograph amplifier; $250.00, 1946. (31)

**G ◊ HALLICRAFTERS SX-88** With the SX-88, Hallicrafters set out to design the "finest amateur receiver in the world." The 20-tube set covered .535 to 33 MHz in six bands. It was double conversion with IFs at 2075 and 50 kHz except for band two, which used 1550 and 50 kHz. L/C circuits at 50 kHz offered six degrees of selectivity from 250 Hz to 10 kHz. A switch changed the BFO injection level to optimize CW or SSB reception. The SX-88 had a phono input jack and 10 watts of audio from a pair of P-P 6V6s; $595.00, 1954. (27)

**H ◊ HAMMARLUND FOUR-20 & FOUR-11** The Four-20 ran 20 watts output on CW with an 805 final and could also work AM when paired with Hammarlund's Four-11 modulator. The crystal-controlled transmitter covered 80–10 meters and used a patented feature called "Mono Sequence Tuning" to simplify changing bands ($120.00, 1947). The Four-11 used 6 tubes, including a pair of 7C5s in Class B as modulators; ($72.50, 1947). (24)

**I ◊ HAMMARLUND HQ-129X** Hammarlund's HQ-129X receiver was an update of the company's pre-war HQ-120 design. The 11-tube receiver tuned from .54–31 MHz in six bands. It was single conversion and had a crystal filter; $129.00, 1946. (49)

**A ◊ HAMMARLUND SP-400-X** Hammarlund's post-war Super Pro continued the company's emphasis on quality construction and performance. The 18-tube set tuned from .54 to 30 MHz in five bands. The SP-400's power supply was housed in a separate cabinet and the receiver could operate from batteries as well; $342.00 (including speaker), 1946. (1)

**B ◊ HARVEY-WELLS BANDMASTER & VFO** The TBS-50 Bandmaster Deluxe covered not only 80–10 meters but the 6 and 2 meter bands as well. Power-supply options enabled the transmitter to be used in either a fixed-station or mobile setup. The rig is pictured mounted atop the Bandmaster VFO, which was introduced in 1952 for $47.50. The transmitter was $137.50; 1949. (63)

**C ◊ HARVEY-WELLS R-9/T-90 STATION** The individual components were housed in similar-size cabinets. The R-9 receiver was a nine-tube, double-conversion set covering the 80–10 meter bands. It came with a choice of 115 VAC or 6/12 VDC power supplies. It sold for $149.50. Its matching speaker was $10.75. The T-90 transmitter covered the same frequency range as the R-9. The 75 watt phone, 90 watt CW rig was VFO controlled and had provision for crystal operation. Its price was $179.50 minus power supply. The APS-90 fixed-station power supply cost $79.50. The Z-Match antenna coupler covered 80–10 meters without band switching, matching 10 to 2000 ohm loads, balanced or unbalanced. It contained a forward/reflected power meter and cost $69.00; 1954. (1)

**D ◊ HEATH AR-2** Heath's AR-2 kit communications receiver was a six-tube superhet with a transformer power supply. It tuned from .535 to 35 MHz in four bands. The AR-2 featured a built-in speaker, noise limiter, and band-spread tuning. It sold for $25.50. The vinyl-covered wood cabinet was a $4.50 option; 1953. (1)

**E ◊ HEATH AT-1** Heath entered the amateur transmitter market with the AT-1, a three-tube, crystal-controlled rig. It had a built-in power supply and covered 80–10 meters. Power input to the 6L6 final was about 35 watts; $29.50, 1953. (1)

A

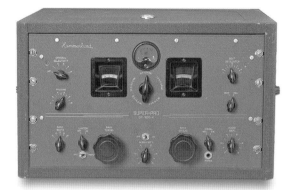

B

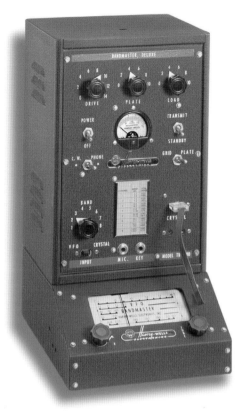

D

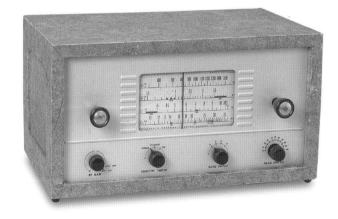

C

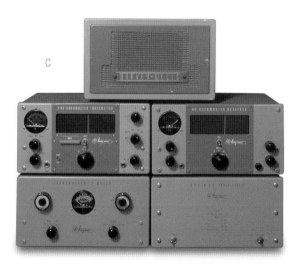

E

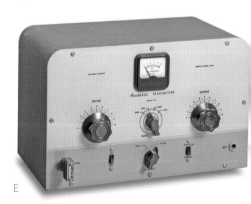

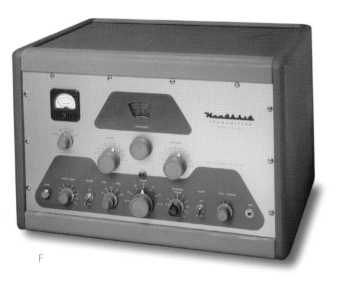

F

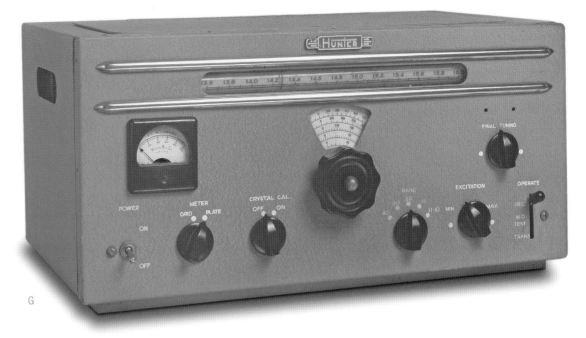

G

H

I

**F ◊ HEATH DX-100** The DX-100 covered 160–10 meters with 125 watts CW and 100 watts plate-modulated AM phone. The transmitter was the first in Heath's DX series. It used a pair of 6146s in the final, and modulation was furnished by push-pull 1625s. It had a built-in VFO and a pi-network output; $189.50, 1955. (23)

**G ◊ HUNTER CYCLEMASTER 20A** Hunter Manufacturing, located in Iowa City, Iowa, was owned by Dr. Theodore Hunter, WØNTI. He was instrumental in the development of the PTO and the Navy TCS system while employed at Collins in the 1940s. After the war, he formed his own company to manufacture amateur radio gear as well as medical equipment. Along with obtaining advanced degrees in electronic engineering and physics, Hunter had also worked as a research assistant in obstetrics and gynecology. The heart of the Cyclemaster 20A was a PTO. In concept, the rig was similar to the Collins 310 series, bearing a strong physical resemblance. The 20 watt VFO/exciter provided band-switching frequency control from 3.5 to 29.7 MHz and contained transmit-receive and metering circuits for the transmitter's amplifier stages; $169.50, 1948. (23)

**H ◊ JOHNSON ADVENTURER** The Viking Adventurer ran 50 watts input CW on 80–10 meters with a 6AG7 oscillator/807 amplifier lineup. Both tubes' cathodes were keyed. It included TVI-suppression measures and had a pi-net output; $54.95, 1953. (1)

**I ◊ JOHNSON VIKING MOBILE** The Viking Mobile was a band-switching AM transmitter covering 75, 20, and 10 meters with provision for a fourth band. Its circuits were gang-tuned and all stages were metered. The transmitter was crystal-controlled or could be used with an external VFO. Power input to the 807 final was 30 to 60 watts depending upon the plate voltage available; $99.50 (kit)/$144.50 (wired), 1952. (1)

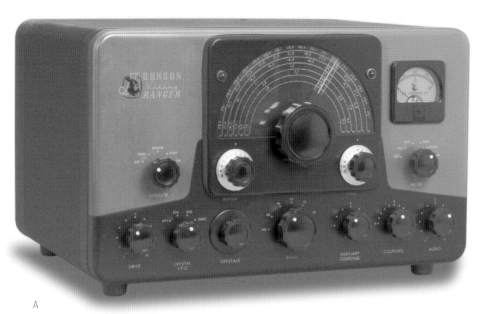

A

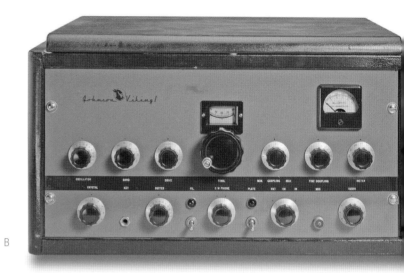

B

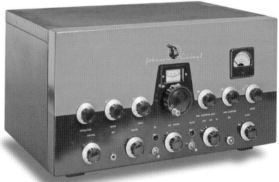

C

**A** ◊ **JOHNSON VIKING RANGER** The Ranger was a flexible transmitter/exciter covering the 160–10 bands with a power input of 75 watts CW, 65 watts phone to a 6146 final. The P-P 1614s in Class AB1 provided 100% modulation and could serve as drivers for a high-power amplifier's modulators when the Ranger was used as an exciter; $179.50 (kit)/$258.00 (wired), 1954. (1)

**B** ◊ **JOHNSON VIKING I** The Viking I was a self-contained, tabletop CW and AM phone transmitter covering 160–10 meters. The 4D32 final was modulated by P-P 807s and had 100 watts output on phone, 115 watts on CW. It had switch-selectable positions for 10 crystals as well as a provision for VFO input; $209.50 (kit)/$259.50 (wired), 1949. (49)

**C** ◊ **JOHNSON VIKING II** The Viking II added TVI measures to the Viking I design and changed the final amplifier to a pair of 6146s. Power output increased to 130 watts on CW and remained 100 watts on phone; $279.50 (kit)/$324.50 (wired), 1949. (49)

**D** ◊ **ALLIED KNIGHT SX-255 & 725 VFO** Knight's 50 watt CW transmitter came in kit form. It offered band-switching coverage of 80–10 meters, with a 6AG7/807 tube lineup and a 5U4 rectifier in its internal power supply. It sold for $42.50. The 725 VFO provided frequency agility for the crystal-controlled SX-255 and similar transmitters. The VFO kit had a 117 VAC power supply and cost $27.50; 1956. (1)

**E** ◊ **LYSCO A-129** Lysco's A-129 mobile transmitter covered 10 and 11 meters. It used clamp tube modulation. "A" models of the monoband transmitter series used 6AQ5 tubes; the "B" versions used 6V6s. Peak input power was 25 watts. The new transmitters were housed in rounded-corner cases and had a stylish, more finished appearance than earlier models. Knobs replaced the screw adjustments for the oscillator and amplifier used in previous Lysco monobanders; $29.95, 1951. (31)

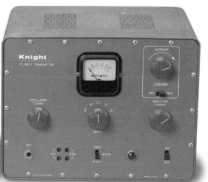

D

E

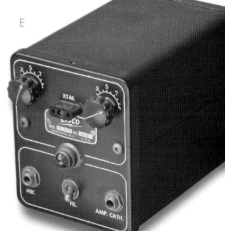

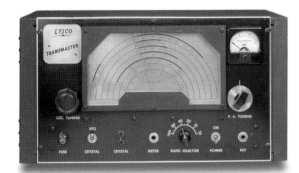

F

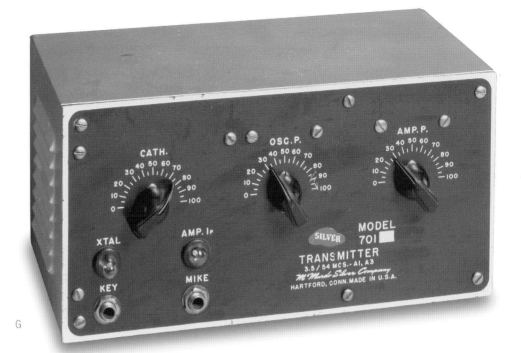

G

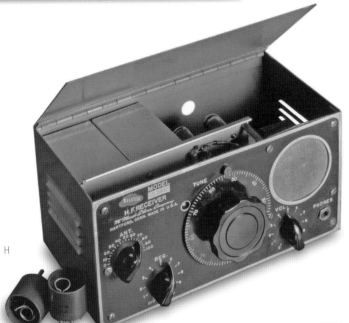

H

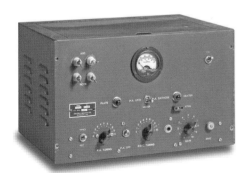

I

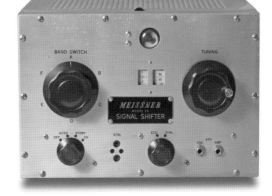

J

**F ◊ LYSCO TRANSMASTER 600** The Transmaster 600 ran 35 watts input CW on the 160 through 10 meter bands. The 600 was a TVI-proof version of the 500. It had connections for an external modulator; $99.50, 1950. (65)

**G ◊ MCMURDO SILVER 701** McMurdo Silver's final venture in the radio business was the McMurdo Silver Co., located in Hartford, Connecticut. They manufactured a line of transmitters, receivers, and test equipment. The model 701 transmitter covered 3.5–54 MHz using plug-in coils. Its 6AQ5/807 circuit produced 75 watts input on CW and 30 watts on AM; $36.95, 1947. (44)

**H ◊ MCMURDO SILVER 800** The model 800 receiver covered 144–148 and 235–240 MHz using plug-in coils. The four-tube, super-regenerative set was based on a W1HDQ design published in a 1946 QST article. It had a built-in speaker. Other receivers in the 800 series had a similar appearance but different internal designs and frequency coverage. The 801 was a regenerative set covering .45–60 MHz. The 802 was an 80 through 6 meter ham-band-only superhet with a 735 kHz IF and a regenerative detector; $39.75 (model 800), 1946. (63)

**I ◊ MECK T-60-1** John Meck Industries introduced the T-60 transmitter in 1946. Audar, Inc. of Argos, Indiana produced improved versions of the same rig under the Audar and Telvar names. The 60 watt phone and CW transmitter used plug-in coils to cover 80–10 meters. A pair of 6L6Gs was used in the final. A second 6L6G pair in push-pull served as modulators; $89.50, 1946. (44)

**J ◊ MEISSNER EX** The EX model Signal Shifter was the same as the 9-1090 but was sold minus power supply and coils. Both models had provision for crystal control and offered keying of either the oscillator or amplifier circuit; $49.75 (kit)/$66.50 (wired), 1948. (1)

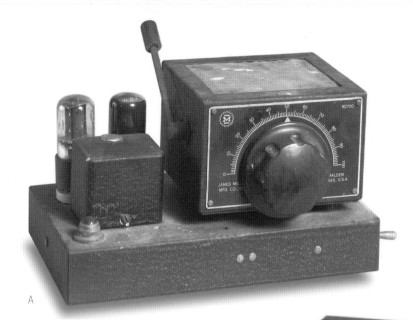

A

B

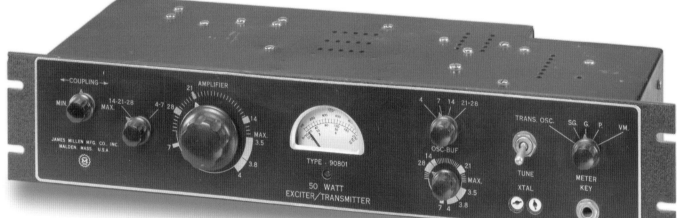

C

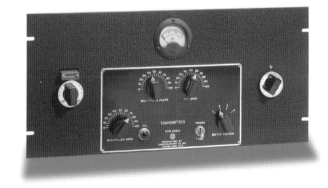

D

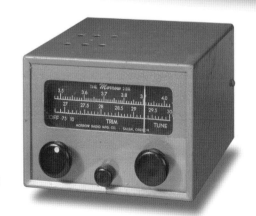

E

**A ◊ MILLEN 90700** The 90700 Variarm ECO was the commercial realization of a design published in a January 1941 QST article by Henry Rice, W9YZH. It operated on the 160, 80, and 40 meter bands. The arm on the left side of the oscillator box provided vernier frequency adjustment once the basic frequency range had been set with the large knob. On top of the box is a calibration chart. The 90700 had a transformerless power supply; $42.50, 1946. (44)

**B ◊ MILLEN 90711** Millen's 90711 VFO had sufficient output to drive an 807 on 160, 80, and 40 meters, with reduced output on 20. Its slide-rule dial was calibrated for 80–10 meters. The lever to the right of the dial was for vernier frequency adjustment; $89.75, 1948. (1)

**C ◊ MILLEN 90801** The 90801 transmitter/exciter evolved from a pre-war design. Earlier models used an 807 final and plug-in coils. The 90801 had band switching, a 6146 final, and was TVI-proof. Power input was 90 watts CW, and 67 watts AM (with an external modulator) on 80–10 meters; $89.75, 1954. (1)

**D ◊ MILLEN 90810** The 90810 transmitter worked on 20 and 10 meters but could also be used on 6 and 2. Power output from its 829B final was 75 watts. Behind the panel, the transmitter's component parts were a Bliley CCO-2A crystal oscillator and Millen's 90811 amplifier. It used plug-in coils; $69.75, 1948. (60)

**E ◊ MORROW 2-BR** The Morrow converter in the photograph covered the 75 and 10 meter bands. The 2-BR was also available in 10/40 and 40/75 combinations. It used five tubes. The main tuning capacitor gang-tuned the RF amp, oscillator, and mixer stages. Its IF amp had four tuned circuits and an output on 1525 kHz. An automatic noise limiter was built in; $54.95, 1951. (1)

**F ◊ MORROW FTR** The 10-tube, fix-tuned receiver was designed to be used alongside Morrow converters in a mobile installation. It provided 3 kHz selectivity in a 200 kHz IF and was sufficiently stable for SSB reception. The 6 VDC power supply was separate; $125.83, 1953. (1)

**G ◊ NATIONAL HRO-7** Even though the HRO-7 shed the basic black livery of its predecessors and acquired a sleeker cabinet, inside it was still cast in the mold of earlier HROs. It had plug-in coils, and frequency readout was interpolated from the PW dial and a scale attached to each coil. Standard HRO practice was also followed with the external power supply. Nine sets of coils covered 50 to 430 kHz and 480 kHz to 35 MHz. The 12-tube HRO-7 improved upon previous HRO designs with the addition of a voltage regulator tube for the HF oscillator B+ and a more effective noise limiter; $311.36, 1947. (1)

**H ◊ NATIONAL HRO-5RA-1** The HRO-5A-1 was an 11-tube receiver covering 50 kHz to 30 MHz with its nine coils. The HRO-5TA-1 came in a tabletop cabinet; the 5RA-1 was the rack model. The 5RA-1 is shown here with the SPC unit, which includes a speaker, power supply, and coil storage space. The base price of the receiver was $274.35; 1946. (31)

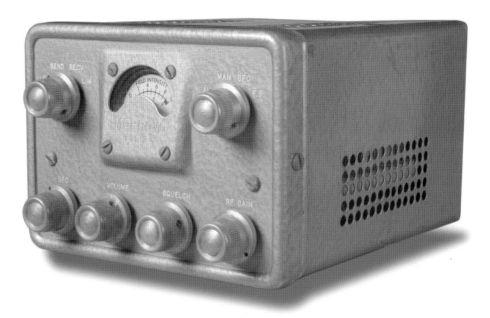

F

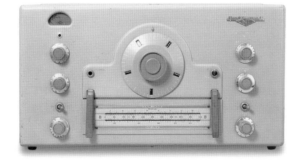

G

H

A

**A ◊ NATIONAL HRO-50T-1 & COIL CABINET** The HRO-50 was introduced in 1950 and was the first HRO to have a direct-reading slide-rule dial in addition to the standard PW main-tuning dial. It also broke with HRO tradition by incorporating an internal power supply. The 15-tube, single-conversion set had a crystal filter and a 455 kHz IF. It tuned from 50–430 kHz and from .48–35 MHz using a dozen plug-in coil sets. In addition to AM and CW, the HRO-50 could receive NBFM signals when equipped with the NFM-50 adapter. 1951 saw the introduction of the HRO-50-1. The -1 models added an additional IF stage, bringing the tube count to 16, and had cascaded IF transformers for improved skirt selectivity. The receiver shown is an HRO-50T-1. It is sitting in a national MRR rack which has the 50SC coil cabinet and speaker; HRO-50, $349.00, HRO-50(T)-1, $383.50. (1)

**B ◊ NATIONAL HRO-60** The HRO-60 was the final vacuum tube HRO. It broke new ground as the long-running receiver series continued to evolve. It introduced double conversion to the HRO line and used 18 tubes. Ten coils gave it a 50 kHz to 54 MHz tuning range; $483.50, 1952. (1)

**C ◊ NATIONAL NC-2-40D** In addition to its general-coverage tuning range of .49–30 MHz, the NC-2-40D had expanded band-spread coil ranges for the 80, 40, 20, and 10 meter amateur bands. Each band occupied 80% of the dial space. The 12-tube receiver used National's moving-coil catacomb and had an improved crystal filter and series noise limiter; $225.00, 1946. (1)

**D ◊ NATIONAL NC-46** National's pre-war NC-44 and war-years' NC-45 evolved into the NC-46 as the company joined the rush to bring a moderately-priced receiver to the post World War II marketplace. The 10-tube, single-conversion set (455 kHz IF) covered .55–30 MHz in four bands. It had an AC/DC power supply, AVC, series noise limiter, and 3 watts of push-pull audio; $97.50, 1946. (1)

**E ◊ NATIONAL NC-57** The NC-57 had a wide tuning range which extended from .54–55 MHz. The nine-tube receiver had a built-in loudspeaker and AC power supply. Accessories for the NC-57 included the SM-57 external S-meter and the tilt-up base shown here. An NC-57B model incorporated minor changes. The accessory socket was rewired to accommodate National's Select-O-Ject and the regulator tube was changed from an OD3 to a VR-150; $89.50, 1947. (61)

**F ◊ NATIONAL NC-88** The NC-88 World Master receiver covered .54–40 MHz with calibrated band spread for the 80, 40, 20, and 10 meter amateur bands. The nine-tube set had two high-fidelity audio stages and a phono input; $119.95, 1953. (1)

**G ◊ NATIONAL NC-98** The NC-98 added a crystal filter, variable selectivity, and an S-meter to the basic NC-88 circuit. It had the same tube lineup and coverage. The NC-98SW model substituted shortwave-broadcast calibration for ham-band calibration on the band-spread dial; $149.95, 1954. (1)

**H ◊ NATIONAL NC-125** The National NC-125 covered .55–36 MHz in four bands. The 11-tube receiver had no IF filter but did include a built-in Select-O-Ject audio filter. It also had a noise limiter and a socket for an optional NBFM adapter; $149.50, 1950. (1)

**I ◊ NATIONAL NC-173** The National NC-173 covered .54–31 and 48–56 MHz in five bands. The 13-tube, double-conversion set had a crystal filter, a double-diode noise limiter, and an AVC system that worked on both phone and CW; $189.50, 1947. (1)

B

D

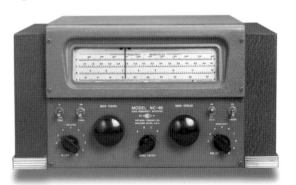

C

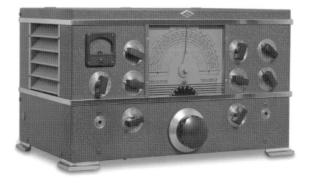

E

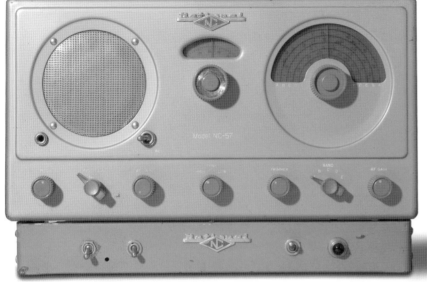

F

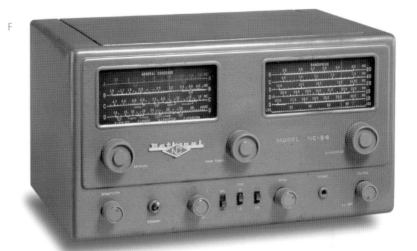

G

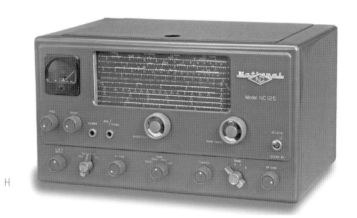

H

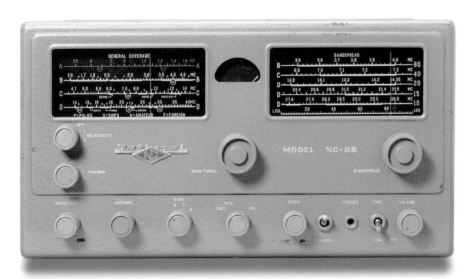

I

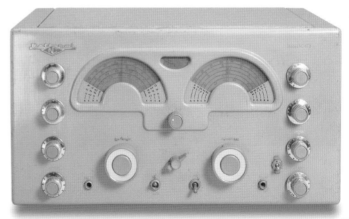

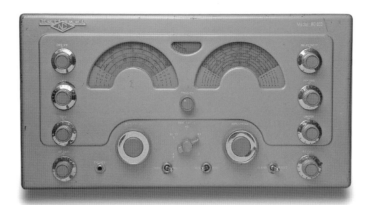

A

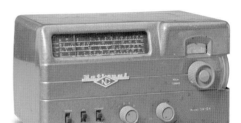

B

**A ◊ NATIONAL NC-183D** The NC-183D was double conversion above 4.4 MHz and single conversion below that. Its five bands covered .54–31 and 48–56 MHz. The NC-183D used 17 tubes, and its IF stages had a dozen tuned circuits in the single-conversion mode, 16 when using double conversion. It had a new crystal-filter circuit and a temperature-compensated main-tuning capacitor. The "Non-D" NC-183 was a 16-tube, single conversion set with the same tuning ranges; $269.50, 1952. (27)

**B ◊ NATIONAL SW-54** The five-tube, four-band SW-54 was an AC/DC set with an internal speaker. It tuned from .54–30 MHz and had a calibrated slide-rule, general-coverage dial along with a numbered logging scale on the band-spread dial; $49.95, 1951. (58)

**C ◊ PIERSON KP-81** Receiver designer Karl Pierson worked for Patterson Electric before the war and also partnered in his own company, Pierson-DeLane. His first post-war effort was the KP-81 receiver, a 20-tube, single-conversion set that tuned from .54–40 MHz in five bands. It used a moving-coil rack for band switching and had both a crystal filter and cascaded transformers for IF selectivity. The KP-81's power supply was housed in its speaker cabinet; $318.00, 1946. (48)

**D ◊ RME MC-55** Prompted by the allocation of 15 meters and the opening of 40 meters to phone operation, RME introduced a five-band mobile converter. The MC-55 covered 80, 40, 20, 15, and 10–11 meters. It had a built-in noise clipper and four tuned circuits in its 1550 kHz IF output stage. RME had entered the mobile market with it MC-53. That converter covered the 2, 6, and 10–11 meter bands; $69.50, 1952. (1)

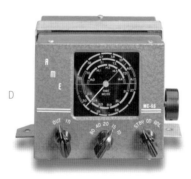

D

**E ◊ RME-45B** Radio Manufacturing Engineers' first post-war receiver built on the company's designs of the pre-war and war years. The initial model, the RME-45, was introduced in mid-1945. Early the following year, the Peoria, Illinois company released the 45B, adding two-speed tuning, calibrated band spread for the ham bands, and improved noise limiting. The receiver covered .55–33 MHz and used 10 tubes, all locktals except for the rectifier and voltage regulator; $198.70 (including speaker), 1946. (58)

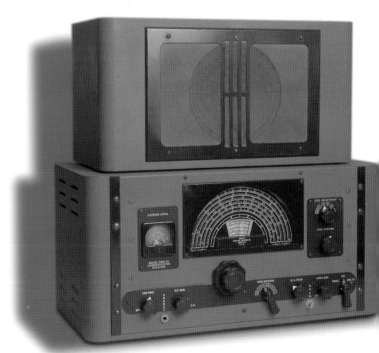

E

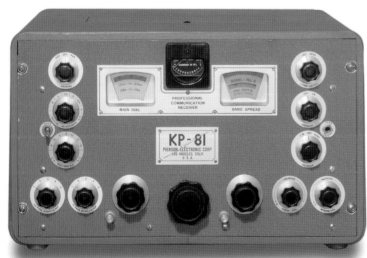

C

G

H

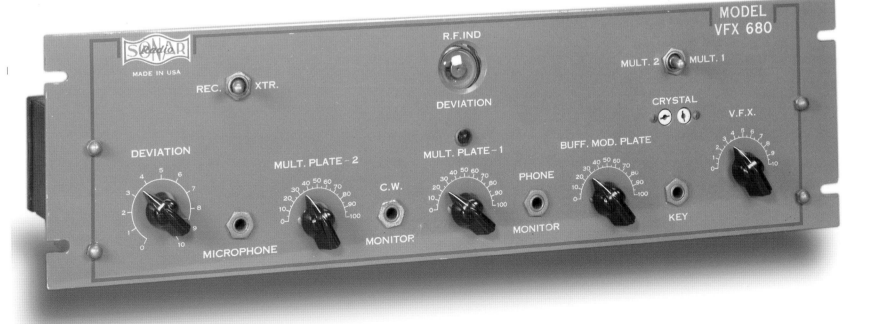

**F ◊ RME-50** The RME-50 used the basic circuitry of the RME-45B, substituting miniature tubes for loctals used in the older receiver. It also used a 6V6 in the audio output stage, a VR-150 voltage regulator, and a 5Y3 rectifier. The 12-tube set came with RME's NBF4 NBFM adapter installed. Frequency coverage was .54–33 MHz in six bands; $197.50 (including speaker), 1952. (1)

**G ◊ RME-84** Except for the audio output and rectifier, the RME-84's eight tubes were lock-in types. It operated from AC mains or batteries. Four bands covered .54–44 MHz and its vernier tuning dial was gear-driven; $98.70, 1946. (1)

**H ◊ SONAR SRT-120** Sonar designed the SRT-120 for either mobile or fixed-station use. Power input to its 9903/5894A final was 120 watts CW, 100 watts AM. It had band-switch positions for 80, 40, 20, 15, and 10–11 meters, plus a spare position for another band; $159.50 (kit)/$198.50 (wired), 1952. (1)

**I ◊ SONAR VFX-680** The VFX-680 incorporated the NBFM circuitry of Sonar's XE-10 exciter and had 4 to 6 watts output on 80 through 6 meters. It operated on CW as well as phone. When no crystal was inserted, the "VFX" knob tuned the oscillator grid through a range of 1562.5–2000 kHz, which could be multiplied to cover all ham bands. When using a crystal, the same control varied the crystal frequency 30 kHz on 80 meters and proportional amounts on the higher bands. The VFX-680 covered 80–6 meters and also served as a phone and CW monitor; $87.45, 1947. (1)

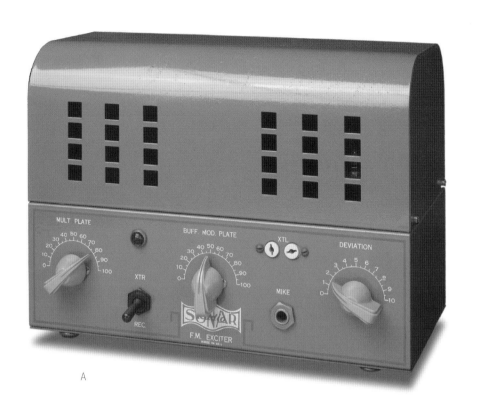

A

B

C

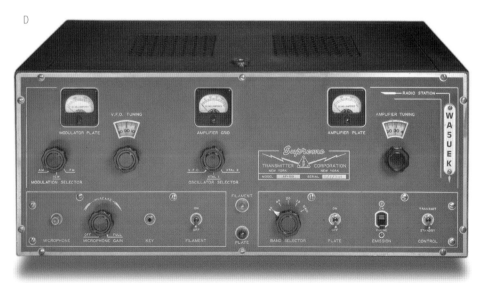

D

E

54

F

G

H

**A ◊ SONAR XE-10** On August 1, 1947, the F.C.C. authorized Narrow Band Frequency Modulation on portions of the 75, 20, 10, and 6 meter amateur bands for an experimental trial period not to exceed one year. The authorization was extended for additional one-year periods until the spring of 1951, when it was made permanent. A year later, NBFM privileges were expanded to include the voice allocations on all bands except for 160 meters.

Modulation power requirements for frequency- or phase-modulated transmitters were modest compared with amplitude-modulated rigs of similar carrier power, and NBFM signals were less prone to cause interference to broadcast services than AM transmissions, with or without carrier.

The Sonar Radio Corporation of Brooklyn, New York was one of the first on the amateur Narrow Band Frequency Modulation scene. Their XE-10 phase modulation exciter turned any CW transmitter into an NBFM rig. It was designed primarily for crystal control but could also be used with a VFO; 1947, $39.45. (1)

**B ◊ STANCOR ST-203-A** The ST-203-A was intended primarily for AM mobile operation but could be used in the home station as well. The transmitter covered 10–11 meters. However, conversion kits were available for 75, 40, and 20. Input power to the 2E26 final was about 27 watts. Power for mobile use could be obtained from a vibrator supply or dynamotor or from an AC supply in a fixed station; $44.70, 1948. (1)

**C ◊ SUBRACO MT-15X** The Suburban Radio Company of East Rutherford, New Jersey introduced their 30 watt AM mobile transmitter in 1948. Versions were available for 75, 40, or 20 meters. The rig weighed 6 lbs. and was compact, measuring 4-1/2 x 5-1/2 x 6-1/2 inches; $79.95, 1948. (33)

**D ◊ SUPREME AF-100** The Supreme Transmitter Corporation's 100-watt transmitter worked CW, AM, and FM on 80 through 10 meters, including the 15 meter band, not yet allocated when the AF-100 was introduced in 1946. It used plug-in coils in the 3D23 final; $450.00. (24)

**E ◊ WRL GLOBE CHAMPION 165** World Radio Laboratories debuted the Globe Champ as a 150 watt CW and AM transmitter in 1948. It was followed by 165 watt, 175 watt, and NBFM versions the next year. The early Champs covered 80–10 meters with plug-in coils, and later models added 160 meters as well. The price for the 165 model was $279.00 kit; $299.00 wired. The NBFM Champ sold for $199.00; (31)

**F ◊ WRL GLOBE KING 400** The Globe King 400 was a 350 watt phone, 400 watt CW transmitter that covered 160–10 meters using plug-in coils. A pair of push-pull V-70D tubes was modulated by Class B push-pull 5514s; $379.45 (kit)/$399.45 (wired), 1949. (13)

**G ◊ WRL GLOBE KING 500A** Although WRL ad copy called the Globe King 500A "New and Improved", it differed little from the GK 500 (introduced in 1954). One change was use of a pair of 811-A modulator tubes in place of the 5514s in the earlier model. Both versions featured band switching coverage of 160–10 meters and had a power input of 500 watts CW & AM with a 4-250A final. The Globe Kings could be used on SSB with an external exciter; $675.00, 1955. (1)

**H ◊ WRL GLOBE TROTTER** The Globe Trotter was presented as a kit but could also be purchased factory-wired. It had an 807 final and 40 watts input CW, 25 watts phone on all bands from 160–10 meters. The Globe Trotter used plug-in coils; $59.95 (kit)/$75.00 (wired), 1946. (31)

# Era Four

# Single Sideband

Amateur Radio was a late-arriving player in the single-sideband game. The mathematical concept for single-sideband, suppressed-carrier voice transmission was developed in 1914. A year later, Bell Laboratories' John R. Carson filed a patent for an SSBSC circuit, a patent he was not granted until 1923. By that time, long-distance and transatlantic telephone service was making use of the narrow SSBSC signals to route more simultaneous phone calls on a given cable circuit. Robert Moore, W6DEI, began experimenting with single sideband on the amateur bands and published a series of articles in R9 Magazine in 1933–34.

The American Radio Relay League tossed their hat into the ring with an October 1935 *QST* article on sideband by Technical Editor James Lamb, W1CEI. Pressure to adopt the mode was not sufficient to overcome the technical difficulties involved, and amateur single-sideband experimentation lay dormant until after World War II had come and gone.

In the fall of 1947, Stanford University Radio Club station W6YX went on the air using a single-sideband transmitter designed by O. G. Villiard, W6QYT. These experiments were reported in *QST* early in 1948. A series of articles and editorials promoting sideband appeared in the following

months. For Amateur Radio, single sideband was an idea whose time had come.

The mode's main selling point was its efficient bandwidth compared to regular AM phone, but early adherents soon came to also appreciate SSB's ability to communicate successfully under difficult propagation conditions. SSB brought significant changes to the Amateur Radio landscape as it gradually replaced AM as the dominate mode for voice communication on the HF bands. ∎

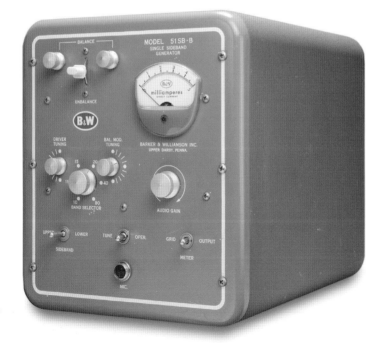

A

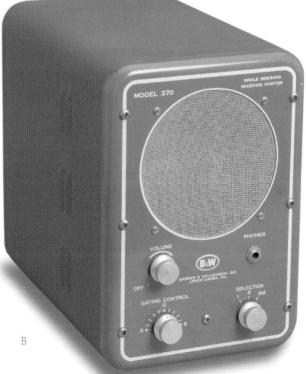

B

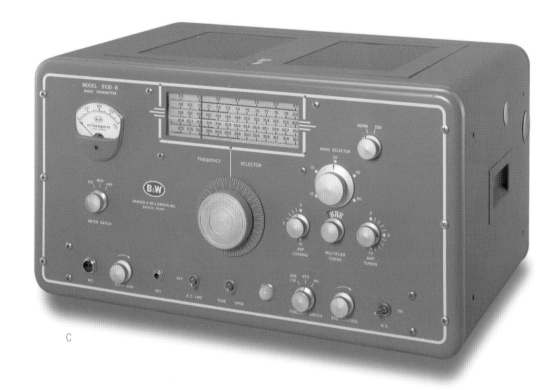

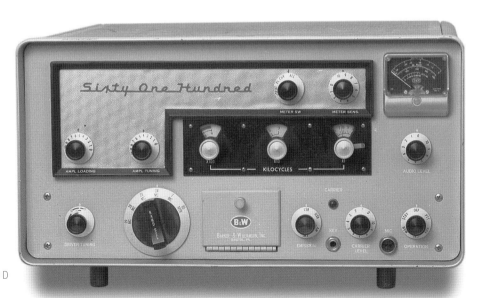

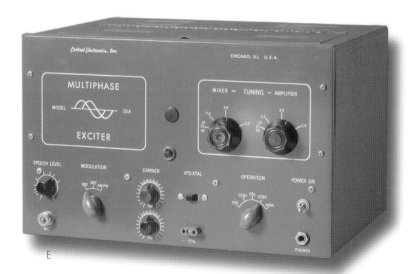

**A ◊ B&W 51SB-B** The 51SB-B was similar in function to the 51SB model but was made to work with the company's 5100-B transmitter. The newer version of the sideband adapter lacked an internal power supply and took plate and filament power from the 5100-B; $265.00, 1957. (52)

**B ◊ B&W 370** Barker & Williamson's model 370 receiving adapter delivered selectable sideband SSB or AM as well as single-signal CW reception with its 17–20 kHz toroidal IF filter. It resembled the selectable sideband adapters from the 1940s, before the advent of amateur SSB activity, more than it did the sideband adapters of the 1950s. The 370 could be used with a receiver having an IF of 450 to 500 kHz. Its Gating control provided vernier tuning of the adapter's passband; $131.50, 1955. (1)

**C ◊ B&W 5100-B** The 5100-B changed a little cosmetically and only slightly electrically from the earlier 5100 model. Power increased to 180 watts, and 140 watts AM phone and CW. The transmitter worked on sideband using the 51SB-B adapter. Unlike the 5100, the B model cabinet already had holes drilled for use with the sideband generator; $475.00, 1955. (35)

**D ◊ B&W 6100** The B&W 6100 was the first synthesized amateur transmitter. There were no free-running oscillators in the 6100. Its synthesizer mixed signals from two banks of 10 crystals each to cover the 80–10 meter bands. A VXO circuit was used to pull the crystals from one bank up to 11 kHz, providing continuous coverage between each of the crystal frequencies. The operating frequency was set using the band switch and the three knobs marked "kilocycles." The 6100 ran 180 watts SSB and CW, and 90 watts on AM; $875.00, 1962. (22)

**E ◊ CENTRAL ELECTRONICS 10A** The 10A was one of the commercial sideband transmitters based on a 1950 GE Ham News article by Don Norgaard, W2KUJ. The 10 watt PEP exciter covered 160–10 meters with plug-in coils. In addition to SSB, it also transmitted double-sideband AM, phase modulation, and CW; $99.50 (kit)/$139.50 (wired), 1952. (51)

A

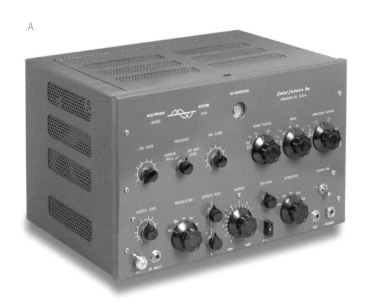

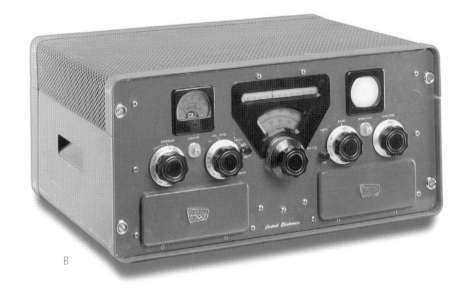

B

C

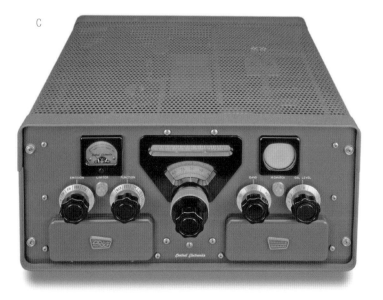

D

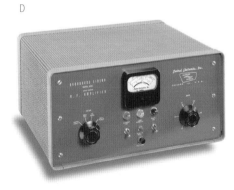

**A ◊ CENTRAL ELECTRONICS 20A** The 20A had band-switching coverage of 160–10 meters. Peak output on SSB, AM, CW, and PM was 20 watts. Its "Magic Eye" tube served as a carrier null and modulation peak indicator. A calibrate circuit allowed the operator to "talk" his VFO signal on frequency using the station receiver; $249.50, 1953. (1)

**B ◊ CENTRAL ELECTRONICS 100V** Only a few years after Central Electronics entered the commercial market with relatively simple sideband gear, they introduced the complex and sophisticated 100V transmitter. The VFO was the 100V's only tuning control. Broadband circuits throughout the transmitter took care of everything else. What it lacked in knobs, it made up for in modes: Along with single sideband, it had double sideband—with and without carrier. It also transmitted CW, FSK, and phase-modulated voice (PM). The two-speed VFO knob turned a linear PTO, which had 1 kHz calibration on all bands. The slow tuning rate was 750 Hz per knob revolution. True to Central Electronics form, it used the phasing method of sideband generation. Power output was 100 watts PEP. It covered 80–10 meters with a spare band-switch position for 160 meters or non-ham-band operations; $595.00, 1957. (1)

**C ◊ CENTRAL ELECTRONICS 200V** The 200V expanded on the innovations found in the company's earlier 100V model. It retained the phasing-type sideband generation, as well as the broad-banded, no-tuning RF circuits. The 200V featured improved mic preamp, mixer, power supply, and oscillator circuits along with a two-speed VFO tuning knob. In addition to SSB, the mode selection included DSB, AM, PM, FSK, and CW. Power out on sideband, CW, and PM was 100 watts, 25 watts on AM. The 100 watt rating on FSK was based on a 50% duty cycle. The transmitter covered the 80 through 10 meter bands in a series of 1 MHz ranges. An additional band was available for frequencies not covered by the amateur bands or for use with optional 160 meter broadband couplers; $795.00, 1961. (1)

**D ◊ CENTRAL ELECTRONICS 600L** The 600L used a single 813 in Class AB2 for 500 watts DC input with 2 watts drive. Central Electronics introduced their "no-tune" technology with the 600L. The 160–10 meter band-switching amplifier employed the company's patented broad-band couplers to eliminate the customary tuning and loading controls; $349.50, 1955. (24)

E

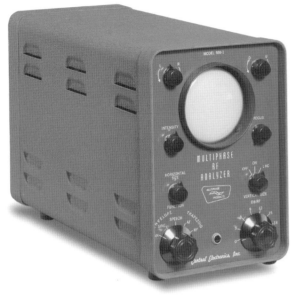

F

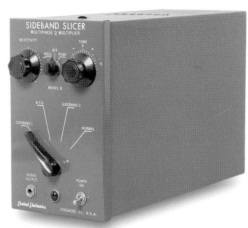

H

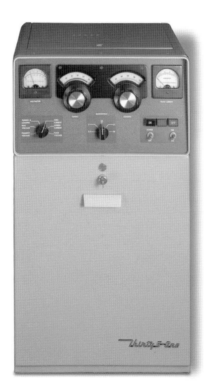

G

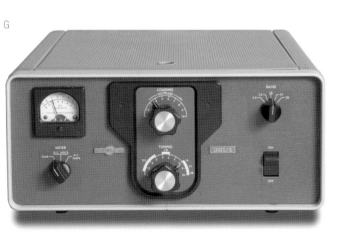

I

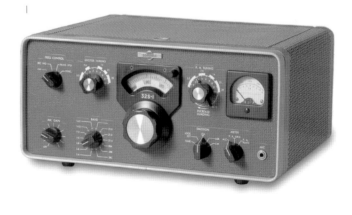

**E** ◊ **CENTRAL ELECTRONICS MM-1** The MM-1 provided continuous monitoring of CW, AM, and SSB signals. Automatic blanking protected the 3 inch scope tube from burn-in during stand-by periods. The MM-1's response curve was flat from 1–55 MHz. It had a built-in 1 kHz tone generator and displayed AF and RF trapezoid and envelope patterns. A later model, the MM-2, added receiver monitoring. Plug-in modules adapted the MM-2 to various receiver intermediate frequencies; $99.50 (kit)/$129.50 (wired), 1956. (24)

**F** ◊ **CENTRAL ELECTRONICS MODEL B SLICER** The model B Sideband Slicer was the same basic unit as the model A, with the company's DQ Q-Multiplier added to it. The Model B needed no adapter for use with receivers having a 450–500 kHz IF. The Q-multiplier was available as a stand-alone unit; $69.50 (kit)/$99.50 (wired), 1955. (1)

**G** ◊ **COLLINS 30L-1** Collins' compact linear amplifier used four 811-As in grounded grid. Its power input was 1000 watts PEP on SSB, 1000 watts average on CW, and it covered 80–10 meters. It had Automatic Load Control and RF inverse feedback to reduce distortion products. Solid-state rectifiers in the 30L-1's internal power supply reduced heat; $520.00, 1961. (58)

**H** ◊ **COLLINS 30S-1** The 30S-1 was a grounded-grid linear amplifier using an Eimac 4CX100A. Power input on SSB and CW was 1 kilowatt. It employed RF inverse feedback for better linearity. The power supply for the 30S-1 was located in the bottom portion of its cabinet; $1556.00, 1958. (32)

**I** ◊ **COLLINS 32S-1** Along with the 75S-1 receiver, the 32S-1 transmitter formed the first wave of Collins' "new look" S/Line. The relatively compact, matching equipment replaced the Collins St. James grey equipment that had stood atop the world of premium amateur gear for a decade. The 32S-1 was a 175 watt PEP SSB transmitter with mechanical-filter sideband generation. It included CW as an afterthought, but no AM mode was available. The 70K-2 PTO tuned over a 200 kHz range. Specific band segments were selected from among 14 crystal positions. The choice of crystals enabled the 32S-1 to operate on any frequency from 3.4–30 MHz (minus 5–6.5 MHz). With proper cabling, it transceived with the 75S-1; $590.00, 1958. (51)

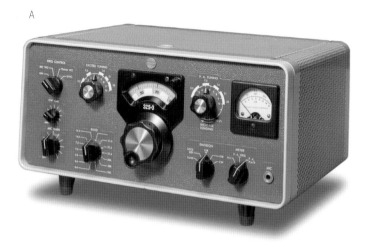

A

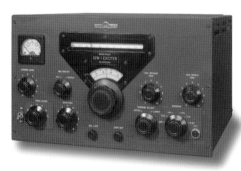

B

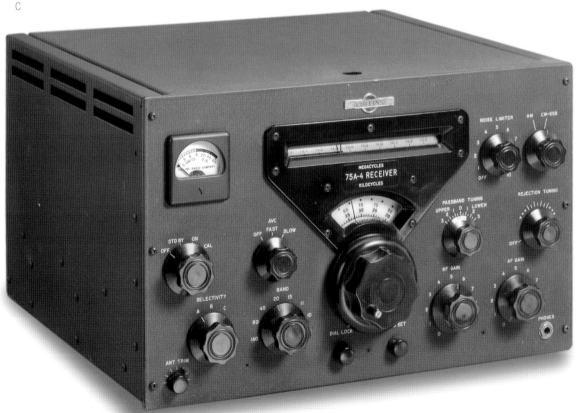

C

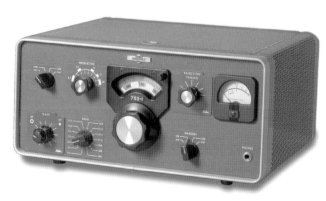

D

**A ◊ COLLINS 32S-3** Several of the changes and improvements in the 32S-3 from the 32S-1 were for the CW mode. The 32S-1's tone-generated CW was eliminated and a carrier signal was routed around the balanced modulator. Zero-beating received signals was easier, and the keying wave shape was adjustable. The 32S-3 had the same power and mode specs as its predecessor and could transceive with 75S-series receivers; $750.00, 1962. (32)

**B ◊ COLLINS 32W-1** The 32W-1 exciter was a KWS-1 without the final amplifier or power supply. It ran 3 watts output. Collins offered a kit to upgrade it to full KWS-1 status; $895.00, 1955. (13)

**C ◊ COLLINS 75A-4** The last of the A-line receivers was tailored for single-sideband operation. It broke new ground on several design fronts, not the least of which was its passband tuning system. A front-panel knob rocked the PTO housing, causing the filter passband to pan across the 455 kHz IF. This selected either upper or lower sideband, as well as helping to dodge interference. The 75A-4 employed 22 tubes and included features such as a Q-multiplier notch filter, 1 kHz calibration, a noise limiter, and selectable AVC. Most of the later models incorporated a 4:1-reduction main tuning knob. The receiver came equipped with a 3.1 kHz mechanical filter, and space was provided for two others from a range of bandwidths that included .5, .8, 1.5, 2.1, and 6 kHz. It covered the 160, 80, 40, 20, 15, 11, and 10 meter amateur bands.

During the course of its production, the A-4 underwent several minor appearance and circuit changes. Early versions used a smaller, non-vernier main tuning knob. Readily apparent differences also included variations in the S-meters, a change in the frequency range covered on 15 meters, movement of the AM/CW-SSB switch label to line up with that of the noise limiter, and renaming the Dial Drag knob Dial Lock.

Between March 1955 and October 1959, nearly 6000 75A-4s came off the assembly line. A number of these, probably fewer than 2000, were made by the Collins facility in Toronto, Ontario. In comparison, production numbers of the KWS-1 transmitter totaled about 1600; $495.00, 1955. (46)

**D ◊ COLLINS 75S-1** The 75S-1 was the original S/Line receiver. The 10-tube, double-conversion set covered the 80–10 meter bands and could be used on any 200 kHz segment between 3.4 and 30 MHz with the appropriate high-frequency beating crystal. Its crystal deck had 14 positions. A 75S-2 model with an expanded crystal deck and 14 additional 200 kHz tuning ranges was also made. The 75S-1/S-2 could receive SSB, CW, and AM. A 2.1 kHz mechanical filter provided selectivity on sideband, and an optional 500 Hz mechanical filter was available for CW. The 455 kHz IF transformers were used for AM. The CW BFO was crystal-controlled; $495.00, 1958. (51)

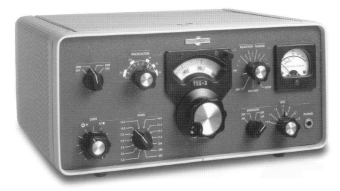

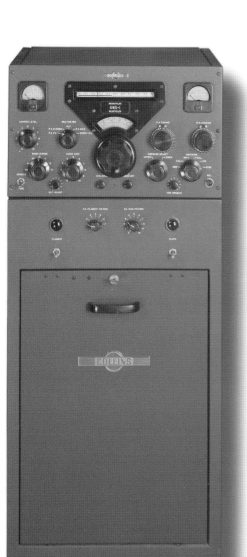

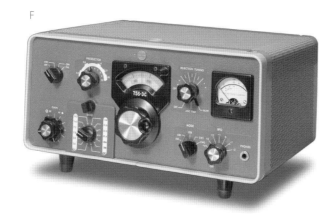

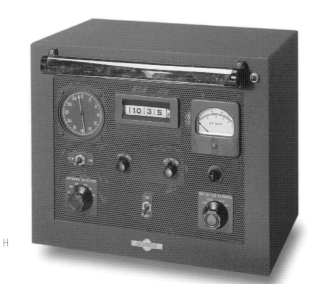

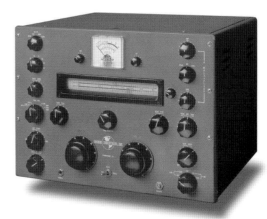

**E ◊ COLLINS 75S-3** The successor to the 75S-1 added rejection tuning, a choice of crystal or variable BFO, and a 200 Hz CW filter. Other changes included concentric knobs for the RF and AF gain controls and selectable AVC. A later 75S-3A version added extended frequency coverage with the addition of another 14-position crystal deck; $620.00, 1961. (58)

**F ◊ COLLINS 75S-3C** The 75S-3B and C continued the evolution of the Collins S/Line receiver. The B model added flexible selectivity choices to those found in the 75S-3. It was supplied with a 2.1 kHz mechanical filter and had plug-in sockets for three others. These were selected by the front-panel Mode switch. Zener-diode regulation was added to improve oscillator stability. The 75S-3C was the expanded crystal-deck version of the 75S-3B; $620.00 (75S-3B) $850.00 (75S-3C), 1964. (32)

**G ◊ COLLINS KWS-1** The KWS-1 was the Gold Dust Twins' transmitter sibling. Paired with a 75A-4, it not only defined the ultimate mid-50s amateur station but was also a key component in the Strategic Air Command's Big Talk communications network. Its complement of 33 tubes included two 4X150As in the final amplifier. Later versions used a pair of 4X250Bs. It covered the 80, 40, 20, 15, 11, and 10 meter bands, producing 1 KW on SSB, CW, and 650 watts AM. The latter mode was implemented by transmitting one sideband plus carrier. SSB generation was via balanced modulator/mechanical filter. It used grid-block keying on CW. It shared the PTO tuning and 1 kHz dial calibration of the 75A-4, but lacked the receiver's 160 meter band coverage. The exciter unit could be operated sitting atop the power supply cabinet or separated for placement next to the receiver. The units together stood 40.5 inches tall and had a combined weight of 223 lbs. A lower-cost version, the KWS-1K was available minus the high-voltage power supply and final amplifier; $1995, 1955. (32)

**H ◊ COLLINS SC-101** The Collins SC-101 station control system consisted of the 312A-2 console shown here plus an antenna selector relay box, a cable duct, and the necessary wiring to connect the 75A-4 and KWS-1 together; $695.00, 1956. (32)

**I ◊ COSMOPHONE 35** Cosmos Industries called the Cosmophone 35 a "2-Channel Bilateral Transceiver" when it was introduced. It had two VFOs with individual dial scales. The Cosmophone 35 could transceive using either of the VFOs or operate as a separate transmitter and receiver using them both. It had a 3.1 kHz mechanical filter and transmitted and received SSB, AM (1 sideband + carrier), and CW. The Cosmphone 35 covered 80–10 meters and used a 6146 final; $799.50, 1958. (1)

**A ◊ DRAKE 1-A** The Drake 1-A was a landmark development in the amateur receiver field. At a time when bigger was considered better and other companies advertised receivers "built like a battleship," R.L. Drake introduced a receiver that was light and compact, but gave away nothing in performance. The 11-tube, triple-conversion 1-A covered 80–10 meters using a crystal-controlled converter and a 2900–3500 kHz tunable IF. The second and third IFs were at 1100 and 50 kHz. L/C filtering and passband tuning were done at 50 kHz. The tube count grew to 13 in later production models with the addition of a crystal calibrator and another IF tube; $259.00, 1957. (1)

**B ◊ DRAKE 2-A** The 2-A was triple-conversion, used 10 tubes, and tuned 3.5–30 MHz in twelve 600 kHz segments. Seven of these were dedicated to the 80 through 10 meter ham bands. The remainder could be set for other 600 kHz ranges within the receiver's coverage limits by inserting appropriate crystals. The 2-A offered 2.4 and 4.8 kHz selectivity. It had a product detector and passband-tuning sideband selection; $269.95, 1959. (1)

**C ◊ DRAKE 2-B** The 2-B built on the strengths of Drake's 2-A model. It offered selectivity in .5, 2.1, and 3.6 kHz steps and had an improved passband tuner. It covered 80–10 meters in seven 600 kHz ranges. Five others could be used anywhere between 3.5 and 30 MHz with optional crystals; $279.95, 1961. (42)

**D ◊ ELDICO SSB-100** The SSB-100 covered the phone portions of the 75, 40, 20, 15, and 10 meter bands. The phasing-type transmitter worked AM and CW as well as SSB. A front-panel oscilloscope monitored the linearity of audio and RF stages. The SSB-100 also included a VOX circuit. Input power was 100 watts SSB, 60 watts AM and CW. It was succeeded by the SSB-100F, which used a crystal lattice filter at 413 kHz to generate sideband; $695.00, 1955. (1)

**E ◊ ELDICO SSB-1000** The Eldico SSB-1000 tabletop linear amplifier used a pair of 4X250B tubes and needed only 3 watts to drive it to a full kilowatt. It had a built-in power supply, a pi-net output, and covered 80–10 meters. The next-generation SSB-1000F (1958) used a single Eimac 4CX300A tube; $625.00 (kit)/$745.00 (wired), 1956. (1)

**F ◊ ELDICO T-102 & R-104** These Eldico twins bear a strong resemblance to the Collins S/Line. They were part of Eldico's S-119 communications system and were often used in MARS installations. The transmitter (T-102) and receiver (R-104) both used Collins mechanical filters. Sometimes the pair was badged with the RELiant name, a brand associated with Radio Engineering Laboratories; 1960. (48)

**G ◊ G.E. YRS-1** In the early days of amateur single-sideband operation, the hobby's periodicals carried articles explaining the new mode along with circuits to implement it. Prominent among the authors was Donald Norgaard, W2KUJ, who described the work he had done at General Electric's research laboratory. Shortly after his articles were published, several of his circuits became the basis for commercial products from various manufacturers. The YRS-1 receiving adapter was marketed by G.E. It employed the phasing method for sideband selection and was useful not only for single-sideband, suppressed-carrier reception, but also for dodging interference on regular AM with carrier signals; $275.00, 1948. (40)

**H ◊ ELENCO 77** The Elenco 77 was a 160–10 meter band-switching SSB transmitter. It had built-in VFO and VOX circuits. A crystal lattice filter was used in the sideband generator. PEP output was 100 watts. The Elenco 77 also transmitted AM and CW. The VFO covered a 200 kHz segment of each band. Full coverage of 10 meters was obtained with separate mixer crystals; $595.00, 1955. (65)

A

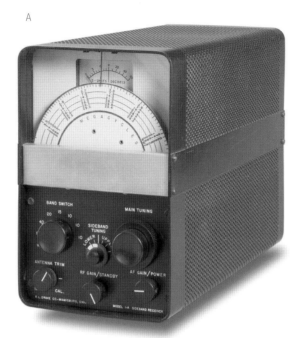

B

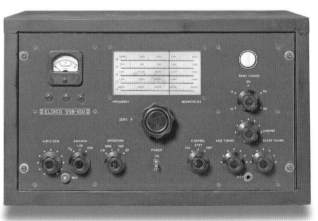

C

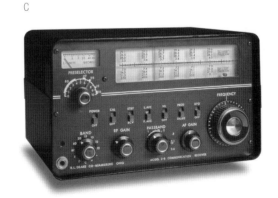

D

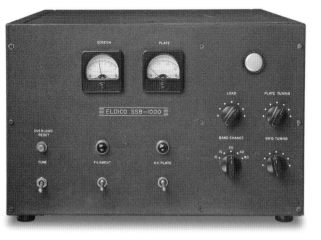

E

F

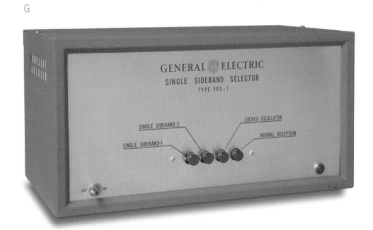

G

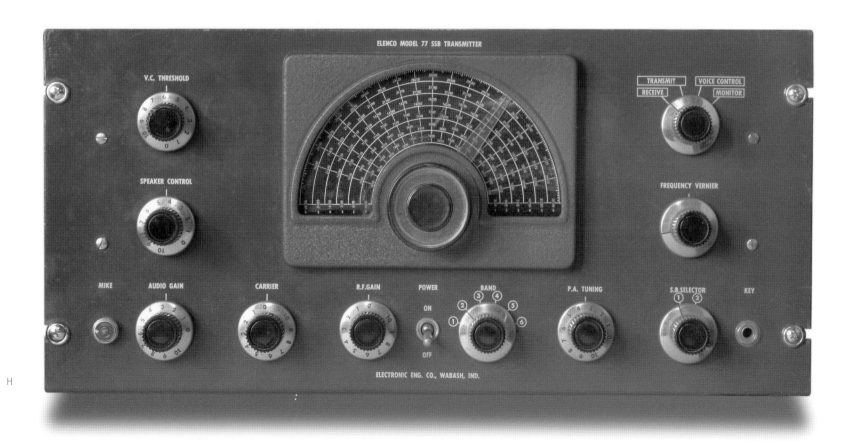

H

A
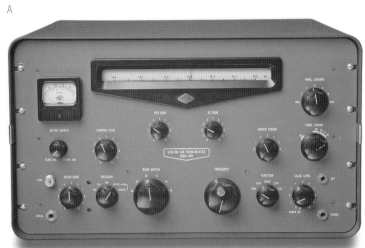

B
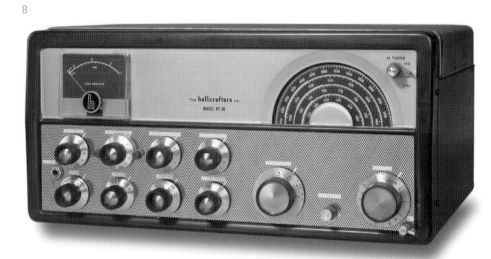

C
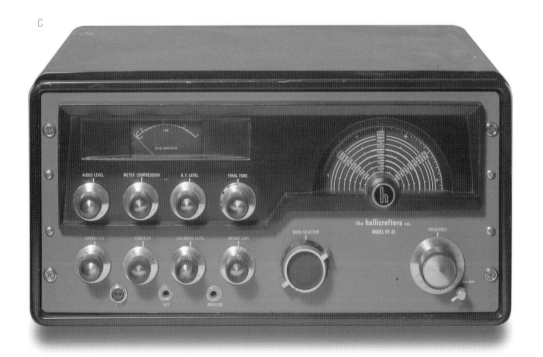

D
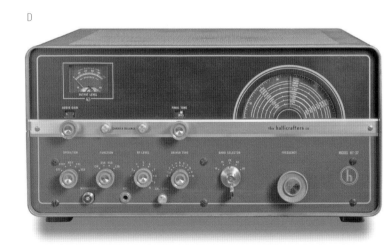

E

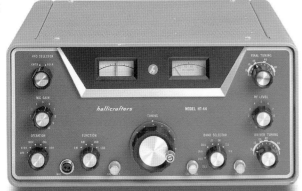

F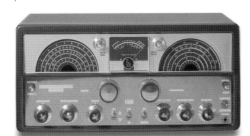

G

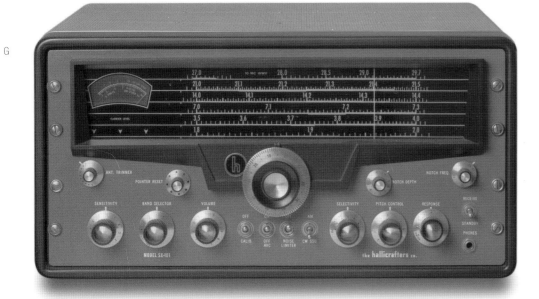

H

**A ◊ GONSET GSB-100** The GSB-100 was a 100 watt PEP phasing-type sideband transmitter. It offered AM, CW, and PM modes as well. Both sidebands were transmitted on AM. Amateur bands from 80–10 meters were fully covered; $439.50, 1961. (31)

**B ◊ HALLICRAFTERS HT-30** The HT-30 had band-switching coverage of 80, 40, 20, and 10 meters but skipped 15. The 22-tube transmitter used a 50 kHz filter for sideband generation. SSB and CW output from the pair of 807 finals was 35 watts; $495.00, 1954. (1)

**C ◊ HALLICRAFTERS HT-32** The HT-32 used a bridged-tee balanced modulator and a 4.95 MHz crystal filter to generate SSB. It also transmitted AM and CW. Power output from the 6146 finals was 70–100 watts on SSB and CW, 17–25 watts on AM. The HT-32 covered 80 through 10 meters using a linear, capacitor-tuned VFO. The tuning knob's skirt was calibrated in kHz. The transmitter had VOX, but no provision for PTT operation. There was no load control for the pi-net output circuit. It was set for 50 ohms on each band using fixed capacitors ($675.00, 1957).  The HT-32A (1959) added PTT, as well as provision for phone patching, and RTTY. Changes in the HT-32B (1961), the final model of the HT-32 series, were mostly cosmetic. Its styling matched that of the SX-115 receiver. (55)

**D ◊ HALLICRAFTERS HT-37** The HT-37 had the same VFO, amplifier, and VOX circuits as its more expensive sibling, the HT-32. The distinct difference was the HT-37's phasing SSB generator. Power output on SSB and CW was 70–100 watts, on AM 17–25 watts; $450.00, 1959. (56)

**E ◊ HALLICRAFTERS HT-44** Hallicrafters' phasing-type sideband transmitter matched their SX-117 receiver and the pair could transceive when hooked together with the appropriate cables. SSB and CW input on 80–10 meters was 200 watts, 50 watts on AM. The HT-44's Automatic Amplified Level Control gave greater talk power with up to 12 dB of speech compression; $395.00, 1963. (1)

**F ◊ HALLICRAFTERS SX-100** The SX-100 offered selectable sideband reception. It was double conversion with IFs at 1650 and 50 kHz. It had a tee-notch filter and crystal calibrator. The set used 14 tubes and tuned from .538–34 MHz (gap at 1580–1720 kHz); $295.00, 1955. (1)

**G ◊ HALLICRAFTERS SX-101** Hallicrafters' advertising introduced the SX-101 as "Bigger, Heavier . . . Built like a battleship." The 15-tube set was the company's first ham-band-only receiver. It covered 160 through 10 meters and also the 10 MHz WWV frequency. It was double conversion and employed L/C circuits in a 50.5 kHz IF, yielding bandwidths from .5 to 5 kHz. The SX-101 also featured a tee-notch filter and crystal calibrator. The receiver went through several model changes. The SX-101 Mk IIIA replaced the 160 meter band with a 30.5–34.5 MHz range to be used as a tunable IF for VHF converters. The new range was calibrated for 2 and 6 meters. The SX-101A was a MK IIIA with an improved product detector, two-position AVC, and full band spread on 10 meters; $395.00, 1956. (31)

**H ◊ HALLICRAFTERS SX-111** The SX-111 covered 80, 40, 20, 15, and 10 meters in five separate bands. A sixth band covered 10 MHz WWV. The receiver used 12 tubes and was double-conversion. L/C circuits in the 50.75 kHz second IF provided selectivity. Its style matched that of the HT-37 transmitter. Later versions of the SX-111 added another tube and a crystal calibrator; $249.50, 1959. (1)

**A ◇ HALLICRAFTERS SX-115** The SX-115 covered 80–10 meters in nine 500 kHz bands. The 18-tube receiver was triple-conversion with a crystal-controlled front end and a tunable first IF. The 50.75 kHz third IF's L/C circuits provided five degrees of selectivity from .5 to 5 kHz. Frequency was calibrated in 1 kHz increments; $595.00, 1961. (14)

**B ◇ HALLICRAFTERS SX-117** The SX-117 tuned from 3 to 30 MHz in 500 kHz bands. The triple-conversion receiver was furnished with crystals for 80, 40, 20, and 15 meters, plus 28.5–29 MHz on 10 meters. Four additional band-switch positions were available to complete coverage of 10 meters or add other frequencies with optional crystals. The receiver used 13 tubes and four silicon diodes. It could transceive with Hallicrafters' HT-44 transmitter; $379.95, 1962. (1)

**C ◇ HAMMARLUND HQ-170-A VHF** The evolution of Hammarlund's HQ-170 receiver continued with the addition of a pre-amp for 6 meters and a converter for 2 meters, both employing nuvistors. Its 160–2 meter coverage encompassed the most popular amateur spectrum of the day; $429.00 (with clock), 1964. (31)

**D ◇ HAMMARLUND HX-50** The HX-50 was an AM, CW, and SSB transmitter that used a 3 MHz filter for sideband and ran 130 watts PEP input with a 6DQ5 final. Power input was 90 watts on CW, and 20 watts on AM. The HX-50 covered 80–10 meters and offered 160 meters as an option; $399.50, 1961. (52)

**E ◇ HAMMARLUND HX-500** The HX-500 used 60 kHz L/C filters in its sideband generator. Other modes were CW, AM, FM, and FSK. It used a pair of 6146s for 100 watts output on 80–10 meters. AM output was reduced to 25 watts. It had a built-in antenna relay and a fixed 50 ohm pi-net output; $695.00, 1960. (63)

**F ◇ HAMMARLUND PRO-310** Hammarlund broke with their long-standing design traditions in creating the Pro-310 receiver. Tuning was done using the three large front-panel knobs. The knob on the left is the band switch and moved the coil turret. The slide rule dial has two scales. The upper scale is the "band-set" scale. Its pointer was moved by the center knob and was used for rapid changes within a tuning range. The bottom scale is calibrated in fractional MHz and its pointer was controlled by the right-hand knob through a 200:1 reduction. The frequency displayed is the sum of the upper and lower scales; 7 on the upper scale and .10 on the lower would tune the receiver to 7.1 MHz on 40 meters. The band-spread range changed for each of the six bands and was continuously calibrated from .55 to 35.52 MHz. The Pro-310 was double conversion above 2.2 MHz and had a 52 kHz IF. The 13-tube receiver came in a choice of a black cabinet with gold trim or the grey cabinet with silver trim shown here; $495.00, 1955. (48)

**G ◇ HEATH HX-20 & HR-20** The compact dimensions (6.25 x 12.25 x 9.75 inches) made Heath's matched pair an appealing choice for mobile or portable use. The HX-20 transmitter covered 80–10 meters with 90 watts input to its 6146 final on CW and SSB. Its sideband generator used a crystal filter. The transmitter had automatic level control as well as provisions for both VOX and PTT. The eight-tube HR-20 receiver tuned 80 through 10 meters and received AM as well as SSB and CW. A crystal filter in the set's 3 MHz IF provided selectivity. The HX-20 & HR-20 pair replaced the MT-1 & MR-1 in Heath's lineup; HX-20 $199.95, HR-20 $134.50, 1962. (1)

**H ◇ HEATHKIT SB-10** The SB-10 phasing single-sideband adapter put Heath's TX-1 "Apache" transmitter on SSB and could also be used with slightly modified DX-100s. VOX and anti-trip circuits were included, and it covered 80–10 meters. It required an external power source and could be plugged into the TX-1's accessory socket for that purpose; $89.95, 1959. (1)

A

B

C

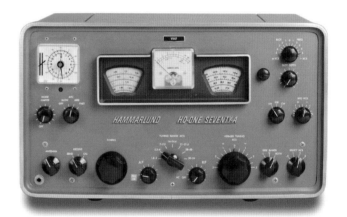

D

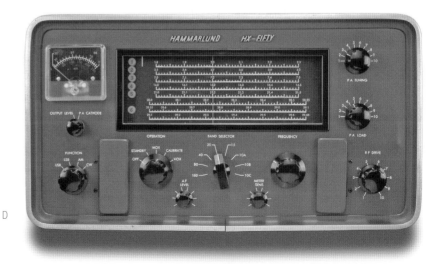

E

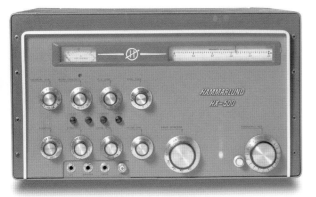

F

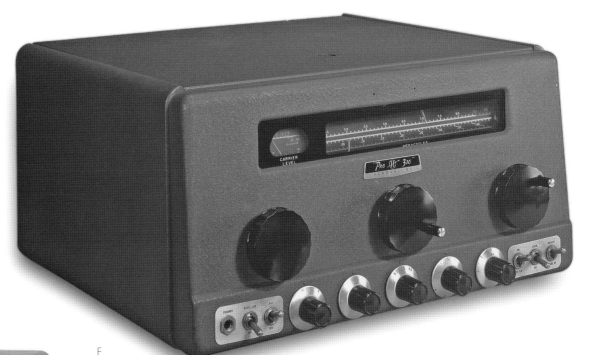

G

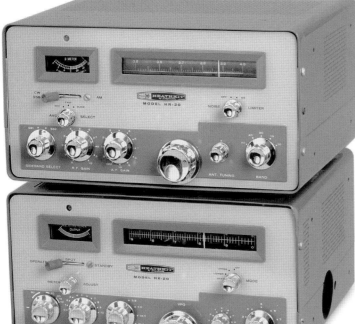

H

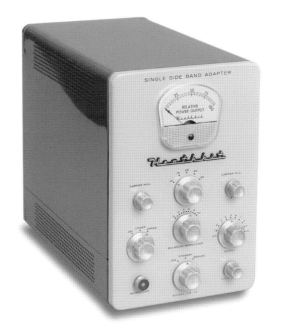

**A ◊ JOHNSON DESK KILOWATT** The Johnson Desk Kilowatt transmitter came in a floor-standing pedestal enclosure that could be combined with an optional desktop and three-drawer pedestal. Everything about the Desk KW was heavy-duty. The amplifier unit pulled out of its enclosure on ball-bearing rollers for access and maintenance. The amplifier contained an RF deck, modulator, power supplies, and control equipment. It ran a solid kilowatt on SSB, CW, and AM. Frequency coverage was continuous from 3.5 to 30 MHz. It used a pair of 4-250A tubes modulated by a pair of push-pull 810s in Class B. The Desk KW required 30 watts RF and 15 watts audio drive. The amplifier is shown set up as it often appeared in Johnson ads; the exciter is a Johnson Viking Ranger and the receiver is a National HRO-60. The unit at the far right is a Johnson antenna rotator indicator; amplifier, $1595.00, desk, $123.50, 1955. (19)

**B ◊ JOHNSON INVADER** The Johnson Invader operated SSB, CW, and AM on 80–10 meters. It was a filter-type sideband transmitter with a 9 MHz IF. Power input to the pair of 6146 finals was 200 watts SSB and CW, 90 watts AM. It had ALC for greater talk power and a built-in VOX circuit ($619.50, 1960). A 2 KW model, the Invader 2000, was also available. The Invader's internal power supply was removed and the space filled with a Class AB2 linear amplifier using a pair of PL-175A tubes. The Invader 2000's power supply was on a separate chassis. (63)

**C ◊ JOHNSON PACEMAKER** The Pacemaker was a phasing-type transmitter with 90 watts CW and SSB input on 80–10 meters using a 6146. It ran 35 watts on AM. It was sold factory wired & tested only; $495.00, 1956. (1)

**D ◊ JOHNSON VALIANT II & SIDEBAND ADAPTER** Dressed up in Johnson's new style, the Valiant II shared most operating features and specifications with the original Valiant transmitter. It added rear-panel connections for RF and control circuits when used with a sideband adapter. The Johnson Sideband Adapter was a filter-type generator that worked on 80 through 10 meters. Its 2-watt output would drive a Valiant or Valiant II to full power. The adapter's power supply was a separate unit and could be mounted remotely; Valiant II $375.00 (kit)/$495.00 (wired), Sideband Adapter, $369.50, 1962. (27)

A

C

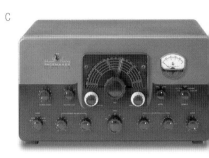

B

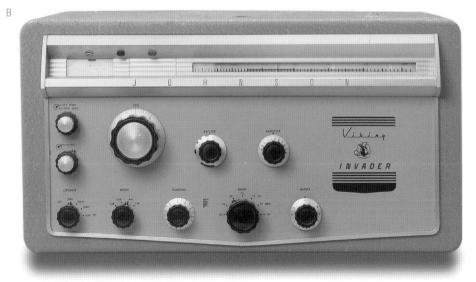

D

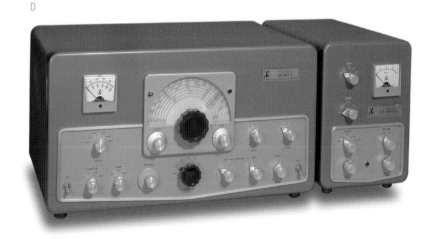

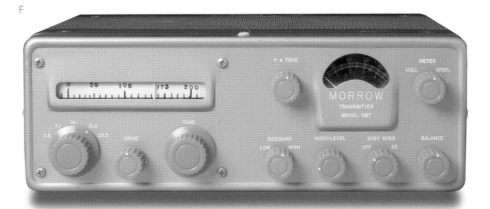

F

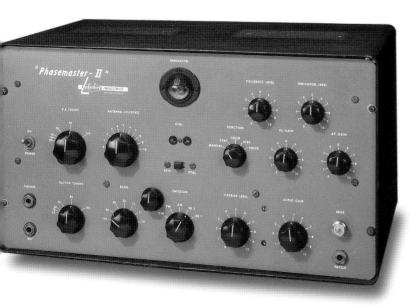

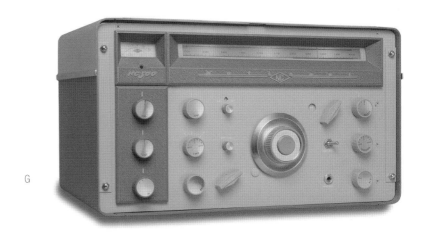

G

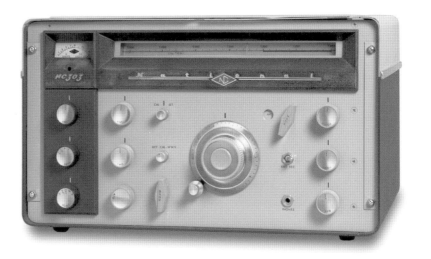

H

**E ◊ LAKESHORE PHASEMASTER II** The Phasemaster II was available in both kit form and factory-wired. True to its name, it was a phasing-type sideband transmitter. Other modes were CW, AM, and PM. It had band-switching coverage of 160–10 meters, as well as built-in VOX and anti-trip circuits. SSB power input to the 6146 final was 100 watts PEP, 50 watts on AM and CW; $279.50 (kit)/$329.50 (wired), 1955. (2)

**F ◊ MORROW SBT** The Morrow SBT transmitter covered the phone portions of 75, 40, 20, and 15 meters, and 28.5–28.7 MHz on 10. The tuning range of the VFO was 200 kHz, and the transmitter was equipped for both VOX and PTT operation. It used a mechanical filter for sideband generation and transmitted CW and AM as well. Power output from the 6146 final was 50 watts; $349.50, 1958. (1)

**G ◊ National NC-300** National's NC-300 was double-conversion with IFs at 2215 and 80 kHz. It had a crystal filter in the 1st IF. It covered the 160–10 meter bands and had a band at 30–35 MHz that served as a tunable IF for VHF converters. It was calibrated for 6, 2, and 1-1/4 meters. The 13-tube NC-300 had a product detector, and its AVC could be used on CW and SSB; $349.95, 1955. (70)

**H ◊ NATIONAL NC-303** The NC-303 added new features to the NC-300 and changed others. It eliminated the 2215 kHz IF crystal filter and added a Q-multiplier in the 80 kHz IF. A separate SSB/CW noise limiter was added, and the AVC circuit improved. It covered the 160–10 meter ham bands and included a 5 MHz wide tuning range to use with optional 6, 2, and 1-1/4 meter converters. Calibrated tuning scales for the VHF bands were included; $449.00, 1958. (1)

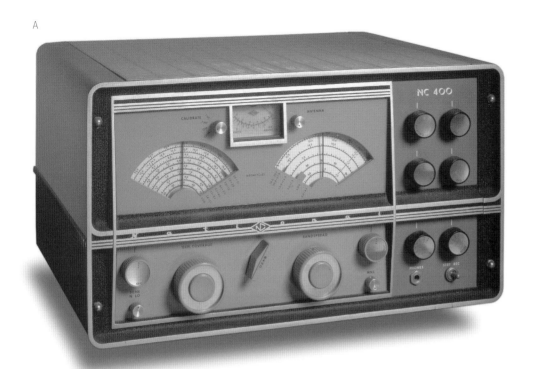

A

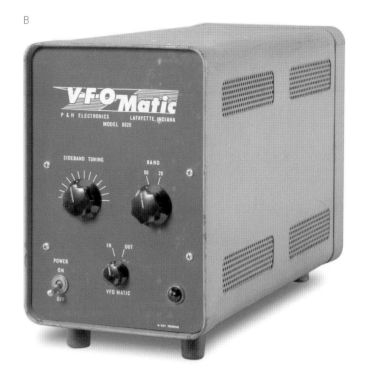

B

C

D

E

G

F

**A** ◊ **NATIONAL NC-400** With the NC-400, National set out to provide a versatile communications receiver cable of top-notch performance in both amateur and commercial applications. The double-conversion receiver tuned .54–31 MHz in 7 bands. It had a crystal filter and mechanical filters were offered as an option. The NC-400 could be tuned manually or crystal-controlled on pre-set frequencies. It also had provisions to use an external frequency synthesizer. The band spread dial was calibrated for the 80–10 meter ham bands. The set used 18 tubes; $895.00, 1959. (19)

**B** ◊ **P&H 8020** The model 8020 VFO-Matic plugged into a Collins 75A-2, -3, or -4, and then used the receiver's PTO to control the frequency of a phasing-type SSB transmitter having a 9 MHz mixer frequency. The 8020 worked on 75 and 20 meters; $124.50, 1957. (1)

**C** ◊ **P&H DI-1** The DI-1 RF Distortion Indicator assisted in the adjustment of SSB transmitters, displaying trapezoid or RF envelope patterns on its 3 inch scope tube. It operated on 160 meters at power levels of 5 watts to 2 kilowatts; $99.95, 1961. (58)

**D** ◊ **SQUIRES-SANDERS SS-1R** The SS-1R was designed to provide freedom from front-end overload and cross-modulation while still delivering outstanding sensitivity. The Squires-Sanders receiver had no RF stage. IF crystal filters yielded selectivity bandwidths of .35, 2.5, and 5 kHz. The 12-tube set also used 10 solid-state diodes. The main dial's tuning rate was 10 kHz per revolution; push-button motor tuning was used for rapid changes. Eighty through 10 meters was covered in eight 500 kHz segments. There were two additional general-coverage ranges, as well as fixed-tuned positions for 10 and 15 MHz WWV; $895.00, 1963. (1)

**E** ◊ **TRI-STATE ELECTRONICS TRI-X-500** The Tri-X-500 was made by Tri-State Electronics of Falls Church, Virginia. It transmitted SSB, CW, and AM on 80–10 meters. It generated sideband using a mechanical filter at 455 kHz. Power input to the 4X150A final was 500 watts SSB, 400 watts CW, and 300 watts AM; $795.00, 1963. (1)

**F** ◊ **WRL DSB-100** The DSB-100 "Sidebander" was one of the few double-sideband transmitters to reach the commercial marketplace. It was available as a kit ($99.95) or factory-wired ($119.95). The Sidebander covered 80–10 meters and used a pair of 6DQ6A tubes in the final. DSB input was 100 PEP, with 50 watts CW and 40 watts AM; 1958. (1)

**G** ◊ **WRL METEOR SB-175** The Meteor transmitted CW, AM, and double-sideband, suppressed carrier on 80 through 10 meters. Power input to the pair of 6DQ6B finals was 175 watts CW, 100 watts AM, and 140 watts DSB. The crystal-controlled SB-175 required an external VFO and power supply; $99.95, 1962. (1)

# Post-War VHF

Post-World War II VHF operation took shape along different lines than that of the 1930s. In the earlier decade, even 10 meters was considered VHF. Most amateur operation used simple super-regenerative receivers and modulated-oscillator transmitters. During the war, some participants in WERS (War Emergency Radio Service) used similar equipment on the 112 MHz band, although government regulations imposed stricter frequency accuracy and stability standards than were customary 1930s amateur practice.

VHF, UHF and microwave technology took great strides forward during the war. Amateurs incorporated many of these improvements when they returned to the air at war's end. The changes encompassed more than just equipment and technical matters. The old 2½ (112 MHz) and 5 meter (56 MHz) bands were gone, replaced by new allocations at 144–148 MHz (2 meters) and 50–54 MHz (6 meters).

Some post-war equipment included 6 meters as an extension of its HF coverage. RME made a tunable VHF converter for their RME-45 receiver. Companies such as Lafayette and Columbus Electronics offered similar converters. National sold dedicated VHF receivers, updating 1930s technology with improvements from the war years.

In July 1951, the FCC instituted the Novice class license, granting with it privileges for voice operation at 145–147 MHz. The Technician class license, introduced at the same time, carried all amateur privileges on frequencies above 220 MHz. Holders of these new license classes expanded the potential market for manufacturers of VHF ham gear.

The modest antenna requirements for VHF operation made it attractive for both mobile and portable work. Gonset Corporation brought several converters to market, followed by their station-in-a-box, the Communicator. The first of these transmitter-receivers were for use on the 2 meter band. The Communicator featured an AM transmitter and a superhet receiver, both vast improvements over the gear available to pre-war amateurs. Built-in power supplies enabled them to work on either dc car-battery voltages or from commercial ac mains. ∎

**LEFT** ◊ **ALLIED LINCOLN 6-METER TRANSCEIVER** Allied Radio's model L-2754 transceiver had a superhet receiver tunable from 50–54 MHz and a 7-watt, crystal-controlled AM transmitter. The 115 VAC power supply was self-contained, and both 6 and 12 VDC supplies were available; $57.50, 1961. (1)

**OPPOSITE** ◊ **ALLIED T-175** The Knight-Kit T-175 6 and 10 meter linear amplifier used a pair of 6JE6A sweep tubes. It ran 150 watts input on CW, 300 watts PEP on SSB, and could be used on AM by reducing input power to 240 watts. It had an automatic antenna changeover relay and internal cooling fan; $99.95, 1968. (1)

**A ◊ ALLIED TR-106 & V-107** The Knight-Kit TR-106 covered the 50–52 MHz portion of the 6 meter band. The model TR-108 was for 2 meters. The TR-106 is shown here with the V-107 VFO, which covered the 6 and 2 meter bands and worked with both transceivers; TR-106, $139.95, V-107, $19.95, 1966. (1)

**B ◊ AMECO TX-62** The TX-62 transmitter covered the 6 and 2 meter amateur bands. It ran 75 watts input on phone and CW. The power supply was built-in, as was the AM modulator. The TX-62 used 8 MHz crystals or an external VFO; $149.95, 1964. (1)

**C ◊ AMPLIDYNE 621** The 621 VHF transmitter ran 60 watts CW and plate-modulated AM on 6 and 2 meters. It used seven tubes and included a built-in dummy load. A front-panel switch selected five crystal positions or VFO operation. Amplidyne made a model 261 VFO and a model 221 plug-in unit to put the transmitter on 220 MHz; $274.50, 1964. (1)

**D ◊ CENTIMEG 432 TRANSMITTER** Centimeg's 432 MHz transmitter was a simple but effective design. It ran 10 watts plate-modulated AM output with a 2C39 final. All circuits except for the tripler and final amplifier were fixed tuned. The El Segundo, California company also manufactured VHF & UHF receiving converters; $184.50, 1959. (65)

**E ◊ CLEGG 66'ER** The 22 watt transceiver had a built-in 115 VAC/12 VDC power supply. Its double-conversion receiver tuned 49.9–52.1 MHz and the transmitter was crystal-controlled. It featured high-level amplitude modulation and speech clipping; $249.95, 1966. (1)

A
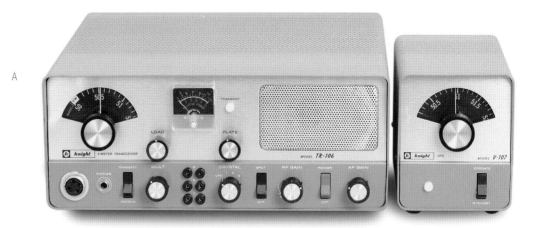

B
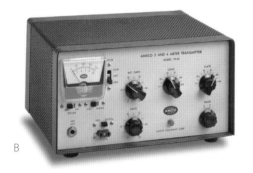

C
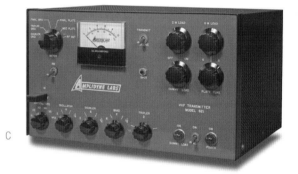

D
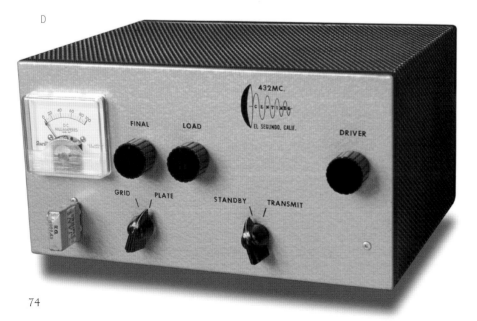

E
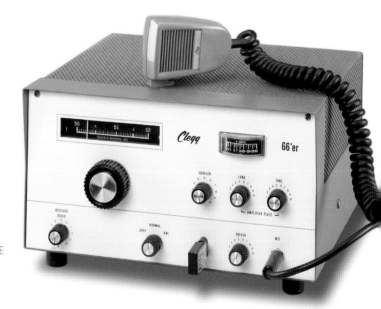

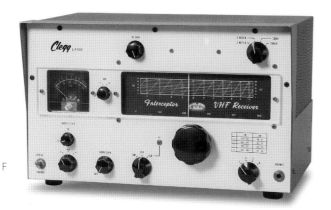

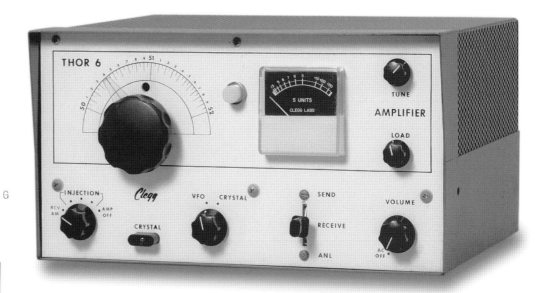

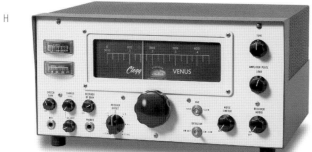

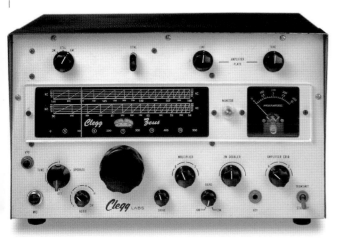

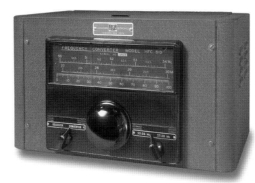

**F ◊ CLEGG INTERCEPTOR** The Interceptor was the companion piece to Clegg's Zeus 6 and 2 meter transmitter. It had low-noise nuvistor RF stages and was designed to minimize cross modulation. A crystal lattice filter in the Interceptor's 10.7 MHz IF provided selectivity; $473.00, 1962. (1)g ◊

**G ◊ CLEGG THOR VI** Clegg's 50 MHz Thor transceiver was the first VHF rig to use the same VFO for transmit and receive. Another innovation was the cascode amplifier between the transmitter's mixer and driver stages. Power output was 50 watts on AM and CW. The mode switch offered three levels of receiver BFO injection. The 115 VAC power supply and modulator were on a separate chassis. A transistorized modulator/power supply for mobile operation was available; $349.95, 1962. (1)

**H ◊ CLEGG VENUS** The Venus 6 meter SSB transceiver used a crystal lattice filter and had 85 watts output on sideband and CW. The AM mode was available at reduced power. Its receiver was a double-conversion superhet. The AC power supply was a separate unit that could be mounted remotely; $495.00, 1962. (1)

**I ◊ CLEGG ZEUS** Clegg gear came from several different companies in a variety of New Jersey and Pennsylvania locations. The driving force behind the designs was Edward T. Clegg, W2LOY (also W3 and W8LOY). The Zeus 6 and 2 meter transmitter featured a handsome Eddystone dial and had a power output of 125 watts AM and CW. The transmitter's clipper-filter circuit (called Automatic Modulation Control) gave it additional talk power on AM. The power supply and modulator were housed in a separate cabinet; $595.00, 1961. (1)

**J ◊ COLUMBUS ELECTRONICS HFC 610** Columbus Electronics' tunable converter was designed to pep up the performance, or extend the upper range, of an HF communications receiver. Its two bands covered 27–30 and 50–54 MHz. The HFC610 was manufactured in Yonkers, New York and had an internal power supply; $79.50, 1947. (35)

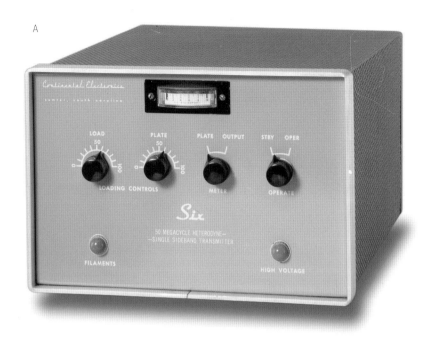

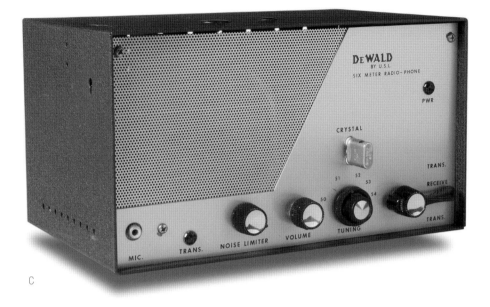

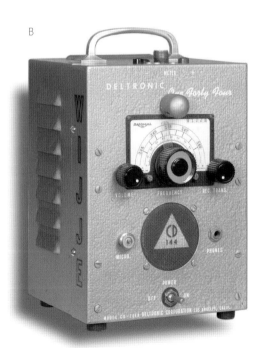

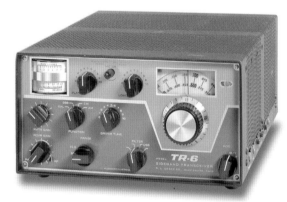

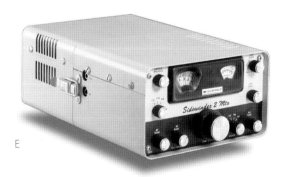

**A** ◊ **CONTINENTAL SIX** The Continental Six transmitting converter was based on a K4RLX design. It was sold by Continental Electronics of Sumter, South Carolina. It was driven by an exciter's 20 meter output. Six meter power output from the Continental Six was 30 watts PEP SSB, with reduced output on AM; $99.95, 1962. (1)

**B** ◊ **DELTRONIC CD-144A** The Deltronic CD-144A was designed for portable Civil Defense and Civil Air Patrol work as well amateur communications on the 2 meter band. The 10-tube transmitter-receiver tuned from 143.9–148 MHz. It ran 7 watts input to a 5763 final. A dual-source 110 VAC/6 VDC power supply was built in; $195.00, 1954. (65)

**C** ◊ **DEWALD 6 METER RADIO-PHONE** DeWald was a division of United Scientific Laboratories in Long Island City, New York. The 6 meter Radio-Phone had a superhet receiver that tuned from 50–54 MHz. The crystal-controlled transmitter ran 7 watts plate-modulated AM. It had an internal 115 VAC power supply and came with a ceramic microphone and one crystal; $99.95, 1961. (1)

**D** ◊ **DRAKE TR-6** The TR-6 transceiver provided full coverage of 6 meters with 1 kHz dial calibration and 300 watts input on CW, SSB, and AM (PEP on the phone modes). The TR-6 used 19 tubes, 7 transistors, 3 FETs, and 12 diodes. Its final amplifier was three 6JB6 sweep tubes in parallel. One of Drake's AC or DC power supplies was required; $599.95, 1968. (1)

**E** ◊ **GONSET SIDEWINDER** The Gonset Sidewinder SSB, CW, and AM transceiver covered the 2 meter band in four 1 MHz segments. The receiver was completely transistorized. Input power was 20 watts on CW and SSB, 6 watts on AM. The accessory power supply snapped on the back of the transceiver or could be mounted remotely; $349.95, 1963. (63)

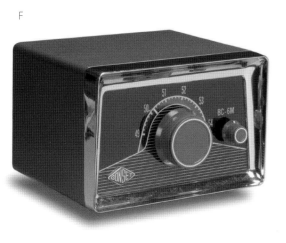

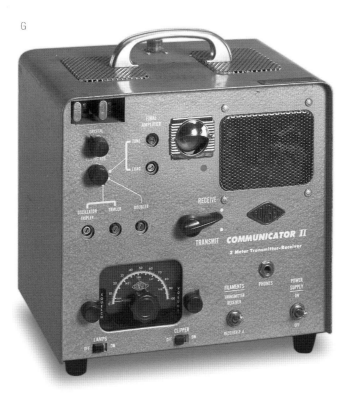

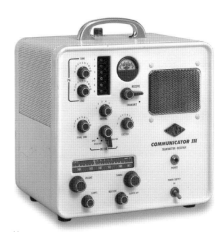

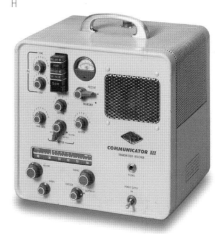

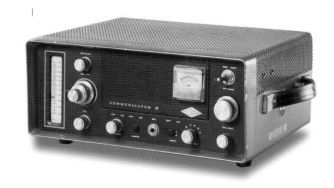

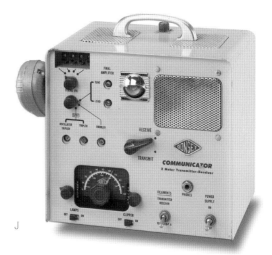

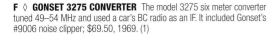

**F ◊ GONSET 3275 CONVERTER** The model 3275 six meter converter tuned 49–54 MHz and used a car's BC radio as an IF. It included Gonset's #9006 noise clipper; $69.50, 1969. (1)

**G ◊ GONSET COMMUNICATOR II** Gonset introduced the Communicator in 1952. The Communicator II model followed in 1953. The initial versions were 2 meters only, but a year later a Communicator II for 6 meters appeared, as did 12 VDC power supplies. The set weighed 20 lbs., and AM phone power output was 5–7 watts from the 2E26 final (8–10 watts on 6 meters). The Standard version (less microphone, squelch, and 12 V supply) was $209.00; the Deluxe model was $229.50. (63)

**H ◊ GONSET COMMUNICATOR III** The model III improved upon its predecessors in the Communicator line and came in the 6 and 2 meter versions shown here. The Communicator III included a 115 VAC/6 & 12 VDC power supply, a low-noise cascade RF stage, AVC, PTT operation, a slide-rule dial, and a panel meter to replace the magic-eye tube. All transmitter tuning controls were adjusted using knobs rather than a screwdriver. Solid-state diodes replaced the power supply's rectifier tube; $269.50, 1957. (1)

**I ◊ GONSET COMMUNICATOR IV** Along with a new shape, the Communicator IV offered a higher-power transmitter and a triple-conversion receiver. It was introduced in 6 and 2 meter versions; $369.50, 1960. (1)

**J ◊ GONSET COMMUNICATOR** Gonset introduced the Communicator in 1952. The 2 meter transmitter/receiver had a universal 110 VAC/6 VDC power supply. Its superhet receiver tuned 144–148.3 MHz. The 15-watt input AM transmitter was crystal-controlled; $189.50, 1952. (63)

A
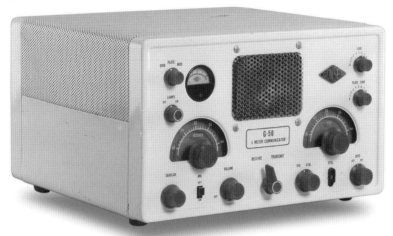

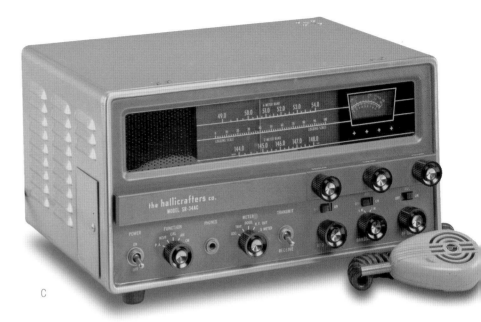
C

B

E

D

**A ◊ GONSET G-50** The Gonset G-50 was a complete 50 watt, 6 meter AM station. The transmitter was VFO-controlled and both it and the receiver tuned 50–54 MHz. The final amplifier was a 6146. The G-50's 115 VAC supply was built-in; $319.50, 1958. (63)

**B ◊ GONSET GSB-6** The GSB-6 Sideband Communicator (model 910A) covered the 6 meter band in 1 MHz segments and had AM and CW modes in addition to SSB. Solid-state design was used in low-level stages and common use was made of IF and oscillator circuits as well as the crystal lattice filter. A similar model covered 2 meters; $399.50, 1965. (1)

**C ◊ HALLICRAFTERS SR-34** The SR-34 provided coverage of both the 6 and 2 meter bands on AM and CW. With its built-in, three-way power supply, the transceiver could operate from 115 VAC, 6 VDC, and 12 VDC. Cross-band operation was possible. Power output from the crystal-controlled transmitter was 6 to 7-1/2 watts on 2 meters, 7 to 10 watts on 6 meters. The unit pictured is the SR-34AC. Intended for base-station use, it lacked the DC power supply, carrying handle, and cover; SR-34, $495.00, SR-34AC, $395.00, 1958. (1)

**D ◊ HALLICRAFTERS SR-42** The SR-42 transceiver's two tuning ranges covered 144–146 and 146–148 MHz. Eleven tuned circuits minimized interference from broadcast and commercial services. The 11-tube set had a crystal-controlled transmitter and provisions to use the Hallicrafters HA-26 VFO. A similar 10-tube SR-46 covered the 6 meter band. Both transceivers ran 10–12 watts input and had internal 115 VAC supplies; $189.95, 1965. (1)

**E ◊ HARRISTAHL NE-6** The NE-6 transmitter from Harristahl Laboratories of Brooklyn, New York covered 6 meters with 12 watts input to a 5763 final. The crystal-controlled AM/CW rig used neon-bulb indicators for tuning and monitoring. It had an internal relay for antenna changeover and receiver muting. It worked from 6 or 12 VDC power. An NE-2 model was made for 2 meters; $69.50, 1956. (1)

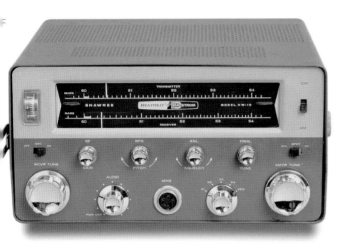

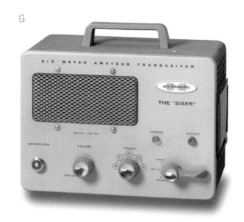

**F ◊ HEATH HW-10** The HW-10 "Shawnee" 6 meter rig had individual VFOs for its transmitter and receiver. Tuning for the AM and CW transmitter's exciter stages tracked with VFO. Four switch-selected crystal positions were available. It ran 10 watts out with a 6350 final. Its three-way power supply worked on 117 VAC, as well as 6 and 12 VDC. The HW-20 "Pawnee" was the 2 meter equivalent; $199.95, 1961. (1)

**G ◊ HEATH HW-29** The "Sixer" was the 6 meter "Lunchbox" transceiver. The one shown here is the plain HW-29. The design had some problems, and Heath didn't ship many before replacing it with the HW-29A. It had a super-regen receiver and crystal-controlled transmitter; $39.95, 1960. (1)

**H ◊ HEATH HX-30** The HX-30 six meter SSB transmitter ran 20 watts PEP input with a 6360 final. It had a built-in power supply and used phasing SSB generation. The HX-30's VFO covered 50–54 MHz in four 1 MHz bands. It also operated CW and AM; $189.95, 1962. (1)

**I ◊ HEATH SB-110** Heath brought the SB-line to 6 meters with the SB-110 transceiver. It covered any four 500 kHz band segments between 49.5 and 54 MHz using the SB-line's Linear Master Oscillator. Power output was 100 watts PEP on SSB and 90 watts on CW with a pair of 6146s. Heath's HP-23 power supply was used for fixed-station operation; $320.00, 1965. (1)

**J ◊ HEATH VHF-1** The "Seneca" was a self-contained AM/CW transmitter for 6 and 2 meters. It had VFO control on both bands, or the operator could choose from four switch-selected crystals. It used controlled-carrier modulation on phone. The VHF-1 had a pair of 6146s in the final amplifier. Power input on 6 meters was 120 watts AM, 140 watts CW. It was rated at about 80 percent of those figures on 2 meters; $159.95, 1958. (63)

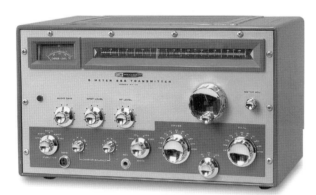

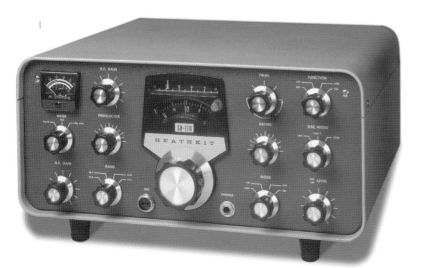

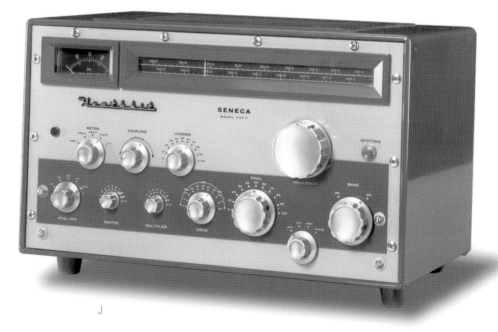

**A ◊ JOHNSON 6N2 TRANSMITTER** The 6N2 transmitter offered band-switching coverage of 6 and 2 meters. The final amplifier used a 5894 dual tetrode in push-pull. Input power was 150 watts on CW and 100 watts on phone. All tuning controls were located on the front panel and all circuits were metered. The 6N2 borrowed power and modulating audio from a host transmitter such as the Johnson Ranger or Viking II; $99.50 (kit)/$129.50 (wired), 1956. (1)

**B ◊ LAFAYETTE HE-35** The HE-35 six meter transceiver had a tunable receiver and crystal-controlled 7-watt transmitter. The speaker and 115 VAC power supply were built in. The panel meter and switch next to it are not original; $57.50 1960. (1)

**C ◊ LAFAYETTE LESTER VHF CONVERTER** Frank Lester, W2AMJ, designed this 6, 10, and 11 meter converter for Lafayette. It was sold as a kit in the late 1940s. The three-tube converter used plug-in coils to accommodate FCC band changes; $34.50 (kit)/$49.50 (wired). (1)

**D ◊ LETTINE 242** Lettine Radio Mfg. Co. of Valley Stream, New York ran ham magazine ads for their 240- or 260-series transmitters and accessories during the 1950s and '60s. Even though the content changed, the ads maintained a consistent appearance from month to month. The Model 242 was a 45 watt AM and CW transmitter for 6 and 2 meters. It used plug-in coils and had a 6146 final; $89.95, 1956. (1)

**E ◊ L'IL LULU RECEIVER** Only a half-dozen L'il Lulu receiver prototypes were produced. These were distributed as part of a beta-test project, with improvements and changes in each receiver. None of the known prototypes exactly duplicates another. The 6 meter receiver first appeared in January 1965 magazine ads and continued to show up by itself, or paired with the matching transmitter, before disappearing completely a year-and-a-half later; 1965. (53)

A
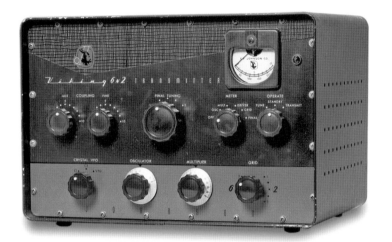

B
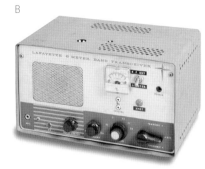

C
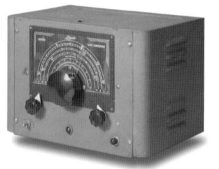

E
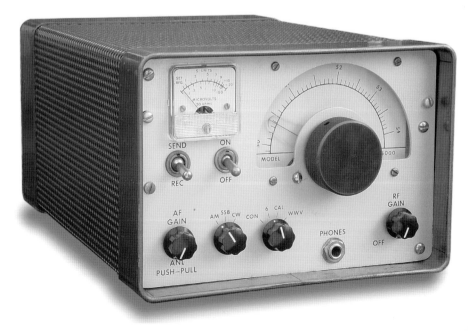

D
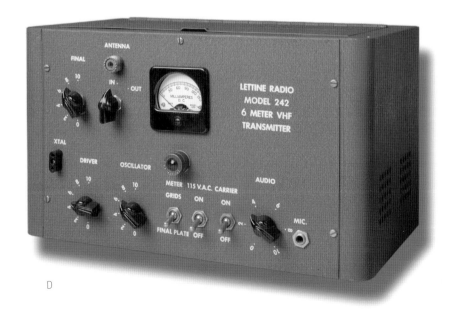

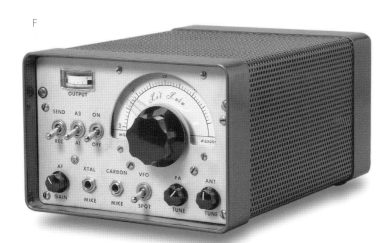

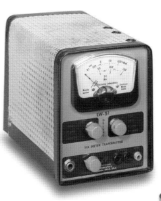

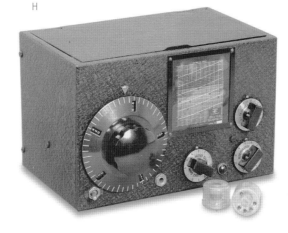

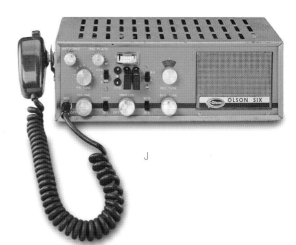

**F ◊ L'IL LULU TRANSMITTER** Whippany Laboratories was owned by Ed Ladd, W2IDZ. In 1963, the West Caldwell, New Jersey company introduced the commercial version of Ladd's L'il Lulu transmitter. The rig had already become a popular homebrew project among 6 meter ops during the previous decade. All stages up to the final amplifier were gang-tuned and tracked with the VFO. Power output was 6 watts on CW and 5 watts on AM. The L'il Lulu was legendary for being able to operate interference-free on the TVI-prone 6 meter band; $225.00, 1963. (1)

**G ◊ LW ELECTRONICS 51, 61, & 80** LW Electronic Laboratory of Jackson, Michigan made a line of 6 and 2 meter gear in the 1950s and early '60s.The LW-51 transmitter ran 50 watts input on 6 meters with a 6146. It was plate-modulated. The factory-assembled LW-51 came with tubes and a crystal; the kit version did not. The LW-51 Deluxe included a cabinet and meter ($57.50 kit/$69.50 wired, 1959). The LW-61 two meter converter was available with a variety of 4 MHz wide IF output ranges in the HF spectrum. A broadcast-band output could be used for mobile installations. The LW-61 was also made for 6 meters ($18.50, 1954). The LW-80 cascode VHF pre-amplifier had 20 dB gain and a 5 dB noise figure. The pre-amp in the photo is for 6 meters. The LW-80 was also made for 2 meters ($12.50, 1956). (1)

**H ◊ NATIONAL 1-10A** National's 1-10A updated the pre-war 1-10 design by improving performance and smoothness of control. The super-regenerative receiver covered 27–290 MHz with six sets of plug-in coils. It operated from batteries or an external supply; $67.50, 1946. (1)

**I ◊ NATIONAL HFS** The HFS covered 27–250 MHz using six sets of plug-in coils. It was a super-regenerative receiver that could also be used as a tunable VHF converter ahead of a communications receiver. An Internal/External switch connected the 10.7 MHz IF output to a separate receiver and disabled its own detector and audio stages. An external power supply was required; $125.00, 1948. (1)

**J ◊ OLSON SIX** The Olson Six was one of the few pieces of ham gear sold by the electronics retailer. The Six (also model RA-570) was made by Utica Communications and appears identical to that company's 650 model. The transceiver tuned from 50–52 MHz and its power supply operated from 117 VAC and 12 VDC sources. Its receiver was a double-conversion superhet. The 15 watt AM transmitter used a 2E26 in a Class C final; $69.95, 1964. (1)

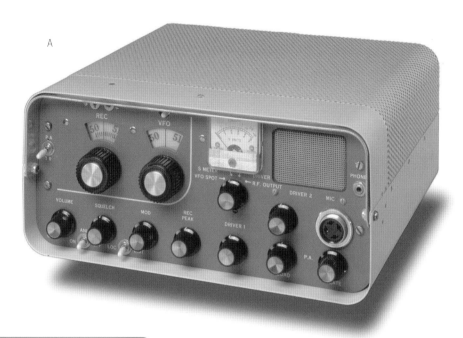

A

**A ◊ POLYTRONICS POLY-COMM 6** In addition to the Poly-Comm 6-2 two-band transceiver, Polytronics made the 6-meter only Poly-Comm 6. Improvements over the previous model included nuvistor RF amps and a more stable VFO. It covered the entire 6 meter band. There were also single-band Poly-Comm transceivers for 2 and 10 meters; $319.50 (AC/DC model)/$299.50 (AC only), 1962 (1)

**B ◊ RME 2-11** RME's 13-tube receiver covered the 2, 6, and 10-11 meter amateur bands. A limiter stage and ratio detector equipped the 2-11 for NBFM reception in addition to the CW and AM modes; $130.00, 1948. (71)C ◊

**C ◊ RME VHF-126** The VHF-126 had two-speed tuning with ratios of 1:1 and 75:1. It was styled to match RME's newer receivers.  The converter covered the 6, 2, and 1-1/4 meter bands; $239.00, 1958. (1)E ◊

**D ◊ RME VHF-152A** The RME VHF-152A was a tunable converter covering 2, 6, and 10 meters. The bands were calibrated to cover the full sweep of the semi-circular dial. It had a built-in, voltage-regulated power supply. The VHF-152A used a 6AK5 RF amp and 6J6 oscillator-mixer. The IF output frequency was 7 MHz; $86.50, 1951. (1)

**E ◊ RME VHF-602** The RME VHF-602 was made when the company was part of G C Electronics and was a re-badged Globe HG-602 meter transmitter. It ran 60 watts CW, 50 watts phone on 6 & 2 meters. The 6146 final was plate-modulated; $179.95, 1962. (1)

**F ◊ ROGERS BLACK WIDOW TXR10-CQ** The Black Widow transceivers had already become a cult classic among Southern California VHF ops when they gained national distribution in 1957. The Compact sets produced 8 watts of plate-modulated AM. The TXR10-CQ was the 6 meter model. The TXR-9 covered 2 meters; $165.00, 1958. (1)

**G ◊ SONAR SR-9** Along with the 2 meter model pictured, the Sonar SR-9 was also made in 6 and 10 meter versions. The 9-tube receiver was compact enough for mobile use and had 3 watts of audio.  An external power supply was required; $72.44, 1951. (1)

**H ◊ SPRINGFIELD TR-144** Springfield Enterprises, of Springfield Gardens, New York, supplied the 1-tube TR-144 Radiophone as a partially assembled kit. The 2 meter transceiver's wired chassis and tube sold for $6.95. The other components and circuit diagram were extra; 1956. (1)

**I ◊ SWAN 250C** The Swan 250C six meter sideband transceiver covered the complete 50–54 MHz band. Power input was 240 watts PEP on SSB, 180 watts CW, and 75 watts AM. Its final amplifier was a pair of 6146Bs. The 250C here is shown with the accessory NS-1 noise blanker; $429.00, 1968. (1)

**J ◊ TAPETONE SKY SWEEP RECEIVER** The Model 345 Sky Sweep was a single-conversion 6 meter receiver. The 11-tube set could be used as a tunable IF for converters and also had calibration for the 144, 220, and 432 MHz bands on its slide rule dial. It had a high-frequency IF for image rejection and used a crystal lattice filter for selectivity. The Sky Sweep had separate RF and IF gain controls, a noise limiter for AM, and a product detector with an adjustable BFO for SSB/CW; $279.95, 1958. (1)

B

D

C

E

F

G

I
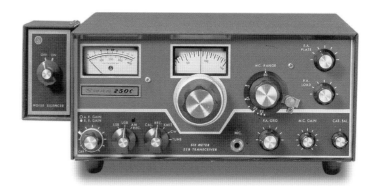

J

H

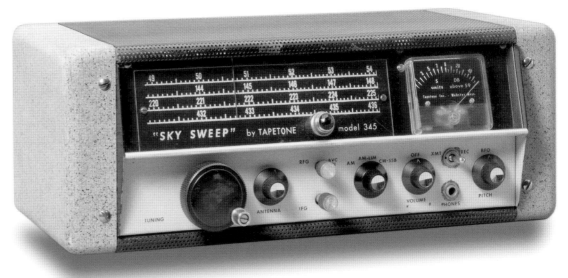

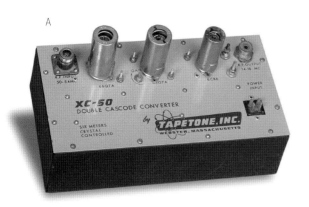

A

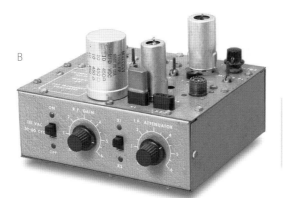

B

C

D

E

F

G

**A ◊ TAPETONE XC-50** The XC-50 crystal-controlled converter covered six meters and had its IF output at 14-18 MHz. Tapetone's XC-144 covered two meters. The RF input connector on the unit shown is not original; $59.95, 1956. (65)

**B ◊ TECRAFT MODEL 50 CRITERION** Tecraft made their Criterion series of converters for the 50, 144, and 220 MHz bands. They offered the operator management of input and output signal levels and the converter's gain could also be controlled by the receiver's AVC. The six meter model shown here could use any IF from 6–30.5 MHz. The converters had sockets for two heterodyne crystals. The power supply was built in; $49.95, 1963. (1)

**C ◊ TECRAFT TR-20/50** The TR-20/50 used a 6360 Class C final plate modulated by a pair of 6AQ5s in Class A. The final operated straight through on 6 meters at 20–25 watts input. It had an RF bridge circuit and rectifier for monitoring output. The TR-20/144 model added a buffer/multiplier stage for operation on 2 meters, and the TR-20/220 covered 1-1/4 meters. All transmitters in the TR-20 series came complete with tubes and crystal; $59.95, 1956. (1)

**D ◊ TELCO MODEL 201 CONVERTER** The Telco (Tapetone) 201 six meter converter used a 6CW4 and a 6U8. Its IF output range was 14–18 MHz; $37.40, 1964. (1)

**E ◊ UTICA 650 & VFO** The Utica Communications Corporation was located in Chicago. They made equipment for other companies and put their own name on some pieces. The Utica 650 six meter transceiver also appeared as the Olson HA-570. The Utica version was often packaged with an external VFO; $189.95 (including VFO), 1964. (1)

**F ◊ VANGUARD 301J** The Vanguard 301J used three epitaxial planar UHF transistors. It had a crystal oscillator, a tuned RF stage, and a low-noise mixer. It covered 50–52 MHz with a 28–30 MHz IF; $16.95, 1966. (1)

**G ◊ WRL MOBILINE SIX** The Mobiline Six had internal power supplies for 115 VAC as well as 6 and 12 VDC. Globe Electronics' 6 meter transmitter/receiver weighed 20 pounds. The receiver used seven tubes, and the VFO-controlled transmitter ran 20 watts of Class B modulated AM with a 2E26 final; $229.95, 1960. (1)

**H ◊ WRL TC-6A TECHCEIVER 6** World Radio Labs touted its 6 meter transceiver as the "World's Smallest." It measured 5" x 9-1/4" x 6" and weighed 5 lbs. The superhet receiver tuned from 48–54 MHz, and the 5 watt AM transmitter used 8 MHz crystals. A separate power supply was required. The TC-6A replaced the TC-6, a similar 1 watt model; $39.95 (kit), 1962. (1)

**I ◊ WRL GLOBE VHF-62** The VHF-62 "Hi-Bander" transmitter covered 6 and 2 meters. Power to its 6146 final was 70 watts CW/60 watts phone on 6 meters, and 60 watts CW/50 watts phone on 2; $119.95 (kit)/$139.95 (wired), 1958. (65)

# The Rise of the Transceiver

The idea may have occurred earlier to someone, but the growth of single sideband made the transceiver concept both practical and appealing. In its most basic form, a transceiver uses the same oscillators to control the frequency of both transmitter and receiver. In most applications, other circuits are shared as well.

The transceiver makes mobile operation easier, too. One piece of equipment replaces the separate transmitter and receiver or converter. Frequency is controlled with one knob, and the number of other knobs and switches often decreases.

In 1957, Collins Radio brought the transceiver to the commercial market with the introduction of the KWM-1. The Collins transceiver was born out of a workshop tinkering session by Gene Senti, WØROW, a company engineer. It went on to set the stage not only for Collins products, but for other manufacturers as well. Collins and the R.L. Drake Company continued to manufacture separate receivers and transmitters for another 20 years, but even these were designed to transceive when hooked together with the proper cables.

In the 1960s, almost every company making HF equipment added a transceiver to their lineup. Except for low-power and basic equipment, few separate transmitters and receivers could be found by the mid-'70s. Transceivers offered automatic TR switching, and many incorporated full break-in on CW. Some eventually took advantage of digital technology to include memories and multiple VFOs along with frequency readable down to a few cycles. The desk full of equipment had become a complete station capable of sitting on a shelf or hanging beneath the dashboard of an automobile. ■

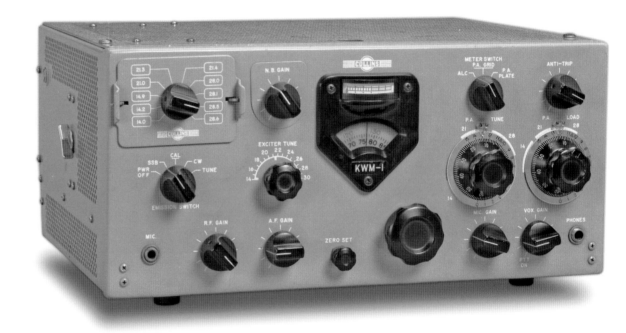

**ABOVE ◇ COLLINS KWM-1** Collins created a new category of ham gear when they introduced the KWM-1 in 1957. Although large, heavy receivers and transmitters would stay around for some time to come, the compact transceiver eventually changed the ham shack and the way amateurs operated. Designed initially as a mobile rig, Collins developed a line of accessories that made it a good candidate for fixed stations and portable work. Its major shortcoming, in the eyes of many amateurs, was that it operated only on 20, 15, and 10 meters. The KWM-1 used 24 tubes in a circuit that employed the famous Collins PTO and mechanical filter. Power output from the 6146 finals was 100 watts; $770.00. (1)

**RIGHT ◇ COLLINS KWM-2A** The KWM-2A added a second crystal deck and front-panel switch to the original KWM-2. The additional crystals permitted operation anywhere in the 3.4–5.0 and 6.5–30.0 MHz range. Factory KWM-2As had wide white bands above the exciter and PA tuning controls; $1250.00, 1961. (1)

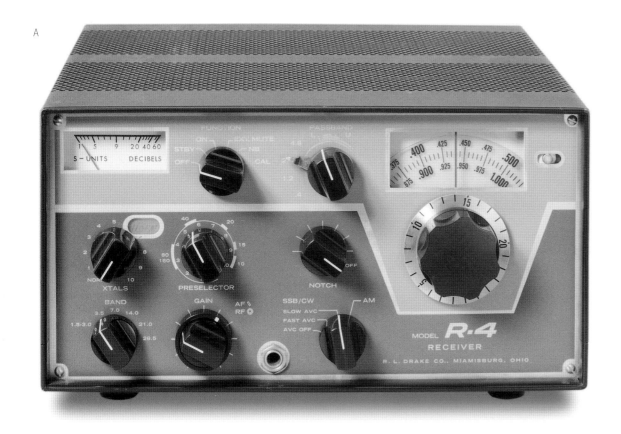

**A ◊ DRAKE R-4** Drake's R-4 receiver tuned fifteen 500 kHz ranges between 1.5–30 MHz (with the exception of 5 to 6 MHz) and was supplied with crystals for 80, 40, 20, 15 meters, and 28.5–29 MHz on 10 meters. The crystal switch had 10 spare positions for optional crystals. Its linear PTO had 1 kHz dial divisions. The double-conversion receiver had a first IF at 5645 kHz with a crystal lattice filter and a 50 kHz 2nd IF with L/C filtering. Its passband tuning offered bandwidths of .4, 1.2, 2.4, and 4.8 kHz. The R-4 used 13 tubes and 7 diodes. It had a noise blanker, notch filter, and crystal calibrator ($379.95, 1964). The Drake R-4A was similar in concept and appearance to the R-4, with some internal circuit changes, including a solid-state PTO. It was manufactured in both 11 and 13 tube versions ($399.95, 1966). The R-4B continued with the same basic setup of earlier R-4 receivers, but made increasing use of solid-state technology with 9 tubes, 10 transistors, 17 diodes, and 2 ICs. Solid-state devices were used in the PTO, crystal oscillator, AVC, BFO, crystal calibrator, and audio amplifier. There was a new tuning knob as well as cosmetic front-panel differences ($430.00, 1968).  (1)

**B ◊ DRAKE R-4C** The R-4C mirrored the basic appearance of its 4-Line predecessors, but it was a very different receiver. The new triple-conversion model used an 8 kHz wide roofing filter in the first IF at 5645 kHz. The 5695 kHz second IF had a standard 2.4 kHz crystal filter and space for three optional crystal filters ranging in bandwidth from .25–6 kHz. Two L/C circuits in the 50 kHz third IF followed. The passband tuning had been changed from mechanical to electrical. Additional flexibility was added to the AVC circuit; $499.95, 1973. (58)

**C ◊ DRAKE T-4 RECEITER** The Receiter was a receiver-controlled exciter. It was Drake's T-4X transmitter minus the PTO, designed to transceive with the R-4 receiver. It used a pair of 6JB6 tubes in the final and ran 200 watts PEP input on SSB. Input on CW was 180 watts, 50 watts on AM ($269.95, 1965). The T-4B was similar to the T-4 and was designed to transceive with Drake's R-4A and R-4B receivers ($350.00, 1968). (1)

**D ◊ DRAKE T-4XC** The T-4XC transmitter could transceive with any of the Drake 4-Line receivers, going back to the R-4. A front-panel switch selected the transmitter or receiver PTO, or allowed them to be used separately. The PTO had a new, more easily-read dial, and the mic input connector and VOX controls were moved from the side of the transmitter, where they had been located on the T-4XB, to the rear panel. Other changes included the replacement of vacuum tubes with solid-state devices in some circuits. Input power was 200 watts on SSB, CW, and controlled-carrier AM. The T-4XC had provisions for AFSK RTTY operation. The final amplifier was a pair of 6JB6As; $529.95, 1973. (1)

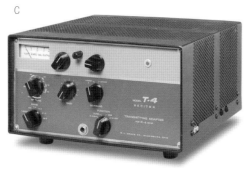

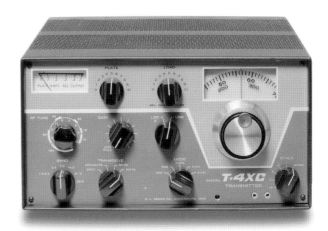

**A ◊ DRAKE TR-3** R.L. Drake's first transceiver used three 12BJ6 sweep tubes in its final amplifier to generate 300 watts PEP input. The TR-3 offered full coverage of 80–10 meters and featured linear PTO tuning. Although primarily designed for sideband operation, it could also be used on CW and controlled-carrier AM. A pair of 2.1 kHz crystal filters provided upper and lower sideband on transmit and receive. External power supplies were required for both mobile and fixed operation; $495.00, 1963. (1)

**B ◊ DRAKE TR-4 (LATE MODEL)** The Drake TR-4 transceiver had a solid-state PTO and used a pair of 9 MHz filters to permit upper and lower sideband selection without shifting oscillators. The TR-4 used three 6JB6s in the final amplifier. Power input was 300 watts PEP on SSB, and 260 watts on both CW and controlled-carrier AM. The transceiver provided full coverage of the 80-10 meter bands in seven 600 kHz ranges. Drake made its optional 34-NB noise blanker standard equipment on the later model TR-4 transceiver. A front-panel knob was added to control the blanker; $699.95, 1970. (1)

**C ◊ DRAKE TR-4C** The TR-4C used Drake's new C-Line dial and tuned the 80–10 meter bands in 600 kHz segments. Standard coverage on 10 was from 28.5 to 29.1 MHz. Accessory crystals were available for the remainder of the band. The final amplifier was three 6JB6s in parallel. It was rated at 300 watts PEP input on SSB, 260 watts CW, and 260 watts PEP controlled-carrier AM. A pair of filters in the 9 MHz IF were used for upper and lower sideband. The TR-4C eventually evolved to incorporate both a CW filter and RIT circuit; $599.95, 1973. (1)

**D ◊ DYNALAB TRI-BAND TRANSCEIVER** Dynalab's Tri-Band Transceiver Kit converted a Heath HW-12, HW-22, or HW-32 monobander into a tri-band transceiver covering the phone portions of the 75, 40, and 20 meter bands. Operation was lower sideband on 75 and 40, upper sideband on 20. All parts mounted inside the original transceiver cabinet, and a single extra hole was required in the panel for the band switch; $39.95, 1965. (1)

**E ◊ EICO 753** Eico offered their tri-band transceiver in kit form ($179.95) or factory-wired ($299.95). External supplies were required for AC or DC operation. Input power was 200 watts PEP. The 753 covered 80, 40, and 20 meters and could be used on AM and CW as well as sideband. The receiver's offset tuning allowed +/–10 kHz excursions from the transmit frequency; 1965. (1)

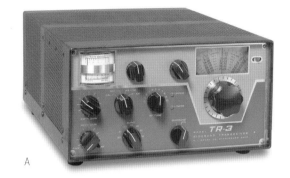

A

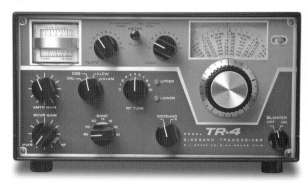

B

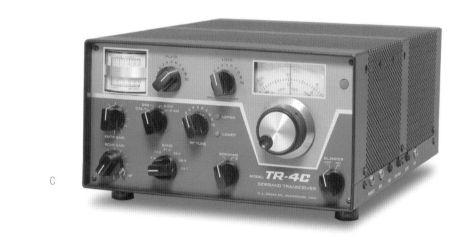

C

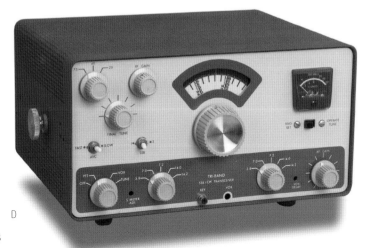

D

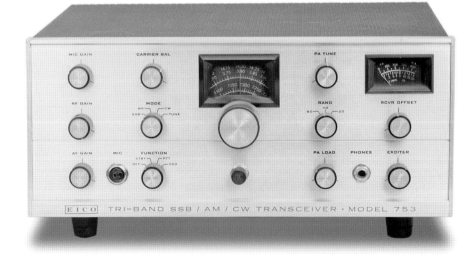

E

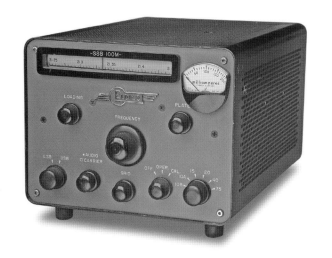

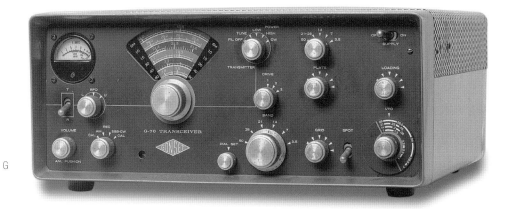

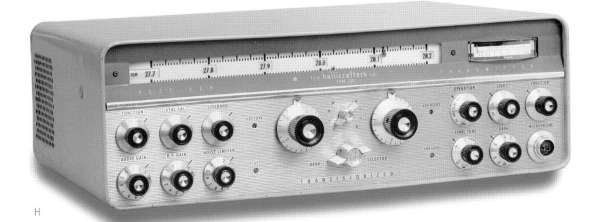

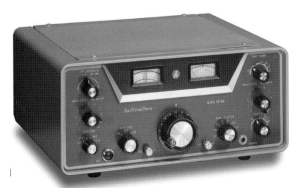

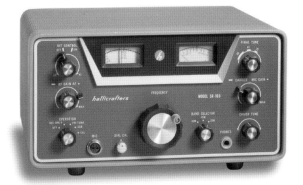

**F ◊ ELDICO SSB-100M** Eldico's 100 watt mobile sideband transmitter used a crystal lattice filter for sideband generation. Its VFO tuned 200 kHz portions of the 80–10 meter phone bands. The SSB-100M used 10 tubes, with a 5894 as the final amplifier; $400.00, 1958. (1)

**G ◊ GONSET G-76** Gonset's mobile transmitter/receiver ran 100 watts input AM and 120 watts CW on 80–6 meters. The transmitter and receiver had separate VFOs, and the transmitter was limited to crystal-controlled operation on 6 meters. Its final amplifier was a 6DQ5 with a pi-network. The G-76's receiver was double conversion with IFs at 2065 and 262 kHz. It had a separate transistorized 12 VDC power supply for mobile operation and a combination 117 VAC power supply/speaker cabinet for home use; $376.25, 1960. (22)

**H ◊ HALLICRAFTERS FPM-200** Hallicrafters announced an astonishing new radio in the summer of 1957. The FPM-200 was a full-featured transmitter/receiver for the 80–10 meter amateur bands on CW, AM, and SSB. The receiver section and low-level transmitter stages were solid-state. Its 6146 finals, their 12BY7 driver, and a pair of OB2 voltage regulators were the only tubes used. The FPM-200's dual PTOs provided linear tuning with calibration in 1 kHz increments. A front-panel switch enabled transceive operation with either PTO, as well as separate transmit and receive functions using both of them. The radio ran directly off 12 VDC. An internal multivibrator supply furnished high voltage for the tubes.

From the outset, Hallicrafters had trouble getting the FPM-200 to market. In fact, there is disagreement about whether it ever became a real production item at all. Estimates range from a total of about 50 to nearly 200. When it finally appeared in 1960, the FPM-200's price tag of $2660.00 represented more than $18,000.00 in 2008 currency. (1)

**I ◊ HALLICRAFTERS SR-150** Hallicrafters' transceiver offered coverage of 80–10 meters in eight 500 kHz bands. Six of the ranges were used for 80 through 15, plus one 500 kHz segment of 10 meters. The two additional ranges could be used to complete coverage on 10 or for non-amateur operation such as MARS. The SR-150 had RIT and used a crystal filter in its 1650 kHz IF. The circuit contained 11 solid-state devices and 19 tubes, including a 12BY7 driver and 12DQ6B finals. Power input was 150 watts SSB and 125 watts CW; $650.00, 1962. (48)

**J ◊ HALLICRAFTERS SR-160** The SR-160 was a tri-band transceiver covering 80, 40, and 20 meters. It used a pair of 12D6B finals. Power input was 150 watts PEP on SSB and 125 watts on CW; $349.50, 1963. (1)

A

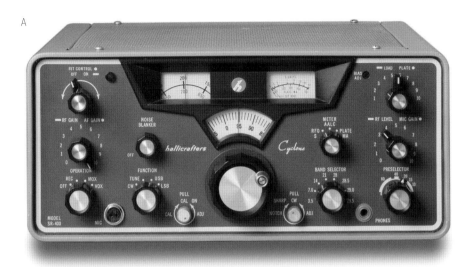

B

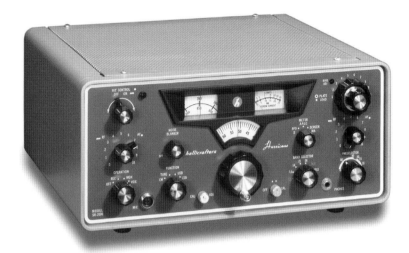

C

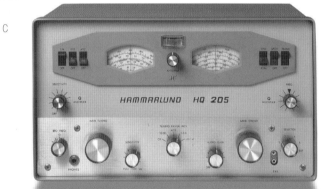

**A ◊ HALLICRAFTERS SR-400** The original SR-400 "Cyclone" transceiver from Hallicrafters ran 400 watts input on SSB and 360 watts on CW. It also had a 200 Hz CW filter. Other features included RIT and a noise limiter ($799.95, 1967). The SR-400A "Cyclone III" improved on the SR-400 with increased power and a factory-installed cooling fan. Input power to the 6DK6 finals was 550 watts on SSB and 350 watts on CW ($895.00, 1969). (31)

**B ◊ HALLICRAFTERS SR-2000** The SR-2000 "Hurricane" was Hallicrafters' legal-limit desktop station. The 2000 watt PEP SSB and 900 watt CW transceiver covered 80–10 meters, tuning the bands in 500 kHz ranges. Its double-conversion receiver incorporated RIT and shared a 1650 kHz crystal lattice filter with the transmitter. A pair of 8122s served as the transmitter's final amplifier. The P-2000 power supply was in a separate cabinet; $995.00, 1965. (48)

**C ◊ HAMMARLUND HQ-205TR** The HQ-205TR was advertised as a transceiver, but in reality was a general-coverage receiver sharing its cabinet with a 5 watt, crystal-controlled transmitter. The six-channel AM transmitter could be used on either the Citizen's Band or the 10 meter amateur band. The 11-tube receiver tuned .54–30 MHz; $259.00, 1967. (1)

**D ◊ HAMMARLUND HXL-ONE** The HXL-One linear amplifier used a pair of 572A triodes in grounded-grid. It had a self-contained solid-state power supply. Hammarlund boasted that the amp could be run "key down for more than an hour" at a kilowatt input. It covered 80–10 meters and was rated at 1500 watts PEP on sideband, 1000 watts on CW, and 250 watts on AM. A later version using 572B tubes ran 2 KW PEP; $395.00, 1963. (1)

**E ◊ HEATH HW-16** The HW-16 CW transceiver was aimed at the beginning ham. Its tunable receiver and crystal-controlled transmitter covered 80, 40, and 15 meters. The double-conversion receiver had a 500 Hz half-lattice crystal filter. It tuned the lower 250 kHz of each band. It had a built-in sidetone oscillator and used electronic antenna switching for true break-in operation. Transmitter power input was adjustable from 50 to 90 watts; $99.50, 1967. (1)

D

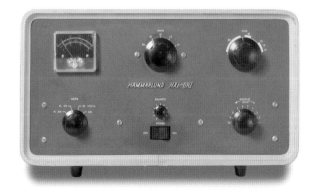

E

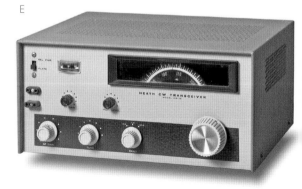

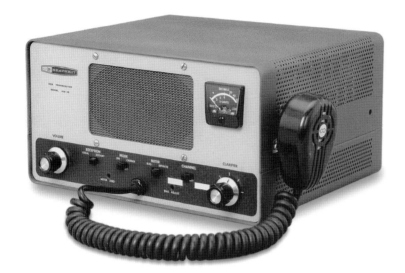

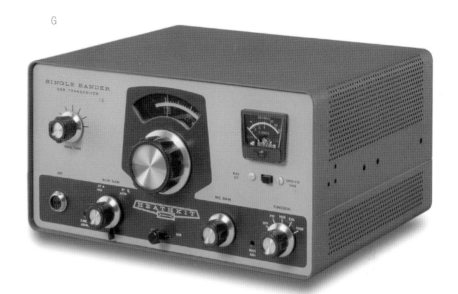

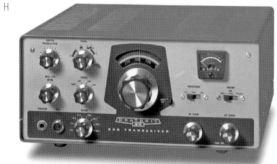

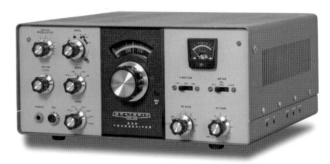

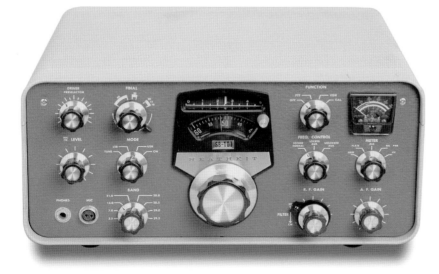

**F ◊ HEATH HW-18** Heath's two-channel SSB transceiver for 160 meters also came in versions for MARS and CAP frequencies. The HW-18 ran 200 watts PEP input on SSB and 25 watts AM with carrier for compatibility with stations using that mode. The transmitter and receiver each were locked to one of the rig's two crystal frequencies, but the receiver had RIT. The 160 meter version (HW-18-3) operated on lower sideband only. The local/distant switch prevented receiver overload on strong signals; $109.95, 1968. (1)

**G ◊ HEATH HW-22A** The Heath HW-12/22/32 "Singlebanders" covered the phone portions of 75, 40, and 20 meters, respectively. The 75 and 40 meter models used lower sideband only, while the 20 meter HW-32 used the upper sideband. The "A" versions of these transceivers received a cosmetic facelift and some new features. A switch was added to choose upper or lower sideband regardless of band. The mic gain control and connector were moved to the front panel and SB-series knobs were used on the controls; $99.95, 1966. (1)

**H ◊ HEATH HW-100** Heath's HW-100 transceiver covered 80–10 meters. It had a solid-state VFO and used a pair of 6146B finals. Input power was 180 watts PEP SSB and 170 watts CW. The IF was at 3395 kHz and the transmitter and receiver shared a 2.1 kHz filter. A CW filter was not offered as an option. The HW-100 required an external power supply; $240.00, 1968. (1)

**I ◊ HEATH HW-101** Heath's HW-101 added features to the HW-100 transceiver without an increase in price. They improved the dial drive mechanism and the receiver's performance. An optional 400 Hz CW filter was made available, and a front-panel switch was added to select it. Power input was 180 watts PEP on SSB and 170 watts on CW; $249.95, 1970. (1)

**J ◊ HEATH SB-101** The SB-101 added to the feature set of the SB-100. It offered an optional 400 Hz CW filter and added a front-panel switch to select it. Frequency flexibility was enhanced when the SB-101 was used with the SB-640 remote VFO. The transceiver could be controlled by the LMO in either unit, or the SB-101 could control the receiver and the SB-640 the transmitter. The SB-101 retained the SB-100's 80–10 meter coverage and 180 watts SSB/170 watts CW power input; $360.00, 1967. (1)

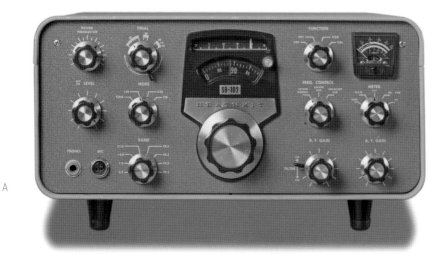

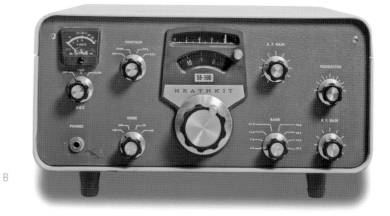

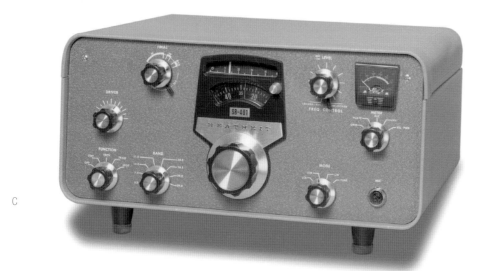

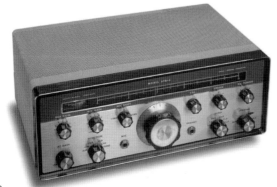

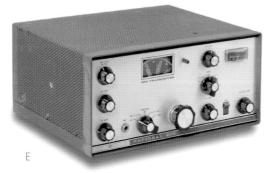

**A** ◊ **HEATHKIT SB-102** It was no mystery why Heath's SB series was often referred to as "the poor man's Collins." It bore a physical resemblance to the S/Line and there were circuit similarities as well. The SB-102 had a solid-state Linear Master Oscillator with 1 kHz dial calibration and a pair of 6146 finals for 180 watts input SSB and 170 watts CW. A 2.1 kHz crystal filter was standard and an optional 400 Hz unit was available. The SB-102 improved upon the stability and sensitivity of the SB-100 and 101, which preceded it; $380.00, 1970. (31)

**B** ◊ **HEATH SB-300** The SB-300 offered full coverage of 80–10 meters and also had provisions for optional VHF converters. The receiver was supplied with a 2.1 kHz SSB filter; 3.75 kHz AM and 400 Hz CW filters were available options. Installation of these filters was necessary for the SB-300 to operate with the mode switch in the AM or CW position. Reception of any mode was possible in the SSB position. The 10-tube receiver could transceive with the SB-400 transmitter with proper cabling ($264.95, 1964). The follow-up SB-301 receiver added an automatic noise limiter and a 15–15.5 MHz tuning range for WWV. A front-panel control was added for selection of the receiver's optional VHF converters. An RTTY position was added to the mode switch and circuits for FSK reception were improved ($260.00, 1966). (56)

**C** ◊ **HEATH SB-401** The SB-401 differed from the 400 in that when used with SB-301 or SB-300 receivers in the transceiver mode, it employed the receiver's heterodyne oscillator crystals. To work as a stand-alone transmitter, Heath's optional SBA-401-1 crystal pack was necessary. It was otherwise the same transmitter as the SB-400 with a few refinements. Among those were a front-panel switch to allow transceiver operation without cable swapping, the addition of a sidetone level control, and a change in LMO tubes from a 6AU6 to a 6BZ6; $285.00, 1966. (1)

**D** ◊ **ELMAC ATR-4** Only a few examples of Multi-Elmac's ATR-4 SSB transceiver were manufactured. The 80–10 meter rig ran 180 watts PEP input on SSB, 75 watts on AM, and 180 watts on CW with a pair of 6146s; $750.00, 1963. (1)

**E** ◊ **NATIONAL 200** The National 200 five-band transceiver was suitable for either mobile or home-station use. It featured complete coverage of the 80–10 meter bands and ran 200 watts PEP on SSB with a pair of 6JB6s. The National 200 also had CW and AM modes. A crystal lattice filter was used in its 5.2 MHz IF. The AC and DC power supplies were external; $359.00, 1966. (1)

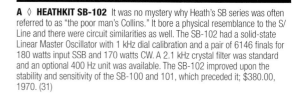
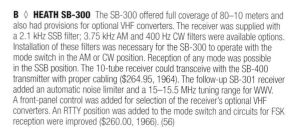
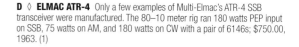

**F ◊ NATIONAL NCX-3** The NCX-3 transceiver covered the 80, 40, and 20 meter bands. It had PTT or VOX operation on SSB and break-in on CW. It was lower sideband on 80 and 40, upper sideband on 20. Power input was 200 watts PEP on SSB, 180 watts on CW, and 100 watts on AM. National's tri-band transceiver used 18 tubes and 6 diodes. The final amplifier was a pair of 6GJ5s; $369.00, 1962. (1)

**G ◊ NATIONAL NCX-5** The NCX-5's solid-state, capacitor-tuned VFO was linked to a mechanical digital readout, enabling the frequency to be read down to 100 Hz. A vernier control provided receiver offset tuning of +/–5 kHz. The NCX-5 used 15 semiconductors and 20 tubes. Power input to the 6GJ5 finals was 200 watts SSB/CW and 100 watts AM on 80 through 10 meters; $585.00, 1964. (48)

**H ◊ NATIONAL NCX-500** The NCX-500 was a full-featured transceiver produced after the National Company had become the National Radio Company, Incorporated (NRCI). The five-band transceiver ran 500 watts PEP on SSB, 360 watts on CW, and 125 watts on AM. The NCX-500 covered 80–10 meters, tuning each band in 600 kHz segments. Optional crystals were required for full coverage of 10 meters. Sideband selection was not available; the transceiver defaulted to the customary sideband. It had RIT and was supplied with a universal mobile mount. The final amplifier was a pair of 6LQ6 tubes; $399.00, 1968. (1)

**I ◊ NATIONAL NCX-1000** National's kilowatt transceiver sold for just less than a kilobuck. The NCX-1000 was all solid-state except for its driver and final. It was rated at 1000 watts PEP on SSB, 1000 watts DC on CW, and 500 watts on AM or RTTY. A pair of RCA 8122 tubes was used in the final. It covered 80–10 meters and the operator could use either sideband anywhere in this spectrum; $995.00, 1969. (55)

F

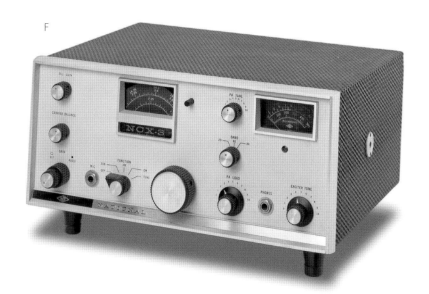

G

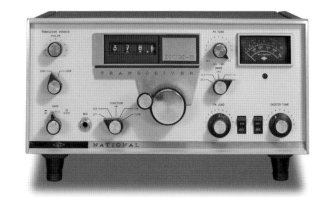

H

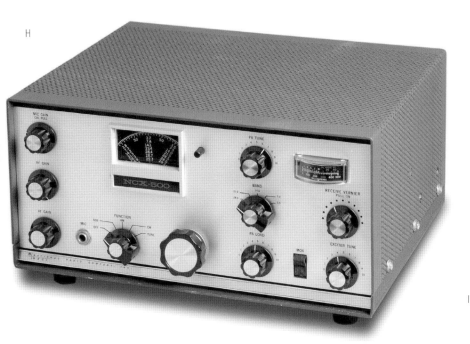

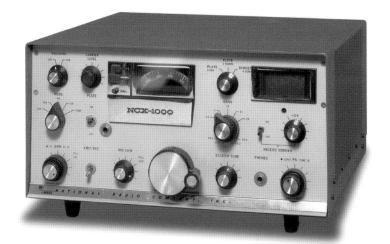

I

93

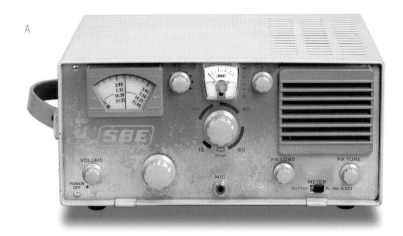

A

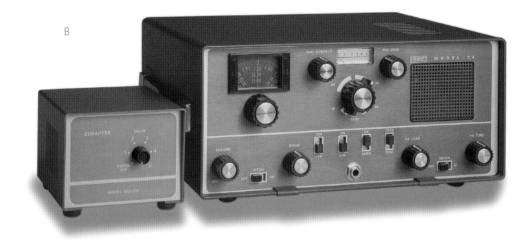

B

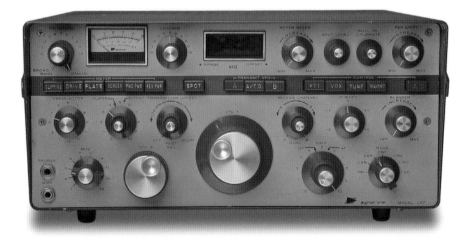

C

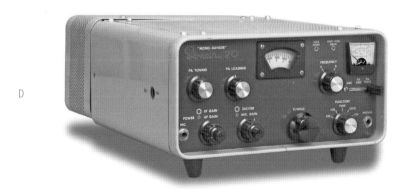

D

**A ◊ SIDEBAND ENGINEERS SB-33** Sideband Engineers, Inc. was started by Faust Gonsett, W6VR, after he left the company bearing his own name. SBE's first product was a compact sideband transceiver covering the phone portions of 80, 40, 20, and 15 meters. It used a Collins 2.1 kHz mechanical filter. The transceiver occupied less than one-half cubic foot and weighed 15 pounds. It had a self-contained 117 VAC power supply. Output power was 70 watts on the lower three bands and 50 watts on 15 meters. Low-level stages were solid-state, and only the driver and final amplifier used tubes; $389.50, 1963. (1)

**B ◊ SBE SB-34 & CODAPTOR** Faust Gonsett, W6VR, started Sideband Engineers in 1962 after retiring from the company that bore his name (Gonset). SBE's first product was an innovative transceiver, the SB-33, and a line of accessories soon followed. The SB-34 was announced in 1964. The new 135 watt transceiver was solid-state except for the driver and finals and covered 80–15 meters. The compact, 20 lb. package contained both AC and DC supplies and a Collins mechanical filter; $395.00. The Codaptor enabled CW by injecting a keyed tone at the SB-34's mic input; $39.95, 1965. (41)

**C ◊ SIGNAL/ONE CX-7** With the CX-7, Signal/One introduced the concept of the high-performance, integrated station. It included two PTOs, an IC keyer, an RF clipper, a noise blanker, and a 115/230 VAC power supply. The CX-7 covered the amateur bands between 1.8–29.7 MHz and optional crystals permitted operation on three other 1 MHz segments. The nixie-tube digital readout displayed frequency down to 100 Hz. The transceiver was solid-state except for the RCA 8072 output tube. The final amplifier was rated at 300 watts peak input. The output was broad-banded and manual tuning was necessary only when the load's SWR exceeded 1.5:1. The receiver used a pair of sharp filters and electronic IF shift. Signal/One was owned by ECI of St. Petersburg, Florida, a division of NCR ($2195.00, 1969). By the time the CX-7A debuted (1971), Signal/One had become a division of Computer Measurements, Inc. of Gardena, California. Other than the change of ownership, there was little difference between the CX-7 and CX-7A. (31)

**D ◊ SONAR 20** Brooklyn's Sonar Radio Company released a line of monoband SSB transceivers in 1962. The one shown is the 20 meter model. The transceivers ran 180 watts PEP input on sideband and 160 watts on CW. They used 2.1 kHz Collins mechanical filters and offered sideband selection, as well as VOX or PTT operation. The Model 20 mono-bander is shown with the optional "piggy-back" AC supply; $395.00. (1)

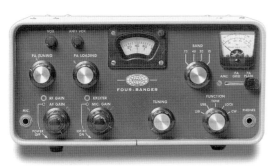

E

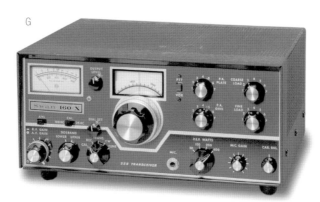

G

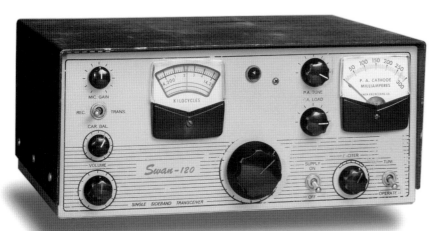

F

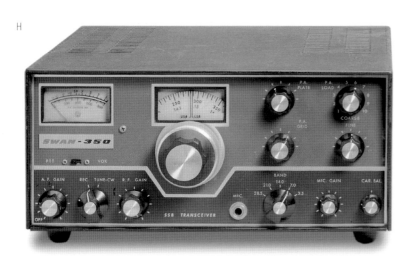

H

I

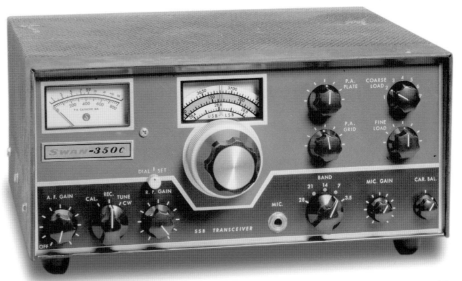

**E ◊ SONAR FOUR-BANDER** Sonar expanded on its mono-bander theme with the "Four-Bander" transceiver. It covered 80, 40, 20, and 15 meters. It used the 2.1 kHz Collins filter and had a 100 kHz calibrator. Power input was 200 watts PEP SSB and 180 watts CW; $495.00, 1962. (22)

**F ◊ SWAN SW-120** Herb Johnson, then W7GRA, built the first Swan transceivers in his Benson, Arizona garage. They were single-band affairs, and the first ones completed were SW-120 models for the 20 meter band. The 40 meter SW-140 and SW-175 for 75 meters followed. They ran 120 watts PEP with a 6DQ5 final. The transceivers' VFOs covered the phone portion of their respective bands; $275.00, 1961. (38)

**G ◊ SWAN 160-X** Swan designed the 160-X for the top band operator. The SSB transceiver covered 160 meters only. It used 13 tubes, 7 transistors, and 11 diodes. The VFO tuned 1.8–2.0 MHz and was calibrated in 1 kHz increments. A panel switch selected among power levels of 50, 100, 200, and 400 watts PEP to keep the operator in compliance with geographical restrictions; $469.95, 1971. (1)

**H ◊ SWAN 350** The Swan 350 made its debut in late 1964 and continued to evolve for another 15 years. The original 350 covered 80 through 10 meters, operating on the sideband customary for a particular band. A kit was available to enable sideband selection. SSB power input was 400 watts, with 320 watts on CW, and 125 watts on AM. The Swan 350's VFO was transistorized and the transceiver also used 16 tubes, including a pair of 6HF5 finals; $420.00. (1)

**I ◊ SWAN 350C** Swan's 350C followed the 350 with an increase in power, but not an increase in price. The new rating on SSB was 520 watts PEP, 360 on CW. The AM rating remained the same at 125 watts. The final amplifier had been changed to a pair of 6LQ6s. The Swan 350C owner still had to do without things such as sideband selection, CW sidetone, a crystal calibrator, and noise limiter. As with its predecessor, an external power supply was required; $420.00, 1968. (1)

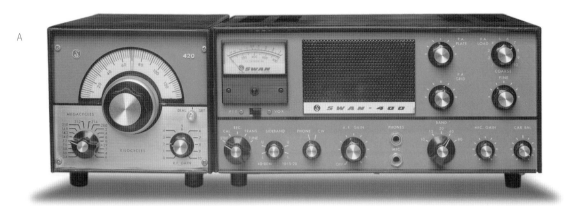

A

**A ◊ SWAN 400 & 420** The Swan 400 transceiver had no internal VFO. It was designed to use the model 420 VFO, which provided complete coverage of the 80–10 bands, or the model 406 VFO, which covered the American phone portions of 80–15 meters and two 200 kHz segments of 10 meters. The Swan 400 was rated at 400 watts PEP on SSB, 320 watts on CW, and 125 watts on AM; $375.00, 1964. (31)

**B ◊ SWAN 500** The 500 transceiver was the top of the Swan line when it was introduced in 1967. It offered selectable sidebands, a crystal calibrator, an automatic noise limiter, provision for an internal speaker, and a factory-installed socket for the 410 remote VFO. Power input was 480 watts PEP on SSB, 360 watts CW, and 125 watts AM. It also featured complete coverage of the 80–10 meter bands; $495.00. (1)

**C ◊ SWAN 500C** Using a pair of 6LQ6 tubes in its final, the Swan 500C transceiver was conservatively rated at 520 watts PEP. The transceiver used 17 tubes, 3 transistors, and 10 diodes. With the addition of Swan's VX-2 accessory, it had VOX operation on phone and semi-break-in on CW; $520.00, 1968. (38)

**D ◊ SWAN 500CX** The Swan 500CX was a 550 watt, five-band transceiver. Its receiver was single conversion, but the 5.5 MHz IF prevented image problems. Changes from the 500C model included improved AGC and product-detector circuits, and a crystal calibrator with both 25 and 100 kHz markers. The unit pictured also has the optional SS-16B IF crystal filter installed; $549.00, 1970. (1)

**E ◊ SWAN 700-CX** The Swan 700-CX covered the 80–10 meter bands using CW, AM, and SSB modes. It had the familiar single-conversion scheme with a 5.5 MHz IF proven in thousands of Swan transceivers before it. SSB input was a substantial 700 watts PEP with a pair of 8950 finals. The 700-CX featured sideband selection, a 25 and 100 kHz calibrator, and a CW sidetone monitor. An external power supply and speaker were required; $569.95, 1973. (1)

**F ◊ SWAN CYGNET 260** The Cygnet 260 had internal power supplies for both 120 VAC and 12 VDC. Its solid-state VFO provided full coverage of the 80–10 meter bands. Early models, such as the one pictured, used a green tuning eye to indicate PA current and mic gain. They also had the hand-held microphone hard-wired to the transceiver. Later versions of the Cygnet 260 had a jack for the microphone and a small current meter. Power input to the 6LQ6 final was 260 watts PEP on SSB and 180 watts on CW. The transceiver had no audio gain control but used the RF gain to set the volume; $395.00, 1969. (1)

**G ◊ SWAN CYGNET 270** The Cygnet 270 was the same size and had the same power as the 260 that came before it, but added new features and performance. The 270 had an S-meter/transmitter tuning meter, selectable sidebands, an improved CF Networks filter, and separate RF and AF gain controls. It offered full coverage of the 80–10 meter bands and also retained the Cygnet 260 internal AC and DC power supplies; $525.00, 1969. (1)

**H ◊ SWAN CYGNET 300B** The 300B "Cygnet De Novo" freshened up Swan's Cygnet transceiver series with a built-in AC supply, an internal speaker, CW sidetone, and break-in capability with the optional VOX accessory. It ran 300 watts PEP and covered 80–10 meters; $499.95, 1973. (1)

B
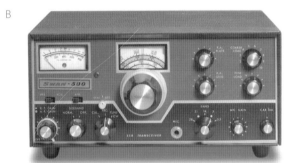

C
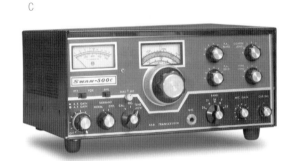

D
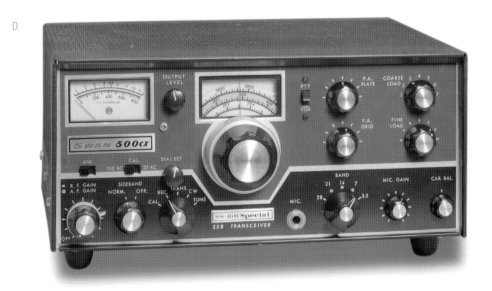

E

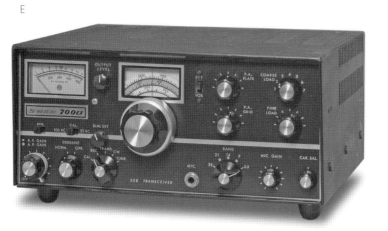

F

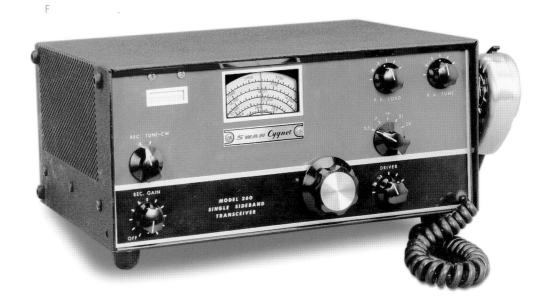

G

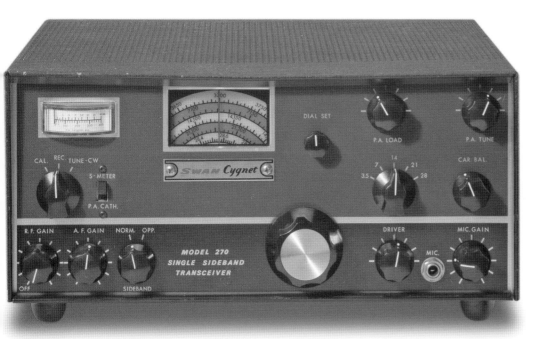

H

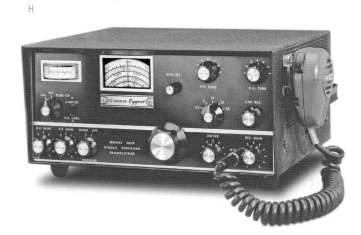

A

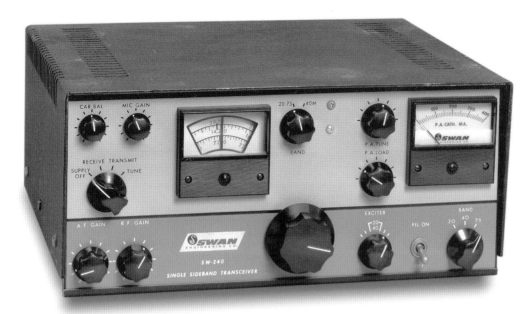

C

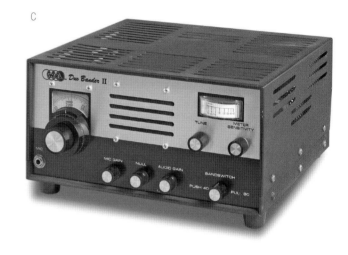

B

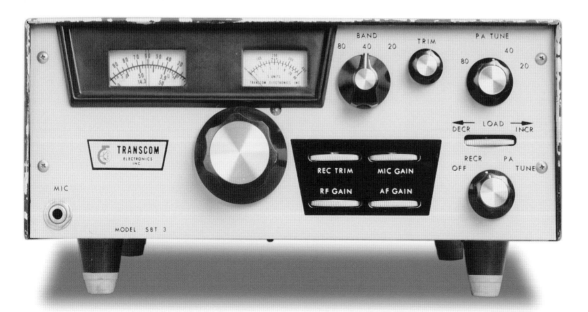

D

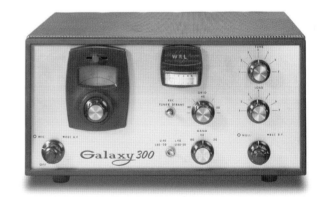

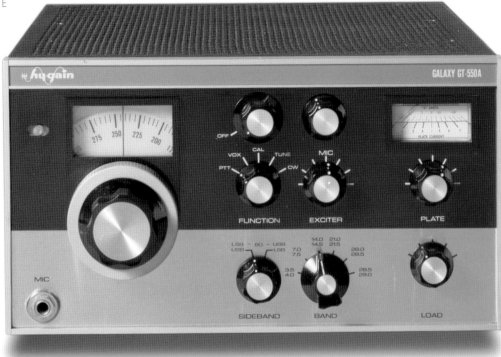

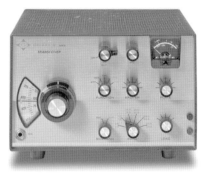

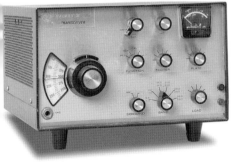

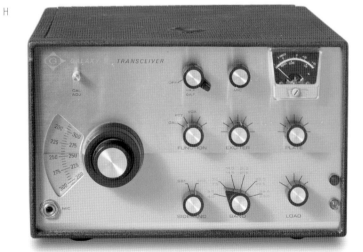

**A** ◊ **SWAN SW-240** The frequency coverage of Swan's 15-tube transceiver was centered on the phone portions of the 75, 40, and 20 meter bands. It was lower sideband only on 75 and 40, upper sideband on 20. An optional accessory was necessary to use the other sideband. Power input was 240 watts SSB, 200 watts CW, and 60 watts carrier power on AM with a 6DQ5 final; $320.00, 1963. (1)

**B** ◊ **TRANSCOM SBT-3** The Transcom SBT-3 transceiver covered the phone portions of 75, 40, and 20 meters. It used 18 transistors and ran 165 watts PEP input to its final. The tubes used, a pair of 8042s, were instant-heating types and the filaments remained off during receive cycles. The SBT-3 operated on the normal sideband to which it was tuned. It required a separate power supply. Transcom Electronics, Inc. was located in Escondido, California; $299.50, 1965. (1)

**C** ◊ **WRL DUO-BANDER II** The Duo-Bander II worked lower sideband on 80 and 40 meters. It was rated at 400 watts PEP input. The transistorized VFO tuned the phone portions of both bands. It had a built-in speaker; $169.95, 1969. (1)

**D** ◊ **WRL GALAXY 300** The Galaxy 300 transceiver covered the phone portions of 80, 40, and 20 meters. It ran 300 watts PEP input on SSB and 175 watts on AM. It used a 9.1 MHz crystal filter and offered selectable sideband operation. PTT was standard and VOX was available as an option; $299.95, 1963. (1)

**E** ◊ **WRL GALAXY GT-550A** The GT-550 series was based on the Galaxy V Mk III transceiver and bore the Galaxy logo. The GT-550A came from Hy-Gain Electronics in Lincoln, Nebraska and displayed that company's logo. Other differences included a minor change in color scheme and a new tuning knob; $495.00, 1971. (51)

**F** ◊ **WRL GALAXY V MK II** The Mk II version of the Galaxy V introduced a solid-state VFO and changed the final tubes to a pair of 6HF5s. Power input increased to 400 watts PEP; $420.00, 1967. (1)

**G** ◊ **WRL GALAXY V MK III** Galaxy upped the horsepower of their Galaxy V transceiver by changing the final tubes to a pair of 6LB6s in the Mk III. The grid/cathode circuit for driving the finals was redesigned and the ALC circuit improved. SSB input power was 500 watts; $420.00, 1968. (22)

**H** ◊ **WRL GALAXY V** Galaxy Electronics was formed by World Radio Laboratories' Leo Myerson, WØGFQ, in 1962. The Galaxy V was a 300 watt PEP transceiver covering 80–10 meters. The VOX as well as the receiver's audio and AVC circuits were solid-state. The price, not including the separate power supply, was $399.95. The Galaxy III, a similar transceiver covering only 80, 40, and 20 meters, sold for $349.95, 1964. (51)

# Era Seven

# Solid State

Until 1947, communications technology closely tracked the evolution of the vacuum tube. In December of that year, Bell Laboratories announced something called the transistor. Two-port solid-state devices had been used in the WW II era, but the little three-legged transistor opened wider vistas than anyone could have imagined.

Its inventors, John Bardeen, Walter Brattain, and William Shockley, were awarded the Nobel Prize in 1956. The first transistor radio, the Regency TR-1, appeared in October 1954. It was a broadcast-band set using four Texas Instruments transistors. TI did the design work, but farmed it out to Regency for production.

A number of small construction projects using the transistor were published in Amateur Radio literature in 1952 and '53. Regency introduced the first commercial transistorized ham product in 1956. The ATC-1 converter covered 80 through 10 meters. Hallicrafters announced the FPM-200 in 1957, but the elaborate and expensive transceiver was not actually produced until 1961, and then only in limited numbers. The FPM-200 was all-transistor except for the driver, final amplifier, and voltage regulator tubes. Several other companies used this hybrid arrangement in their HF transceivers through the 1960s.

In 1969, Ten-Tec made a series of solid-state modules that could be used to construct a low-power CW transmitter or direct-conversion receiver. The following year, the company combined the modules and sold them as PowerMite transceivers. In 1971, Ten-Tec unveiled the Argonaut, a 5-W sideband and CW transceiver. A companion solid-state 50 W amplifier followed in '72. The company launched a milestone product in 1973--the Triton. It was a full-featured, all-solid-state SSB and CW HF design offered in both 100- and 200-W input models. ∎

---

**BELOW LEFT** ◊ **ALDA 103** The Alda 103 was a three-band, solid-state transceiver. Input power on 80, 40, and 20 meters was 250 watts on SSB and CW. The output was about half that. It used modular construction with plug-in circuit boards and required an external 13.8 VDC power source; $495.00, 1978. (1)1961. (1)

**BELOW** ◊ **ATLAS 350XL** The 350XL was Atlas's most ambitious product yet. It ran 350 watts input on 160–10 meters. The production model lacked the filter flexibility advertised while the transceiver was under development, but it did offer options such as a digital dial and an auxiliary VFO that mounted in the front panel. The 350-XL shown has both of these options. The 350-XL was priced at $995.00; DD6-XL dial $229.00; 305 Auxiliary VFO $155.00, 1977. (1)

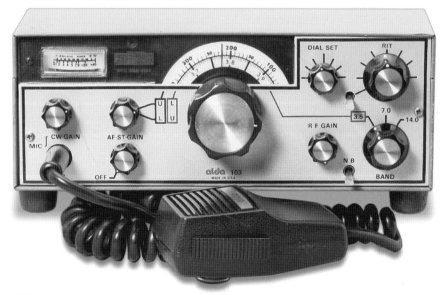

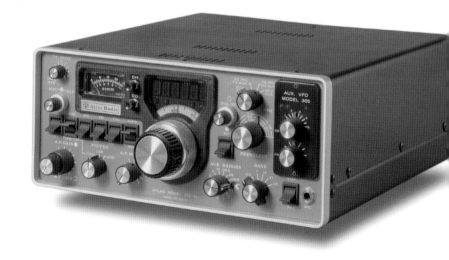

A
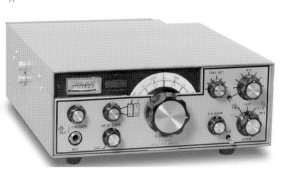

D
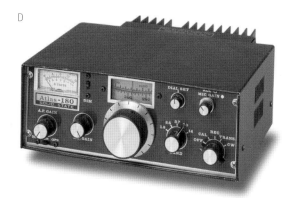

**A** ◊ **ALDA 105** The the Alda 105 was similar to the company's 103 model but added five-band, 80–10 meter coverage. SSB input power was 250 watts; $795.00, 1979. (1)

**B** ◊ **AMECO R-5** The Ameco R-5 was completely solid-state and covered .54–54 MHz in five bands. It had an internal AC supply but could also operate from batteries. The R-5 had electrical band spread, an adjustable BFO, and a noise limiter; $79.95, 1967. (1)

**C** ◊ **AMERICAN STATES MINI-MITTER II** The Mini-Mitter II was a handheld 40 meter SSB transceiver. The Mini-Mitter was made by American States Electronics of Mountain View, California, a company owned by Al Clark, W6IHY. The handheld unit used three ICs, 15 transistors, and had a Collins mechanical filter. PEP output was 4 watts, upper or lower sideband. A 75 meter model was also advertised. The transceiver was sold in kit form; $149.95, 1971. (1)

**D** ◊ **ATLAS 180** The Atlas 180 covered 160, 80, 40, and 20 meters. The solid-state SSB/CW transceiver ran 180 watts input; $479.00, 1974. (1)

**E** ◊ **ATLAS 215X LE** After the end of 210X/215X production and the appearance of the 350XL, Atlas made a 215X "Limited Edition" model until existing parts for the discontinued models ran out.. It was given some cosmetic changes and an RIT control was added. Power was increased to 250 watts input. Unlike earlier 215X models, this one covered 80–10 meters. Some Limited Edition models carried the 210X/LE tag; $810.00 1979. (1)

B
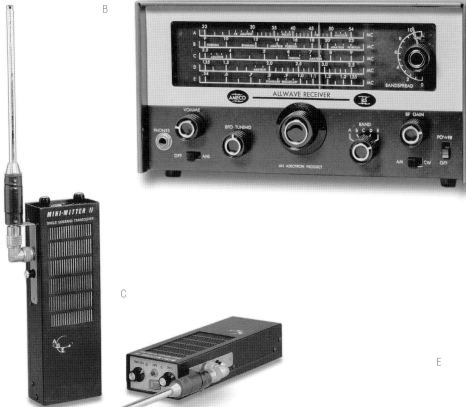

C

E
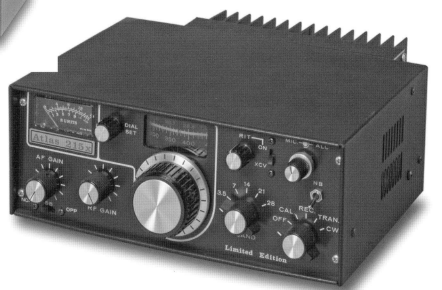

A

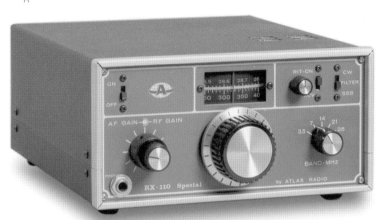

B

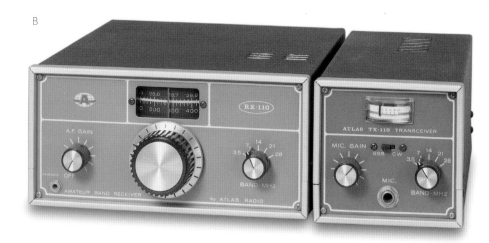

C

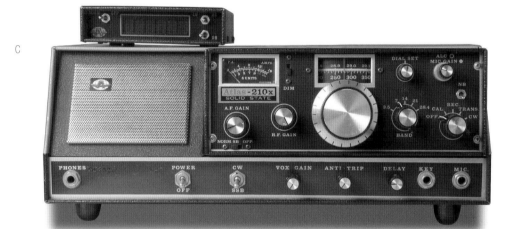

**A ◊ ATLAS RX-110 SPECIAL** Further development of the RX-110 receiver saw the addition of an RF gain control, RIT, and a CW filter; $299.00, 1979. (1)

**B ◊ ATLAS RX-110/TX-110** The solid-state Atlas RX-110 receiver covered 80–10 meters and received the "normal" sideband only on each band. It had a built-in speaker and AC supply. Adding the TX-110 transmitter module turned the RX-110 into a CW and SSB transceiver. The receiver's VFO was used for frequency control. The transmitter came in two models: low power (15 watts input) and high power (200 watts). The RX-110 was $229.00; TX-110H $249.00; TX-110L $159.00, 1978. (1)

**C ◊ ATLAS 210X, VOX CONSOLE & DD-6** The 210X followed Atlas design practice by using a doubly balanced mixer, and no RF amp, in the receiver's front end. Its VFO tuned a different range for each band. The transceiver lacked RIT and the CW mode was mostly an afterthought. Power input was 200 watts. The 210X offered full coverage of 80–15 meters and a 1 MHz segment of 10. Its 215X sibling covered the 160 through15 meter bands but was otherwise identical. The VOX circuit was housed in the lower section of the AC console. The DD-6 dot-matrix digital frequency display read to 100 Hz. The 210X or 215X was $649.00; VOX $45; DD-6 $199.00, 1975. (1)

**D ◊ CIR ASTRO 200A** The Astro 200A added to the features found in CIR's Astro 200. It had up/down tuning buttons on the handheld microphone, an improved noise blanker, high SWR protection, and an illuminated meter. The synthesized 200 watt SSB/CW transceiver tuned the 80–10 meter bands in 100 Hz steps. A noise blanker, VOX, and speech processor were built-in; $1095.00, 1978. (1)

**E ◊ CLEGG ALL-BANDER** The AB-144 All-Bander from Clegg Communications up-converted frequencies from 100 kHz–30 MHz to the 2 meter band. Owners of multi-mode 2 meter transceivers or receivers could use them to receive the LF/HF spectrum. The model MB-28-9 All-Bander gave ham-band-only receivers or transceivers continuous coverage of 100 kHz–18 MHz. Neither All-Bander had transmit capability; $129.95, 1979. (1)

E

D

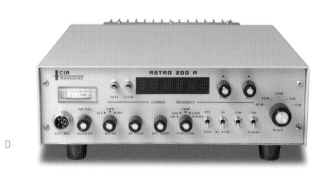

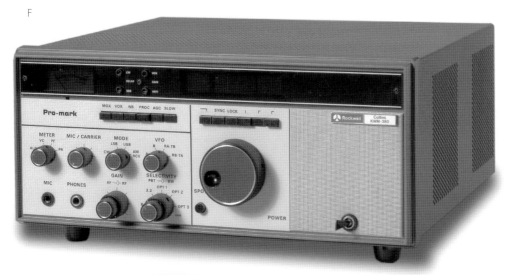

F

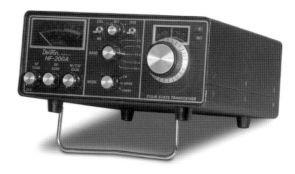

I

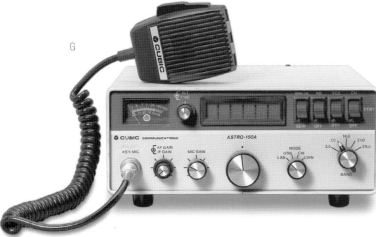

G

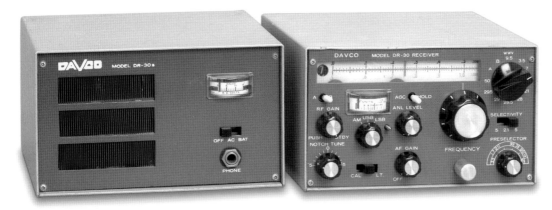

H

**F ◊ COLLINS KWM-380** Collins took several interesting turns as they looked for a replacement for the S/Line and KWM-2. Manufacture of the KWM-2 continued more than 20 years after it was introduced. The transceiver that succeeded it was nothing like the 'M-2. In fact, the KWM-380 was unlike anything else! Collins introduced the amateur, military, and commercial markets to technology and construction that had much in common with computers. Art Collins had been gone from the company seven years when the KWM-380 was introduced, but it still represented the future as he envisioned it. The new transceiver was solid-state, synthesized, and ran on digital technology. It covered .5–30 MHz in 10 Hz steps but had no band switch. The frequency range of interest was selected with the variable-rate main tuning knob. It was limited to the amateur bands on transmit. Output power was 100 watts on SSB and CW. It received, but did not transmit, AM. The internal power supply could be strapped to work from 105–250 VAC or 12–15 VDC; $2995.00, 1979. (51)

**G ◊ CUBIC ASTRO-150A** The Cubic Astro-150A started life as the Swan Astro-150. The 100 watt output, 80–10 meter transceiver became part of Cubic Communications' product line in 1980. Its most significant feature was the "Variable Rate Scanning" tuning knob in the center of the front panel. It was not a tuning knob in the conventional sense, but caused the synthesizer to move up or down in frequency. Turning it clockwise moved up in frequency, counter-clockwise, down. The degree to which the knob was rotated from its center detent determined how fast it scanned. The buttons on the microphone tuned up or down in fixed 100 Hz steps, while the VRS knob made the frequency change appear continuous; $925.00, 1967. (1)

**H ◊ DAVCO DR-30 & DR-30S** Measuring 4" x 7" x 6", the DR-30 packed all-transistor circuitry, a Collins mechanical filter, and sophisticated construction into a small package. The DR-30 was the brainchild of Everest McDade, W4DYW, and James Lovette, K4BXO. The double-conversion receiver tuned the 80–6 meter bands plus WWV in ten 500 kHz ranges. A pair of additional ranges covered optional user-selected frequencies. The DR-30S contained a 110/220 VAC power supply, a DC supply consisting of nine D-cell batteries, and a speaker. Advertising and reviews of Davco's receiver appeared sporadically in amateur periodicals between 1964 and 1967 as the company navigated turbulent business waters. The 1967 price of the DR-30 was $389.50; the DR-30S was $39.50. (1)

**I ◊ DENTRON HF-200A** The HF-200A solid-state transceiver covered 80–10 meters with 200 watts input power. The HF-200A used a six-pole crystal filter in its 9 MHz IF. The power amplifier was meant to work into a 50 ohm load and had no high-SWR protection feature; $699.50, 1979. (38)

103

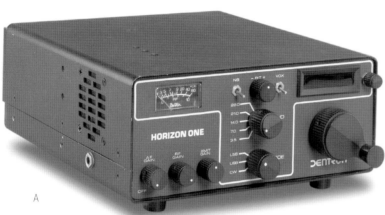

A

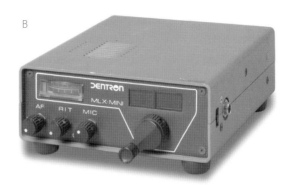

B

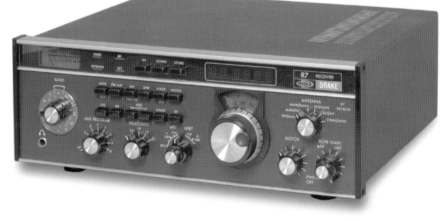

C

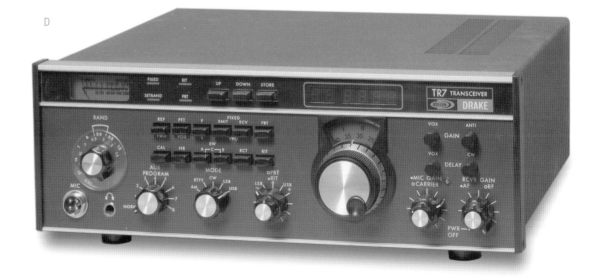

D

**A ◊ DENTRON HORIZON ONE** The all-solid-state Horizon One transceiver covered 80–15 meters and any 500 kHz segment of 10 meters. Power output was 100 watts on 80 through 15 meters, 80 watts on 10 meters; $599.00, 1980. (1)

**B ◊ DENTRON MLX-MINI** The 25 watt MLX-Mini CW and SSB transceivers covered any one amateur band from 160–6 meters. They required a 12 VDC power source. A few dozen MLX-Minis reached the marketplace, all either 80, 40, or 20 meters; $229.50, 1980. (1)

**C ◊ DRAKE R-7** The R-7 receiver provided continuous tuning from 0–30 MHz. It used the same PTO/synthesizer setup as the TR-7 and could be paired with it as an outboard receiver. It had a tunable IF notch as well as a wide selection of optional filters. The R-7's power supply could operate from 100, 120, 200, and 240 VAC or from 13.8 VDC. General-coverage use required the DR-7 board; $1295.00, 1979. (1)

**D ◊ DRAKE TR-7** The R.L. Drake Company introduced the TR-7 transceiver and 7-Line equipment in the spring of 1978. The TR-7 used a combination of synthesizer and PTO frequency control. All circuits were solid-state and broadbanded. It covered the 160–10 meter amateur bands and, with the addition of accessories such as the DR-7 and Aux-7, provided continuous receiver coverage from 0 to 30 MHz. The basic TR-7 had an analog dial and the DR-7 General Coverage/Digital Readout board was necessary for the digital dial and continuous 1.5–30 MHz tuning. The TR-7 used up-conversion and a 48 MHz first IF. The transmitter was rated at 250 watts input on CW and SSB. It also transmitted AM using the upper sideband and 80 watts carrier power; basic TR-7, $886.00, TR-7 with DR-7 board, $1072.00. (1)

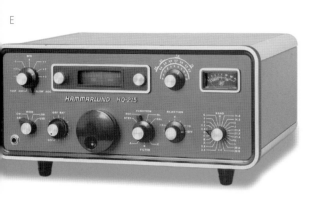

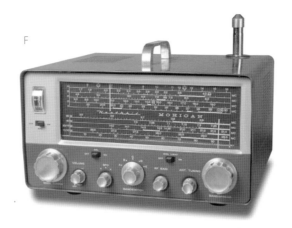

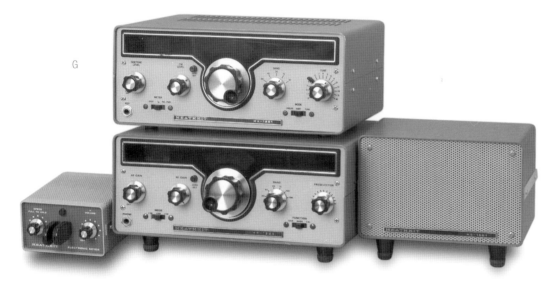

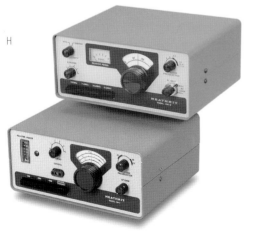

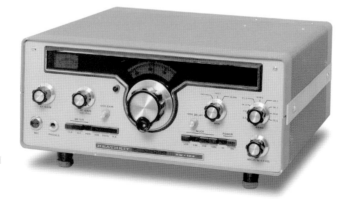

**E ◊ HAMMARLUND HQ-215** With the proper crystals, the HQ-215 could tune any 200 kHz segment between 3.4 and 30.2 MHz. The all-solid-state receiver came equipped with crystals for the 80–15 meter ham bands and 28.5–28.7 MHz on 10 meters. A 2.1 kHz mechanical filter was standard and options included .5 and 6 kHz filters. Hammarlund advertised the HQ-215's transceive capability but sold no companion transmitter. The receiver's HF oscillator and VFO frequencies suggest it could have been used with Collins S/Line transmitters; $529.50, 1968. (1)

**F ◊ HEATH GC-1** The GC-1 "Mohican" general-coverage, solid-state receiver used 10 transistors. It had ceramic transfilters in its 455 kHz IF. They served in place of the transformer, inductive, and capacitive components used in conventional circuits. The GC-1 covered .55–30 MHz in five bands. Its slide-rule dial carried electrical band-spread calibration for the 80–10 meter amateur bands. The Mohican was designed for portable operation. It had a 54-inch telescoping antenna and was powered by eight C batteries; $99.95, 1960. (1)

**G ◊ HEATH STATION** A "mostly" solid-state Heathkit transmitter/receiver station is shown here. The HR-1680 receiver ($199.95, 1976) and HX-1681 transmitter ($239.95, 1979) are a matching pair, although they were not introduced at the same time. The all-solid-state receiver had an analog dial and covered 80–15 meters in 500 kHz segments. Two segments covered the lower 1 MHz of 10 meters. The double-conversion superhet had a four-pole SSB crystal filter and an audio active filter for CW. The companion HX-1681 transmitter was solid-state except for its 12BY7 driver tube and the pair of 6146s used in the final. Power output was 100 watts on 80–15 meters and 80 watts on 10. Coverage on 10 was limited to the lower 500 kHz, with complete coverage on the other bands. The CW-only transmitter featured QSK. Heath's solid-state HD-1410 keyer ($59.95, 1975) could be wired for either of two speed ranges (10–35 wpm or 10–60 wpm) during construction. It had a built-in power supply, paddles, and monitor speaker. The HS-1661 ($22.95, 1975) with its 5" × 7" speaker completed the station. (1)

**H ◊ HEATHKIT HW-7 & HW-8** Heath's HW-7 QRP CW transceiver debuted in 1972. It covered 80, 40, and 20 meters with power inputs of 3, 2.5, and 2 watts, respectively. It had a direct-conversion receiver, and the transmit frequency could be controlled by either the receiver's VFO or a crystal. The HW-8 followed in 1976, improving upon the earlier rig. Heath's designers retained the direct-conversion receiver but added a JFET RF amp, a doubly balanced IC product detector, and an active CW audio filter. The HW-8 also included an RF gain control, coverage of 80 meters, and an S-meter. Power output on all bands was about 2 watts. The HW-7 kit sold for $79.95; the HW-8 was $129.95. (1)

**I ◊ HEATH HW-104** The HW-104 was a budget version of the SB-104 and shared many of the more expensive model's features, although not the digital dial. Its broad-banded coverage extended from 80 meters to 29.0 MHz on 10 meters. The HWA-104-1 accessory was required for complete coverage up to 29.7 MHz. The HW-104 had a band-switch position for 15 MHz WWV, but there was no provision for the WARC bands. SSB and CW output from its solid-state finals was 100 watts; $539.95, 1975. (1)

**A ◊ HEATH SB-104** The announcement of Heath's SB-104 and its accessories marked the company's most elaborate product introduction to date. It also heralded the arrival of a somewhat-flawed product, an all-solid-state transceiver that Heath never managed to get "quite right." The SB-104 was totally broad-banded and provided "no-tune" coverage of 80–10 meters. Its six-digit dial read to 100 Hz and displayed a mix of VFO, HFO, and BFO frequencies. Most of the transceiver's components were mounted on 15 circuit boards. It operated directly from 12 VDC, and its four final-amplifier transistors provided 100 watts output on SSB and CW; $669.95, 1974. (1)

**B ◊ HEATH SB-303** The SB-303 was completely solid-state, the first such radio in Heath's SB series. It covered the 80–10 meter ham bands in 500 kHz segments, using four segments on 10 meters. A band-switch position for 15 MHz WWV was included. A standard 2.1 kHz sideband IF filter was included; optional 3.75 kHz AM and 400 Hz CW filters were available. The mode switch did not work in the AM or CW positions without the optional filters; $319.95, 1970. (1)

**C ◊ KACHINA COMMUNICATIONS KACHINA 1** In the late 1970s, Kachina Communications of Sedona, Arizona manufactured a compact SSB/AM transceiver that covered 6 and 10 meters. SSB power input was 75 watts PEP on 10 meters and 65 watts on 6. AM input was about 18 watts on both bands. The receiver featured a noise blanker and squelch. The transceiver tuned in 1 MHz segments. In addition to the 6 and 10 meter bands, it also tuned from 26–28 MHz, spectrum that not been allocated to the amateur service for a quarter-century! Kachina Communications sold the manufacturing rights to Palomar Electronics, who produced the transceiver under their own name. It was given a cosmetic facelift and minor front panel changes. Looking closely at the area to the right of the dial, it is still possible to see the not-too-cleverly painted-over Kachina logo. (1)

**D ◊ KANTRONICS 8040-B** The 8040-B was an 80 and 40 meter direct-conversion receiver. Its frequency coverage was 3.650–3.760 and 7.050–7.150 MHz; $79.95, 1979. (1)

**E ◊ KANTRONICS FREEDOM VFO** The Freedom VFO had enough RF output to drive older tube transmitters such as the DX-60 or Viking Adventurer. It tuned from 3.65–3.75 and 7.0–7.2 MHz; $69.95, 1978. (1)

**F ◊ KANTRONICS ROCK HOUND** Kantronics' Rock Hound transmitter measured 3-1/2" × 4" × 1-1/2" and generated a 1 watt CW signal on 40 meters; $19.95, 1978. (1)

**G ◊ KLM FORCE 5** KLM's synthesized 80 through 10 meter transceiver had no conventional tuning knob but used up/down and slow/fast front-panel switches for frequency control. Tuning could also be done with buttons on the rig's handheld microphone. It was primarily a sideband transceiver, but CW was available when it was used in an accessory console that also added VOX, a phone patch, and a digital clock; $1095.00, 1977. The base-station console was $379.00, and the AC power supply/speaker sold for $249.95. (1)

**H ◊ METRON MA-1000B** Metron's solid-state amplifier provided serious power for the HF mobile operator. It used eight power transistors and required 60 watts drive to run a KW input. It covered 160–15 meters with no tuning or adjustment. The MA-1000B could be mounted remotely; $795.00, 1979. (31)

**I ◊ MFJ CW FILTER** MFJ's first product appeared in the fall of 1972. It was a 2" × 3" circuit board containing a 2-IC active audio filter for CW. The filter's center frequency was 750 Hz, with bandwidths of 180 and 80 Hz; $9.95 (kit)/$12.95 (wired). (68)

A

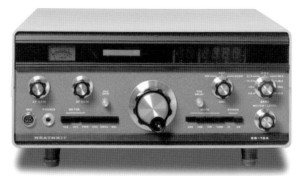

B

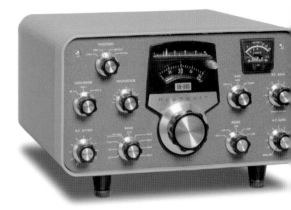

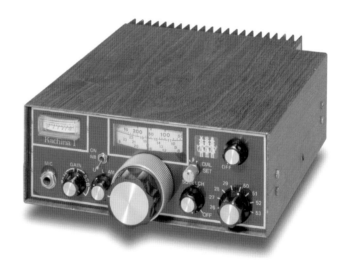

C

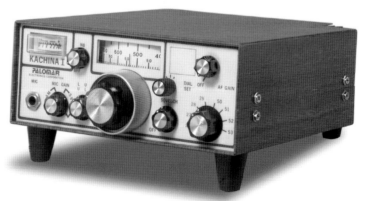

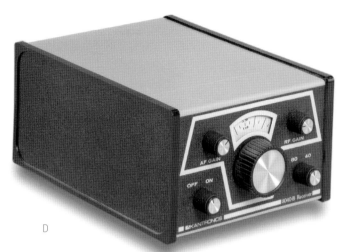

D

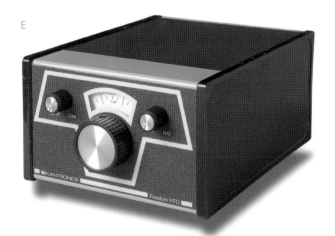

E

F

H

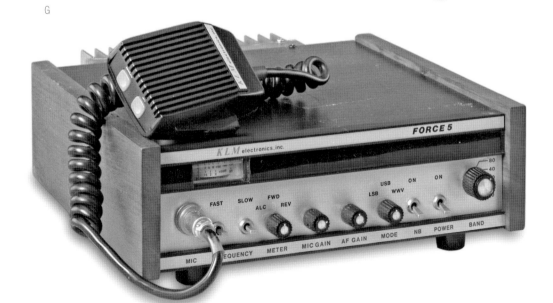

G

I

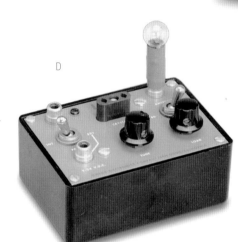

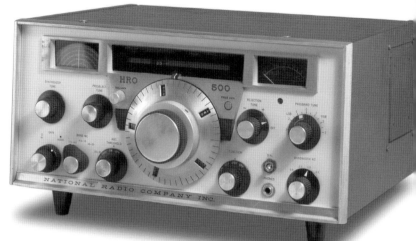

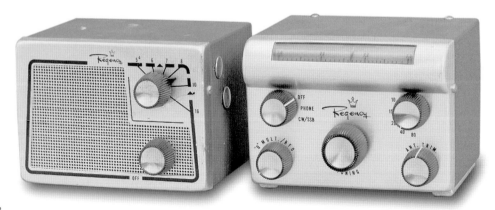

**A** ◊ **MFJ CWF-2, 40V & 40T** This trio of MFJ products was often advertised as part of a stack such as the one shown. On top is a CWF-2BX filter ($27.95). In the middle is the 40V ($24.95); it was the companion VFO for the transmitter below it. The 40V tuned 7.0–7.2 MHz and produced 4 volts peak-to-peak output. The 40T ($24.95) QRP transmitter on the bottom of stack ran 5 watts on 40 meters CW. It was crystal-controlled or used the 40V; 1976. (68)

**B** ◊ **MFJ FREQUENCY STANDARD** The 200BX frequency standard generated markers well into the VHF region. A switch selected intervals of 25, 50, or 100 kHz. The signals were gated for easy identification; $27.95, 1976. (68)

**C** ◊ **NATIONAL HRO-500** Three decades after the production of the first HRO model, National introduced their HRO-500. Only the trademark PW dial remained as a constant. Everything else about the famous receiver line had changed. The HRO-500 was all-solid-state and synthesized. It covered 5 kHz–30 MHz in sixty 500 kHz bands. The VFO's tuning rate was identical on all bands. A tunable six-pole filter provided selectivity bandwidths of .5, 2.5, 5.0, and 8.0 kHz. Passband tuning was used on the .5 and 2.5 kHz positions. Its rejection tuning featured a 60 dB notch. It operated from either 115/230 VAC or 12 VDC power; $1295.00, 1964. (1)

**D** ◊ **OMEGA LT-5** The 5-watt 80 and 40 meter CW transmitter from Omega Electronics was available both as a kit or wired and tested. Shown with the panel lamp dummy load/tune-up indicator inserted in the antenna jack; $24.00 (kit)/$35.00 (wired), 1967. (1)

**E** ◊ **REGENCY ATC-1 & TCR-2** Regency announced the first transistor radio available to the general public in 1954. In 1956 it introduced the first transistorized amateur product, the ATC-1 converter. Using only two transistors, the converter covered the 80 through 10 meter bands and had a Q-Multiplier that aided in selectivity as well as serving as a BFO for CW and sideband signals. It was powered by internal penlight cells and required only a single connection to a broadcast receiver tuned to 1230 kHz. The converter measured 4-3/4" x 3-1/4" x 4-1/16" and sold for $79.50. The TCR-2 pictured with it is a companion broadcast receiver that served as the IF and audio stages. (1)

F

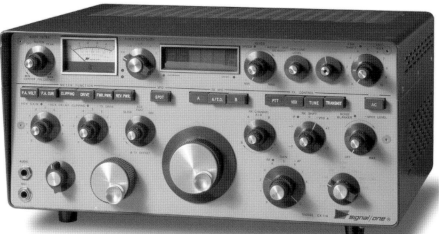

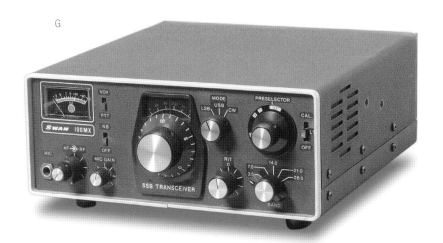

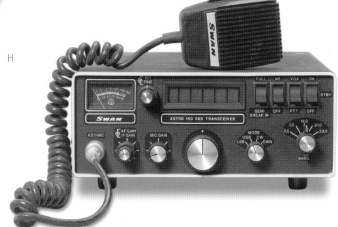

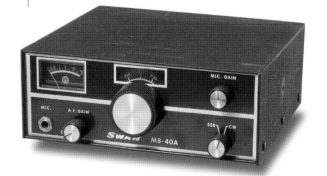

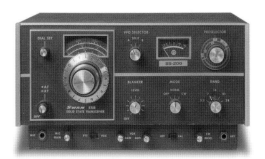

**F** ◊ **SIGNAL/ONE CX-11A** The CX-11A used a combination of frequency synthesis plus dual PTOs to cover the 160–10 meter ham bands in 1 MHz wide ranges. Four additional 1 MHz segments were available. The transceiver had a built-in 115/230 VAC power supply and featured full QSK on CW, and a choice of fast-attack VOX or PTT on phone. IF selectivity was provided by a pair of 2.4 kHz eight-pole crystal filters. Post-detection filter bandwidths were .1, .4, 1.0, and 1.5 kHz. The broad-band, no-tune, solid-state finals were rated at 150 watts output on all bands and all modes. A built-in keyer and RF speech processor were part of the package; $5900.00, 1979. (51)

**G** ◊ **SWAN 100MX** The 100MX was a completely solid-state 80–10 meter transceiver. Output power was 100 watts PEP on SSB and CW. It was tuned with a PTO and used an 8-pole crystal filter in its 9 MHz IF. The 100MX operated directly from 11–15 VDC; $799.95, 1978. (1)

**H** ◊ **SWAN ASTRO 150** The Swan version of the Astro 150 transceiver had most of the same features as the later Cubic Astro 150A, produced following Cubic's purchase of Swan. The Astro 151 version of the 150 added 160 meter coverage in lieu of 10 meters; $925.00, 1979. (1)

**I** ◊ **SWAN MB-40A** In 1974 Swan introduced a pair of 160 watt SSB/CW monobanders for either 40 or 80 meters (MB-40A & MB-80A). The relatively simple, solid-state transceivers were perfect for mobile use. They were compact and had few controls requiring the operator's attention. The MB-40 & MB-80 were 75 watt versions; $329.95, 1974. (1)

**J** ◊ **SWAN SS-200** The SS-200 solid-state transceiver ran 200 watts input on 80–10 meters and operated directly from 12 VDC. It had built-in VOX, a noise blanker, and semi-break in on CW. Broadband finals provided no-tune operation. Swan also made 15 and 100 watt versions of this transceiver; $779.00, 1973. (1)

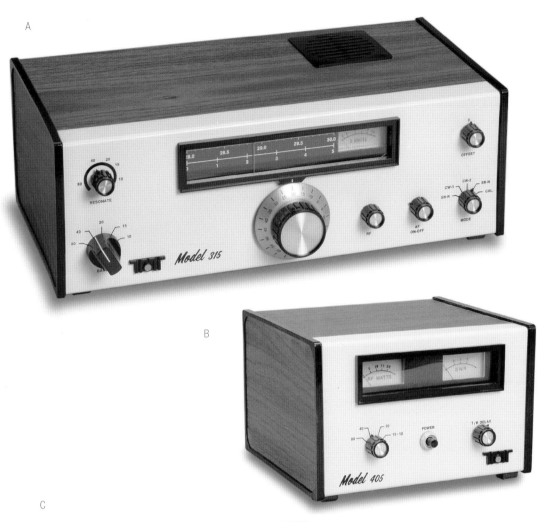

A ◊ **TEN-TEC 315** The Ten-Tec 315 amateur band receiver used all-solid-state circuitry. MOSFETs were used in the RF amplifier and mixer stages. A 9 MHz crystal lattice filter provided SSB selectivity and an optional active audio filter was used for CW. The audio filter had an 800 Hz center frequency and adjustable skirts. The receiver had rear-panel inputs for sidetone and T/R muting. Output jacks for the VFO and carrier oscillator enabled the 315 to transceive with a companion transmitter; $229.00, 1972. (1)

B ◊ **TEN-TEC 405** Ten-Tec introduced the model 405 linear along with the Argonaut 505. The broad-band amplifier provided band-switching coverage of 80–10 meters and needed but 2 watts drive to produce 50 watts output. Its two panel meters showed power output and SWR. The 405 had an exciter-actuated antenna relay. A delay control varied relay drop-out from near QSK speed on CW to a longer hold time for SSB. An external 12 VDC source was required; $149.00, 1972. (1)

C ◊ **TEN-TEC HERCULES 444** Ten-Tec staked a claim on having the first solid-state QSK kilowatt linear amplifier when it introduced the Hercules 444. The amplifier used two 500 watt PA modules in push-pull and a combiner to deliver 600 watts output on 160–10 meters. Band switching was automatic when the Hercules was used in conjunction with Ten-Tec's Omni transceiver. Its 110/220 VAC power supply delivered 45 VDC at 24 amps and was housed in a separate cabinet; $1575.00, 1980. (1)

D ◊ **TEN-TEC TRITON IV** The analog dial version of the Triton IV was also known as the Model 540. During production, the Triton IV name was dropped in favor of the model number on the front panel. The solid-state transceiver had an output power of 100 watts. The broad-banded transmitter required no tuning. The receiver was peaked to frequency with its resonate control. The 540 covered 80–10 meters, with the 10 meter band divided into four 500 kHz segments; $699.00, 1975. (1)

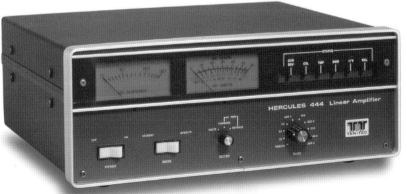

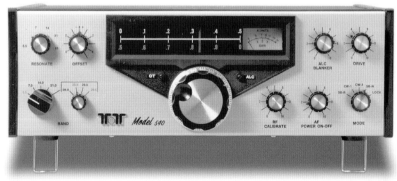

E
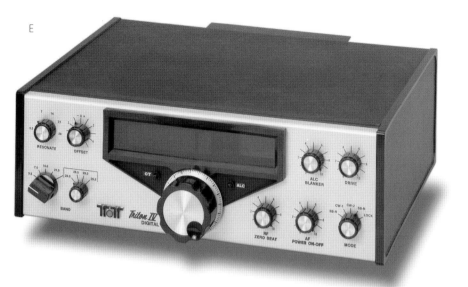

F
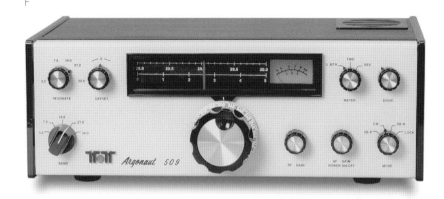

H
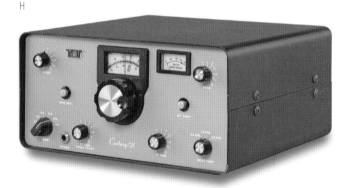

**E ◇ TEN-TEC 544** The 544 was the Triton IV with a digital dial. The front panel of the transceiver pictured here is marked "Triton IV Digital," a designation that would disappear and be replaced with the model number in subsequent production. The digital readout is the only significant difference between the 540 and 544. The CW selectivity of both models was improved with the addition of an optional, plug-in active filter; $869.00, 1977. (1)

**F ◇ TEN-TEC ARGONAUT 509** Ten-Tec introduced the Argonaut in late 1971. Its power input was 5 watts PEP SSB and 5 watts CW on five bands. The rig was fully solid-state and all circuits were permeability tuned. A 2.5 kHz crystal filter in the Argonaut's 9 MHz IF was used on transmit and receive. A year later the Argonaut became the model 505, and the model 509 shown arrived in 1976. It retained the basic flavor of the original Argonaut, with its QSK CW, no-tune broad-band amp, built-in SWR/S-meter, RIT, and direct frequency readout; $329.00, 1976. (1)

**G ◇ TEN-TEC ARGONAUT 515** Ten-Tec restyled the Argonaut cosmetically, adding new features as well. The Model 515 now covered all of 10 meters with new 500 kHz band segments. Offset tuning and RF LEDs were added to the front panel. The PTO and receiver front end were both improved; $429.00, 1980. (1)

**H ◇ TEN-TEC CENTURY 21** The Century 21 solid-state transceiver ran 70 watts CW input on 80–10 meters. Coverage on 10 meters was the lower 1 MHz of the band. It featured full QSK and a three-position audio filter. The receiver was a Double Direct Conversion design. The 120 VAC power supply was built-in; $289.00, 1977. (1)

**I ◇ TEN-TEC OMNI-A** The Model 545 Omni-A and its companion Omni-B replaced the Triton series as Ten-Tec's premier transceivers. The Omni-A had an analog dial. It covered 160–10 meters and had 10 MHz WWV and AUX positions on the band switch to accommodate future allocations. The Omni had two-speed break-in and two offset ranges on the RIT. The 8-pole, 2.4 kHz sideband filter was complemented by a 150 Hz active filter for CW which had three selectable skirt contours. Power input was 200 watts; $899.00, 1978. (1)

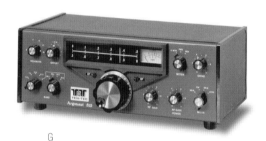
G

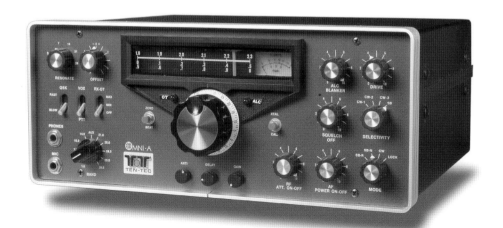
I

**A ◊ TEN-TEC OMNI-D** Ten-Tec's Model 546 Omni-B was identical to the Omni-A except for its digital dial. The six-digit readout used .43 inch LEDs displaying frequency to 100 Hz. The unit shown is an Omni-D, Series B. It offered two additional IF crystal filters in 1.8 and .5 kHz bandwidths. They were switched in series with the standard 2.4 kHz filter. The audio filter had been given 300 and 400 Hz bandwidths in addition to the 150 Hz filter used in the earlier Omni. A tunable notch filter was added as well; $1119.00, 1979. (1)

**B ◊ TEN-TEC PM-1** The PM-1 consisted of Ten-Tec's Power-Mite modules packaged together with their AC-1 "Convenience Kit," an aluminum chassis, a front panel, knobs and switches, and a crystal socket. The 2 watt input CW transceiver covered 80 and 40 meters. An optional converter module extended coverage to 15 meters; $49.95, 1969. (1)

**C ◊ TEN-TEC PM-3A** The PM-3A transceiver covered 40 and 20 meters with 5 watts CW input. It had no crystal socket and was intended for General Class or higher use. The PM-3A had a built-in monitor, receiver muting, and break-in keying; $49.95, 1970. (1)

**D ◊ TEN-TEC POWER-MITE MODULES** Wired-and-assembled circuit boards were available for each of the component modules in the PM-1 Power-Mite transceiver. Each cost $7.95. Clockwise from the top: the MX-1 Synchrodyne detector-converter board, the VO-1 oscillator/buffer VFO board, the TX-1 crystal-oscillator/final-amplifier board, the AA-1 IC- amplifier audio board; 1969. (1)

**E ◊ TEN-TEC RX-10** The RX-10 direct-conversion receiver covered the 80, 40, 20, and 15 meter bands. It had a built-in audio oscillator that served as a transmitter monitor or code practice oscillator. The RX-10 had an internal 120 VAC supply or it could run off external 12 VDC power; $59.95, 1970. (1)

**F ◊ TEN-TEC TRITON I & II** The Triton series of transceivers were fully solid-state, permeability tuned, and operated directly from 12 VDC. A 2.5 kHz crystal lattice filter in the 9 MHz IF provided SSB selectivity; a narrow audio filter could be switched in on CW. Other features included an SWR/Power Meter, a 100 kHz calibrator, RIT, and full QSK. Power Input with the Triton I was 100 watts. The otherwise identical Triton II's input power was 200 watts; $519.00 (Triton I)/$606.00 (Trition II), 1973. (1)

**G ◊ TEN-TEC TX-100 & MODEL 200 VFO** Although the company is known almost exclusively for solid-state gear (other than amplifiers), in the early days, Ten-Tec actually did make a tube transmitter. The crystal-controlled TX-100 covered 80, 40, and 15 meters. The Model 200 companion VFO was all-solid-state and covered 80–10 meters; 1971. (1)

**H ◊ TOMPKINS TUNAVERTER** The Tunaverter from Tompkins Radio Products was a tunable converter, just as its name implies, but it could also be crystal-controlled on a fixed frequency. The output frequency of the Tunaverter was 1500 kHz. Tompkins made them for the 160–10 meter amateur bands as well as for other services. The Tunaverter was power by an internal 9 volt battery; $32.95, 1969. (1)

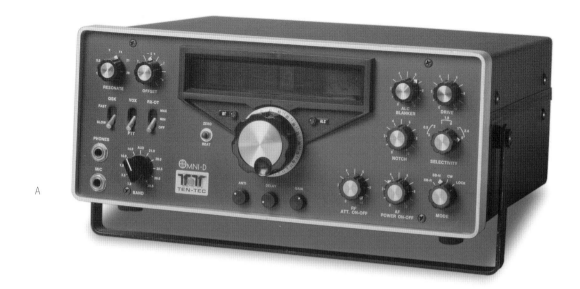

A

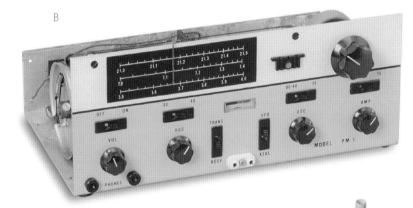

B

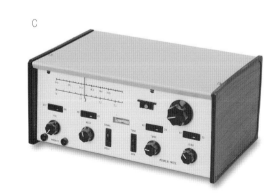

C

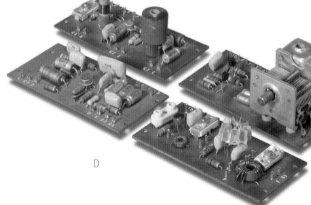

D

E

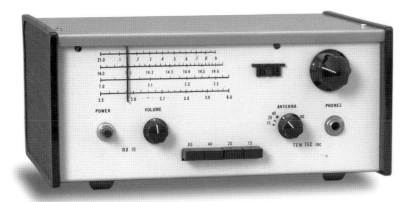

F

H

G

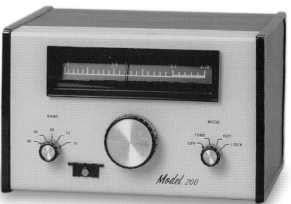

113

# FM and Repeaters

FM and repeaters changed the Amateur Radio landscape more than spark, CW, AM or even single sideband technology. VHF FM operation, both simplex and repeater, became ham radio's Main Street, cutting across almost every facet of the hobby in the process.

The FM movement began in the early 1960s when the Federal Communications Commission mandated changes in the technology used by commercial mobile radio services. The explosive growth of these services soon used up all the allotted spectrum and more channels were needed to accommodate new customers. The FCC decided to squeeze additional channels into the same space by decreasing the bandwidth of the signals. As a result, the mobile services were forced to abandon their wide-band FM gear in favor of narrow-band equipment and thousands of surplus wide-band transmitters and receivers became available to hams at a fraction of their value.

Much of the cast-off gear had been manufactured by Motorola or General Electric and was built to perform reliably in commercial service. Enterprising hams converted the equipment from the business bands to adjacent amateur frequencies. The commercial radios could be converted to a number of amateur VHF or UHF frequencies, but those able to operate on 2 meters were the most popular. Clubs and individual hams improvised repeaters, and on-the-air communities grew around these signal-relaying machines. In the pioneer days of amateur VHF FM, major metropolitan areas supported the most activity and the mountaintop systems on the West Coast were busy as well. ∎

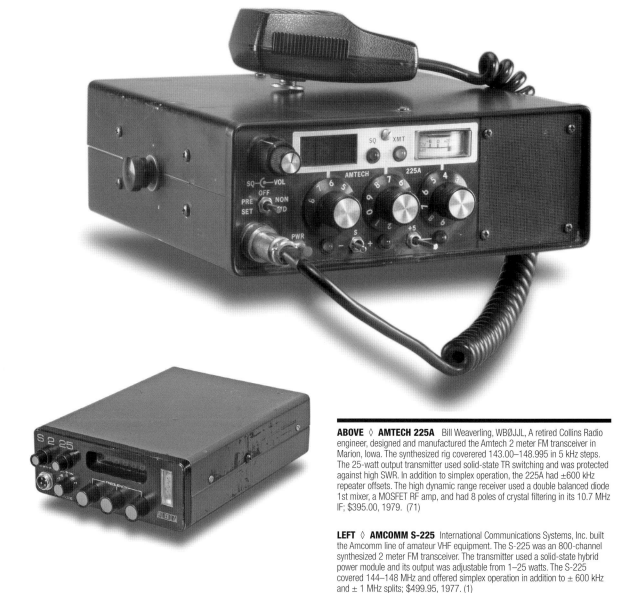

**ABOVE ◊ AMTECH 225A** Bill Weaverling, WBØJJL, A retired Collins Radio engineer, designed and manufactured the Amtech 2 meter FM transceiver in Marion, Iowa. The synthesized rig covererd 143.00–148.995 in 5 kHz steps. The 25-watt output transmitter used solid-state TR switching and was protected against high SWR. In addition to simplex operation, the 225A had ±600 kHz repeater offsets. The high dynamic range receiver used a double balanced diode 1st mixer, a MOSFET RF amp, and had 8 poles of crystal filtering in its 10.7 MHz IF; $395.00, 1979. (71)

**LEFT ◊ AMCOMM S-225** International Communications Systems, Inc. built the Amcomm line of amateur VHF equipment. The S-225 was an 800-channel synthesized 2 meter FM transceiver. The transmitter used a solid-state hybrid power module and its output was adjustable from 1–25 watts. The S-225 covered 144–148 MHz and offered simplex operation in addition to ± 600 kHz and ± 1 MHz splits; $499.95, 1977. (1)

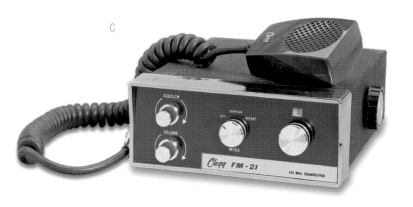

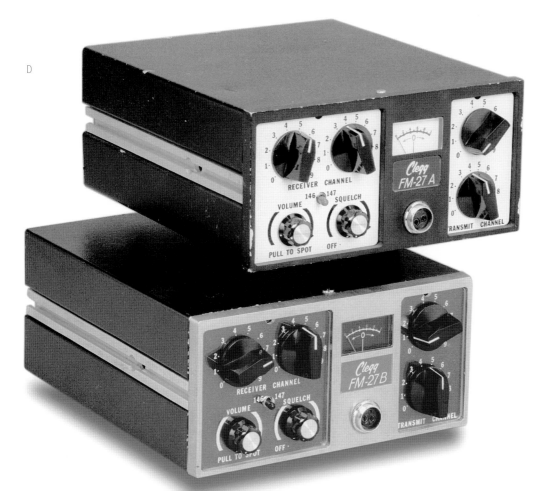

**A ◊ ARCOS UHF KW** ARCOS was an acronym for the Amateur Radio Components Service. The East Greenbush, New York company, owned by Fred Merry, W2GN, made UHF amplifiers and transmitting converters. The amplifier itself was an adaptation of a K2RIW strip line design. It used a pair of 4CX250Rs and would run 2 KW PEP input on 432 MHz ; $490.00 (assembled)/ $340.00 (kit), 1975. (1)

**B ◊ CARMICHAEL 432 TC** Carmichael Communications' 432 MHz transmitting converter could be ordered with either 28 or 50 MHz IF inputs. It used a solid state local oscillator chain. A pair of 2939 tubes served as the mixed and linear output amp stages. Output was rated at more than 5 watts with 1 watt drive from the IF exciter. Power requirements were 225–250 VDC and 6.3 VAC; $129.95, 1973. (1)

**C ◊ CLEGG FM-21** Clegg offered the FM-21 as a means for operators to move off the crowded 2 meter channels to the relatively wide-open spaces on 220 MHz. The FM-21 used one crystal per channel. It supplied both receive and transmit frequencies, as well as an automatic 1.6 MHz offset in the repeater mode. Power output was 8 watts; $299.95, 1973. (1)

**D ◊ CLEGG FM-27A & FM-27B** The Clegg FM-27 two meter transceivers were among the first to liberate the operator from the rock-bound status imposed upon those with crystal-controlled rigs. The FM-27A had completely synthesized coverage of 146–148 MHz in two 1 MHz segments. It was, however, able to transmit only in the 146 MHz range. When the FM-27B followed, it expanded transmit and receive coverage to both the 146–147 and 147–148 MHz ranges. The FM-27s used phase-modulation and were rated at 25 watts output. They had a discriminator meter which assisted in tuning received signals accurately; $449.95 (FM-27A)/$479.95 (FM-27B), 1972. (1)

**A ◊ CLEGG FM-DX** Clegg's FM-DX transceiver ran 35 watts output. Its phased-locked loop synthesizer covered 143.5¬¬–148.5 MHz in 5 kHz steps. Operating modes included Simplex, and the standard ±600 kHz repeater offsets. There were three additional positions for non-standard offsets. The receiver in the FM-DX had a MOSFET RF stage with a 4-pole band-pass filter, and a 4-pole crystal filter in its 10.7 MHz IF. Two more 10.7 MHz stages were followed by another 4-pole crystal filter; $599.00, 1975. (1)

**B ◊ CLEGG HT-146** Clegg's 2 meter FM hand held transceiver covered 144–148MHz and had 5 crystal-controlled channels. Power output was 2 watts. The HT-146's 1974 introductory price was $289.95, decreasing to $197.25 by late 1975. One of the HT's is shown in its charging stand, which bears the logo of ISC, Clegg's parent company at the time. (1)

**C ◊ COMCRAFT CST-50** Comcraft's two-band transceiver provided complete coverage of the 144 and 220 MHz ham bands. It also covered MARS and CAP frequencies from 142 to 149.995 MHz. The repeater offsets were 600 kHz, 1 MHz, and 1.6 MHz. The CST-50's synthesizer tuned in 5 kHz steps. Output power on both bands was 25 watts; $869.95, 1975. (1)

**D ◊ COMCRAFT CTR-144** The CTR-144 was the first solid-state AM and FM transceiver for 2 meters. The receiver tuned continuously from 144–148 MHz, and the transmitter could be VFO or crystal-controlled in the same range. Each function used a separate tuning dial. Power input was 12 watts on both modes; $489.95, 1973. (1)

**E ◊ CONAR 452** Construction of the Conar 452 synthesized two meter transceiver was part of the National Radio Institute correspondence school's curriculum. It was one of ten kits supplied as part of the school's Complete Communications Course. A series of lessons guided the student through the construction and testing of the transceiver. The price of the 452 was included in NRI's tuition; 1978. (1)

A

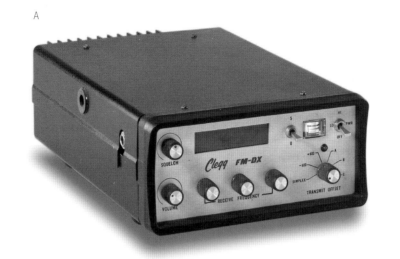

B

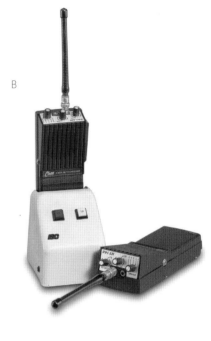

C

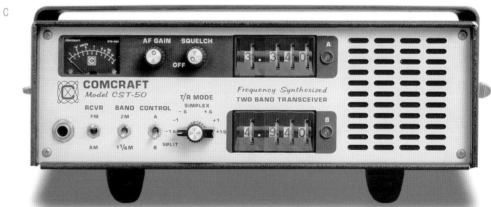

D

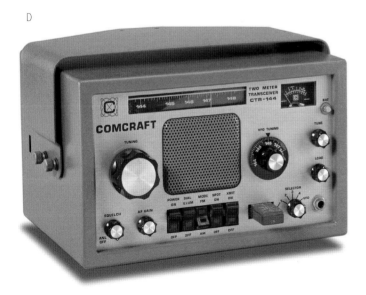

E

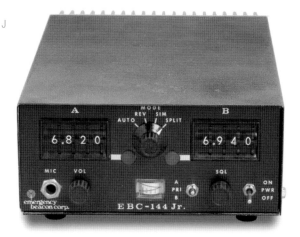

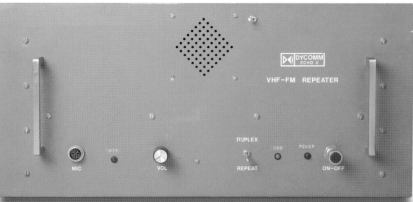

**F ◊ DRAKE AA-22** The AA-22 was a bilateral amplifier: it acted as a pre-amp on receive and a power amplifier on transmit. It used a dual-gate FET pre-amp and had automatic solid-state TR switching. The 3-stage RF amp had a power output of 25 watts when driven by .5–1watt. It covered 144–148 MHz and its power transistors were protected against high SWR ($149.95, 1972). Drake's AA-10 was a single stage, solid-state 2 meter amp that provided 10 dB gain for 1¬–2 watt rigs. It had no receive pre-amp ($49.95, 1972). (1)

**G ◊ DRAKE UV-3** Until 1977, the R.L. Drake company had been importing its vhf fm gear. The UV-3 changed that. It was made in Drake's Ohio plant and changed some other things as well. The synthesized UV-3 was primarily a two meter transceiver but could also operate on both 220 and 440 MHz by adding circuit boards for each of those bands. It could be configured as a full-blown three-band rig, or only 220 or 440 could be added to the basic two meter setup. Standard repeater offsets (600 kHz, 1.6, and 5 MHz) were included. FCC Part 15 rules made it necessary for the owner to return the rig to Drake for the installation of additional bands. Output in the high-power position was 35, 15, and 8 watts on the 144, 220, and 440 MHz bands, respectively; $1130.00 (for the full 3-band package), 1977. (1)

**H ◊ DYCOMM ECHO II/III REPEATER** The repeater pictured is likely a rack-mount Echo III, although its panel is marked "Echo II". It contained a receiver, transmitter, and the carrier-operated circuitry necessary for repeater operation. Also included were a 117 VAC power supply with a battery backup for emergencies. An onboard trickle charger kept the batteries topped up when they weren't in use. Transmitter output was typically 25-30 watts and a crystal filter in the receiver's front end helped fight desensitization. The Echo III could be used over a frequency range of 140 to 175 MHz; $949.00, 1973. (1)

**I ◊ DYCOMM SUPER D** Dycomm's Super D two meter amp used a pair of 2N6084 transistors, and was rated at up to 80 watts output. Driving power was levels were from 2–35 watts. It had RF-sensed TR switching, and High SWR protection; $49.95, 1973. (1)

**J ◊ EBC 144 JR.** The EBC 144 Jr was made by the Emergency Beacon Corporation in New Rochelle, New York. The company's main business was manufacturing avionics used in search and rescue operations for downed aircraft. The 20-watt EBC 144 Jr was fully synthesized and covered 143.5–148.5 MHz using 5 kHz increments. It had standard repeater splits, reverse splits, and simplex modes. The receiver used a 10-pole crystal filter; $699.00, 1976. (1)

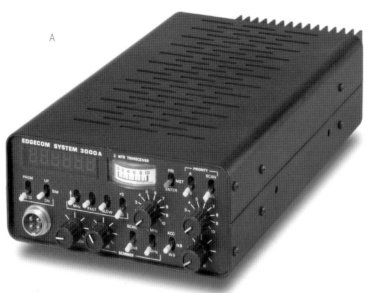

A

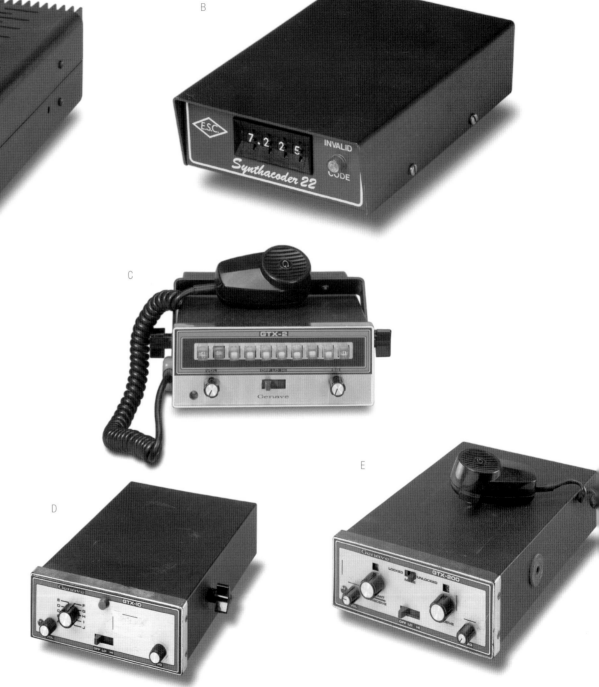

B

C

D

E

**A ◊ EDGECOM SYSTEM 3000A** The System 3000A transceiver featured 20 front-panel-programmable memory channels, a band scanner that covered 144–147.995 MHz in 5 kHz steps, and completely flexible repeater offsets. The receiver had a 5-pole front-end filter, and a 10-pole filter in the IF. Output from the transmitter was 25 watts. It was manufactured by Edgecom, Inc. in Torrance, California; $549.00, 1978. (1)

**B ◊ ESC SYNTHACODER 22** The Synthacoder 22 from Engineering Specialties of Oxnard, California was an after-market accessory for the Icom IC-22S VHF transceiver. Icom's 2 meter rig had a diode matrix used to cover two meter frequencies, but only 22 channels. To add or change a frequency, the owner had to solder diodes into different positions on the circuit board. The Synthacoder 22 plugged into the back of the Icom and gave the owner thumbwheel selection of Any frequency in the transceiver's 146–148 MHz range; $69.95, 1977. (1)

**C ◊ GENAVE GTX-2** The 30-watt, 2 meter transceiver had 10 crystal-controlled channels and used true FM rather than phase modulation. It had a 1 watt low power position and came with a mobile mounting bracket and microphone. Manufactured by General Aviation Electronics, Incorporated, whose main business was avionics; $249.95, 1972 (1)

**D ◊ GENAVE GTX-10** Genave's GTX-10 2 meter FM transceiver had 10 crystal-controlled channels. Power output was 10 watts; $199.95, 1973. (1)

**E ◊ GENAVE GTX-200** The GTX-200 transmitter used true FM rather than phase modulation. The 10- channel transmit/10-channel receive two meter transceiver had 30 watts output with a 1 watt low-power position. The transmit and receive channel could be selected independently or paired in preset combinations; $259.95, 1973. (1)

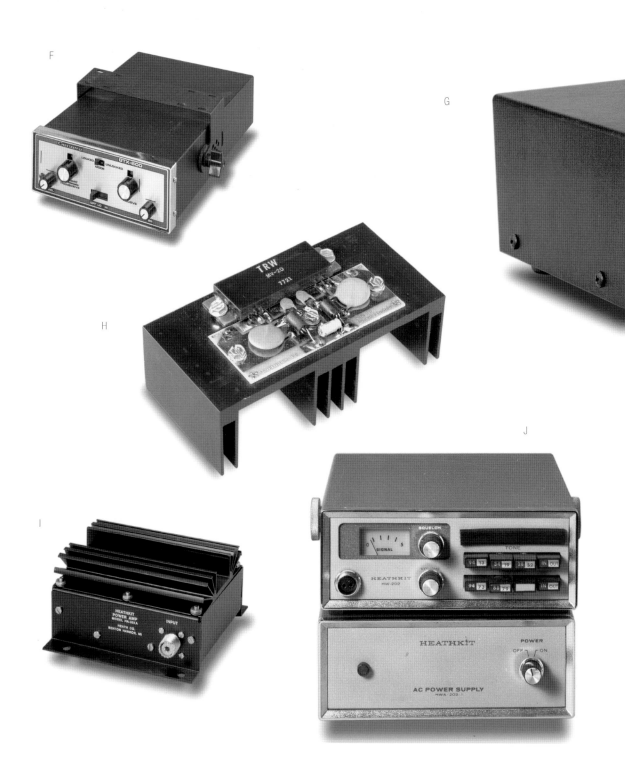

**F** ◊ **GENAVE GTX-600** The GTX-600 was a 6 meter FM transceiver. It had independent selection of 10 transmit and 10 receive frequencies, with a front-panel switch to lock- in preselected pairs; $269.95, 1974. (1)

**G** ◊ **GLB 400B CHANNELIZER** The GLB 400B "Channelizer" frequency synthesizer used rotary BCD switches instead of the more common thumbwheel switches to program frequencies. Two toggle switches selected 5 kHz steps and two others assigned the upper and lower rows of knobs to either receive or transmit frequencies. Internal jumpers provided outputs at 6, 8, or 12 MHz depending upon a specific rig's need. The offset for the receiver's IF was changed by switching a crystal. The 400B operated from 11–15 VDC ; $129.95 (kit)/$189.95 (wired), 1973. (1)

**H** ◊ **HAMTRONICS T-80-150** The Hamtronics T-80-150 was a solid-state power module and associated components mounted on a heat sink. It required 150 mw drive for 20–25 watts output on two meters ($79.95, 1977). Hamtronics of Rochester, New York also sold a wide variety of circuit board kits for the VHF/UHF amateur, especially those interested in FM and repeaters. (1)

**I** ◊ **HEATH HA-202A** The HW-202A ran 50 watts output when driven by 15 watts. 5 watts input produced 20 watts out. The amp was tunable to any portion of the two meter band; $79.95, 1978. (1)

**J** ◊ **HEATHKIT HW-202 & HWA-202-1** Heath claimed 36 channel capability for the HW-202 which used 6 transmit and 6 receive crystals, though few amateurs would have operated on combinations that were not standard repeater pairs or simplex frequencies. Power output was 10-15 watts FM and the transceiver could be set up to cover any 1 MHz segment in the 143.9 to 148.3 range. The HW-202 kit sold for $179.95 and an optional tone burst encoder was $24.95. The companion HWA-202-1 AC power supply cost $29.95; 1973. (1)

**A ◊ HEATH HW-2021 & VF-2031** Heath's HW-2021 (standing) was a 1-watt, 5-channel HT for two meters. It used one crystal per channel for both transmit and receive frequencies. The repeater offset was either plus or minus 600 kHz, depending upon the offset crystal installed. The simplex mode was also included. The unit here has the optional HWA-2021-3 auto-patch encoder. The VF-2031, successor to the HW-2021, is shown with its optional speaker mic. The eight-channel 2 meter HT had 2 watts output. It had both plus and minus 600 kHz repeater offsets; $169.95 (HW-2021) 1975/$189.95 (VF-2031), 1978. (1)

**B ◊ HEATH HW-2036A & HWA-2036-3** Heath's entry into the 2 meter synthesized FM transceiver field was not a happy one. The HW-2026 had serious problems with high-level spurs from its synthesizer. Heath was forced to issue a product recall, offering buyers their money back, or credit toward another Heath product. The company set most of the problems right with its new HW-2036 and offered a further improvement by expanding the 2036's coverage of any 2 MHz segment of the 2 meter band to the full 4 MHZ in the "A" version. The 2036 series also had a continuous tone encoder with a switch selection of three tones between 70 and 200 Hz. The 10 watt rig used the companion HWA-2036-3 for base station operation; $269.95, 1977. (1)

**C ◊ HEATH VF-7401 & VFA-7401-1** The VF-7401 FM transceiver digitally scanned the full two meter band in 1 MHz segments. It scanned only standard channels rather the continuous spectrum. Power output was 15 watts. The VF-7401 had a three-position CTCSS tone encoder. The tones were selected at time of assembly. The transceiver is shown sitting on the VFA-7401 AC supply; $369.95, 1980. (1)

**D ◊ HENRY TEMPO 130A10** Henry Radio sold this solid state 2 meter amp under its Tempo brand name. 10 watts input produced 130 watts out; $179.00, 1975. (1)

**E ◊ INTERNATIONAL COMMUNICATIONS AND ELECTRONICS ICE-1** The ICE-1 "Ice Box" 2 meter FM transceiver was made by International Communications and Electronics in San Antonio, Texas. The 4-watt rig had a built-in 117 VAC supply, could operate from a car battery, or optional internal NI-CADS. The 3-channel ICE-1 offered independent selection of transmit and receive frequencies; $285.00, 1969. (1)

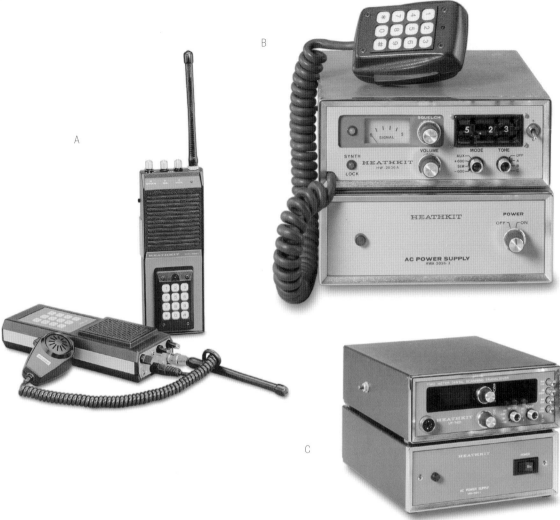

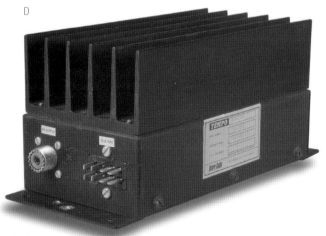

120

F

G

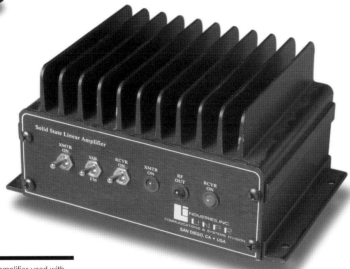

H

I

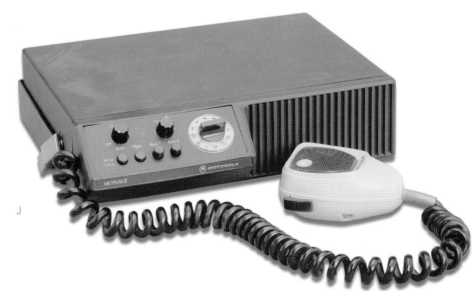

J

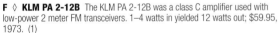

**F** ◊ **KLM PA 2-12B** The KLM PA 2-12B was a class C amplifier used with low-power 2 meter FM transceivers. 1–4 watts in yielded 12 watts out; $59.95, 1973. (1)

**G** ◊ **KLM PA 15-110CL** KLM increased the heat sink area on its VHF/UHF solid state amplifiers and added an over-temp warning LED. The transistors were protected against high SWR, open, and short circuits. The PA 15-110CL covered 420–450 MHz. Its output power was 110 watts with 15 watts input; $229.95, 1978. (1)

**H** ◊ **LUNAR 2M4-40P** Lunar Electronics of San Diego, California, was owned by Louis Anciaux, WB6NMT (now HP3XUG). The company manufactured amps, pre-amps, and accessories, aimed mostly at the high-performance VHF/UHF market. The 2M-40P was one of the Lunar's "Bi-Linear" amplifiers, that is, the power amplifier also contained a receiver pre-amp and could switch from SSB to FM operation. The pre-amp had its own in/out switch. 1–4 watts input produced 10–40 watts out on 2 meters; 1980. (1)

**I** ◊ **M-TECH P50A10** M-Tech Engineering, Inc. was located in Springfield, Virginia. Their product line included solid-state VHF amplifiers. The P50A10 ran 14–60 watts out with 2–18 watts input. The Class C amp covered the two meter band; $98.00, 1975. (1)

**J** ◊ **MOTOROLA METRUM II** Many amateurs converted Motorola commercial VHF/UHF gear for use on the ham bands but the company aimed its Metrum series of 2 meter FM transceivers squarely at the amateur market. The radio's 12 channels were covered with one crystal per channel. An additional offset crystal was used for transmit frequencies during repeater operation. The Metrum II came in 10 watt ($399.95) and 25 watt ($499.95) models; 1973. (1)

**A ◊ PARKS ELECTRONICS 50-1** Parks Electronics of Beaverton, Oregon was run by K7AAD. He also published VHF'er Magazine. The company made pre-amps and converters for VHF and UHF. The 50-1 was a 6 meter converter and could be configured for a number of IF outputs. Its 117 VAC power supply was built in. The 50-1 could be tuned to cover a 1.5 MHz bandwidth; $34.50, 1967. (1)

**B ◊ PIERCE-SIMPSON GLADDING 25** Pearce-Simpson's Gladding 25 two meter FM transceiver had 8 crystal-controlled channels and ran 25 watts in the high-power position. It was solid-state except for a vacuum tube driver and final. The receiver used a slope-detector rather than the more conventional discriminator; $249.95, 1971. (1)

**C ◊ QUEZAR QC-10** The QC-10 from Quezar Communications was a transistorized 2 meter amplifier for low-power transceivers. It featured better than 10 dB gain, supplying 12 watts out with 1 watt drive. It would run directly from 13.6 VDC for mobile operation but had an internal 110 VAC supply that also furnished power for the transceiver during base station use; $69.95, 1973. (1)

**D ◊ REGENCY AR-2** The AR-2 was a 50-watt 2 meter amplifier. It operated from 12 VDC; $119.00, 1972. (1)

**E ◊ REGENCY HR-2** Regency targeted the emerging 2 meter FM mobile market with its HR-2. The 10-watt output transceiver had 6 crystal-controlled channels and covered the entire 144–148 MHz band. It used phase modulation. The double-conversion receiver had 5 watts of audio output; $229.00, 1971. (1)

**F ◊ REGENCY HR-2S** The Regency HR-2S "Transcan" used pushbutton control to scan any or all of its 8 channels. A received signal locked the 2 meter FM rig in the receive mode, then resumed scanning when the signal dropped. Power output was 15 watts. It had an internal 117 VAC supply. The HR-2MS model used 12 VDC power for mobile operation; $349.00, 1971. (1)

**G ◊ REGENCY HR-6** The HR-6 had 12 independently-switchable crystal channels covering the 52–54 MHz repeater allocation on 6 meters. Power output was 25 watts and FM deviation was adjustable up to ±15 kHz on transmit. An adapter was available to reduce bandwidth of receiver modulation acceptance to 8 kHz; $239.00, 1975. (1)

**H ◊ REGENCY HR-212** Regency's HR-212 was a 12-chanel, 20-watt two meter FM transceiver. Its crystal channels could be locked together in pre-set transmit-receive combinations or unlocked and used independently; $259.00, 1972. (1)

**I ◊ REGENCY HR-220** Regency's 220 MHz FM transceiver put out 1.5 watts in the low-power position and 10 watts when running high power. It had provisions for 12 crystal-controlled channels. A single knob selected both transmit and receive frequencies; $239.00, 1975. (1)

A

B

C

D

E

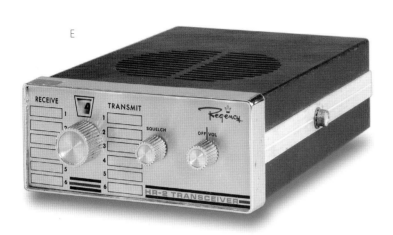

F

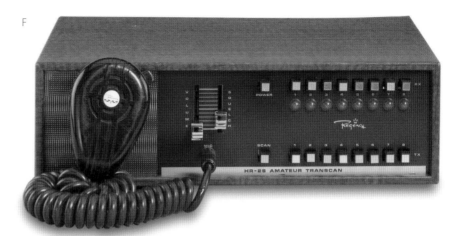

G

H

I

123

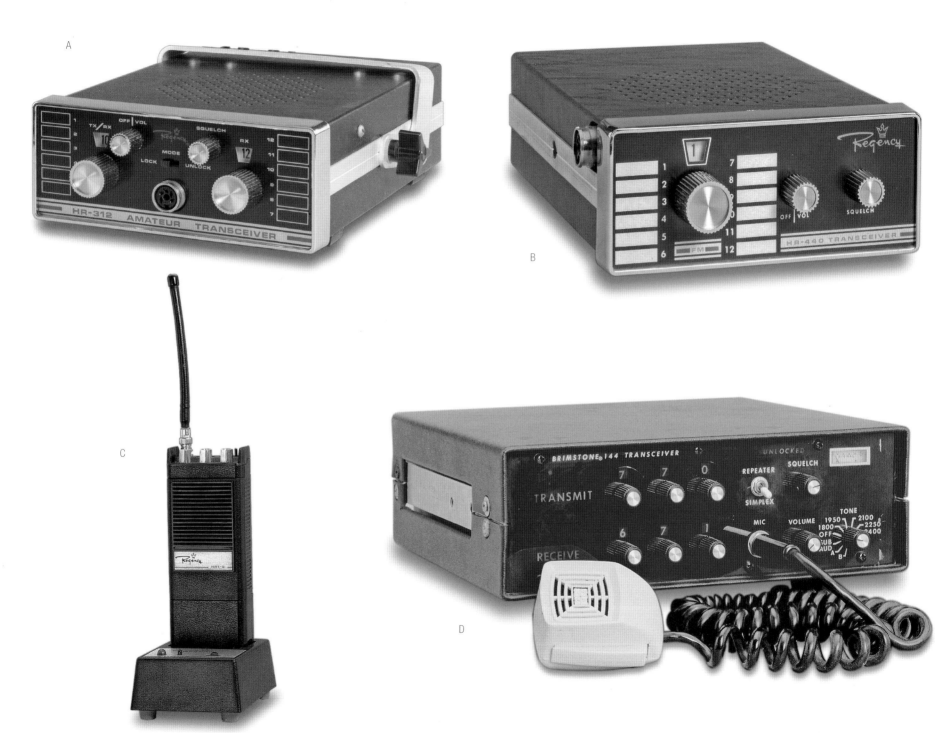

**A** ◊ **REGENCY HR-312** The Regency HR-312 had more channels, more sensitivity, more selectivity, and greater power output than its 2 meter predecessors. Its 12 crystal channels were normally selected in dedicated pairs, but an "unlock" switch enabled independent selection, giving a total of 144 different frequency combinations. Power output was 35 watts; $269.00, 1976. (1)

**B** ◊ **REGENCY HR-440** Regency's 440 MHz FM transceiver was poured from the same physical mold as the company's VHF rigs. It ran 10 watts output using a UHF power module; $349.00, 1975. (1)

**C** ◊ **REGENCY HRT-2** Regency, the company that brought the first solid-state product to the amateur market (the ATC-1 converter, in 1956), introduced its HRT-2 handie-talkie in 1974. It was a 5 channel, crystal-controlled 2 meter FM transceiver with a power output of 2.2 watts. Its HI/LO switch reduced power to 1 watt ; $179.00, 1974. (1)

**D** ◊ **SATAN ELECTRONICS BRIMSTONE 144** The oddly-named FM transceiver tuned from 144.00 to 147.99 MHz in 10 kHz synthesized steps (optionally 5 kHz). Power output was 25 watts and other options included plug-in modules for Touch Tone®, tone burst, and subaudible tones; $650.00, 1974. (1)

**E** ◊ **SCS 1.3M 10-60L** Specialty Communication Systems was run by Louis Anciaux, WB6NMT, who was also the principle at Lunar Electronics. The 1.3M 10-160L was a 220 MHz amp which could be switched from linear operation on SSB to Class C for FM. 10 watts input yielded 60 watts out. It could also be run in low-power (<10 watts) on FM by using the linear mode; $159.95, 1975. (1)

**F** ◊ **SIMPSON MODEL A** Simpson Electronics of Miami, Florida was a well-known manufacturer of marine communications gear. Their FM transceiver for the 2 meter amateur band had four crystal-controlled channels. Transmit and receive frequencies were selected independently using diodes to switch the crystals. The Model A's power output was 6 watts ($249.00, 1971). Simpson's push button-controlled Model B two meter transceiver was based on one of the company's VHF marine radios. (1)

**G** ◊ **SONAR FM-3602** The Sonar Radio Corporation of Brooklyn, NY had its roots in post-war NBFM gear. In later years, its product line expanded with mobile and fixed station HF and VHF gear as well as several sideband transceivers. The FM-3602 was a 25 watt, 8-channel FM transceiver for the 2-meter band. Push buttons selected crystal pairs. It came with a quick-removal mobile mount and microphone; $350.00, 1970. (1)

**H** ◊ **SPEC COMM 512** The Spec Comm 512 two meter portable rig was made by Spectrum Communications of Worcester, PA. The 512 was a 12-channel FM transceiver with 5 watts output. It could be used mobile, as a base station, or over-the-shoulder portable with optional antenna and carrying pack; $199.95, 1975. (1)

**A ◊ SPECTRONICS SPEC-2** The Spec-2 synthesized two meter transceiver used an RP electronics MFA-22 synthesizer. The remainder of the transmitter and receiver components were from Motorola. The Spec-2 had two watts output and covered 144–147.99 MHz; $489.00, 1973. (1)

**B ◊ TPL ECONO-LINE** The Econo-line amps from TPL Communications Inc. were suitable for either SSB or FM on 2 meters. A bias switch changed the class of operation. The amps featured magnetically-coupled transistors and a floating ground. 10 to 20 watts input produced 50 to 90 watts output; $139.00, 1976. (1)

**C ◊ VANGUARD STR SYNTHESIZER** Synthesizers such as Vanguard's STR brought frequency agility to crystal-controlled gear. The STR was designed to work with transceivers using 5 to 85 MHz crystals to operate in the 20 to 475 MHz range. Thumbwheel switches provided tuning in 1 kHz increments from 5-30 MHz and 5 kHz steps above 30 MHz. Standard transmit offsets of ±600 kHz and ±1 MHz were included along with provision for 2 user-specified offsets. The STR for 5-150 MHz sold for $259.95 while the 151-475 MHz unit was $279.95. Transceivers requiring only one crystal could use Vanguard's less expensive Model SR synthesizer; 1977. (1)

**D ◊ VHF ENGINEERING BLE 10/40** VHF Engineering's Blue Line amps used strip line technology for efficient, broadband output as well as mechanical stability. They were available for a variety of frequencies, and a number of input/output power levels. The BLE 10/40 covered 420–470 MHz. Input power was 10 watts for an output of 40 watts; $139.95, 1977. (1)

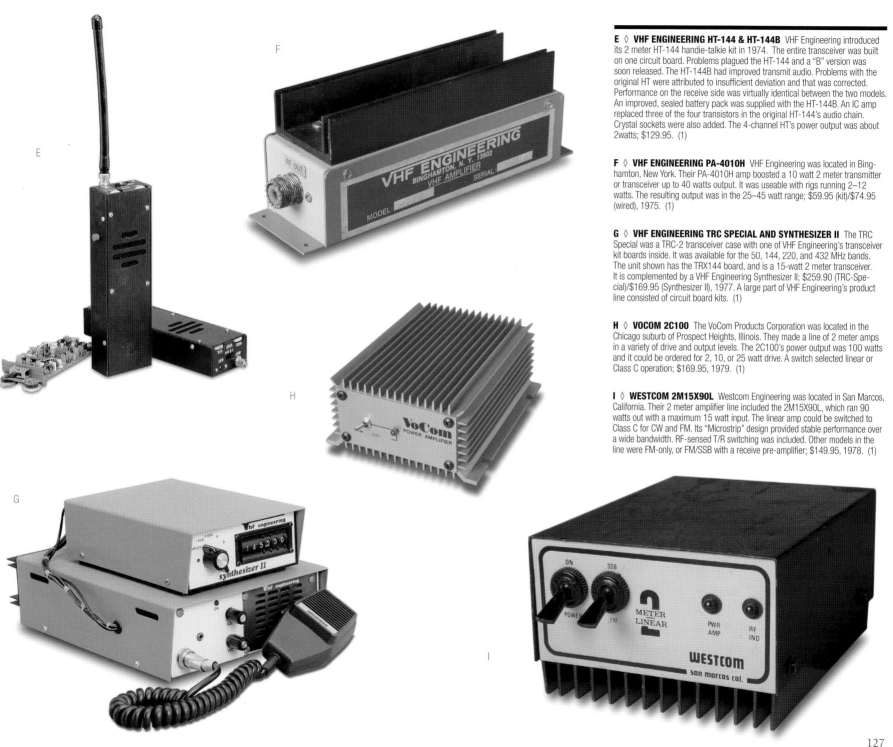

**E ◊ VHF ENGINEERING HT-144 & HT-144B** VHF Engineering introduced its 2 meter HT-144 handie-talkie kit in 1974. The entire transceiver was built on one circuit board. Problems plagued the HT-144 and a "B" version was soon released. The HT-144B had improved transmit audio. Problems with the original HT were attributed to insufficient deviation and that was corrected. Performance on the receive side was virtually identical between the two models. An improved, sealed battery pack was supplied with the HT-144B. An IC amp replaced three of the four transistors in the original HT-144's audio chain. Crystal sockets were also added. The 4-channel HT's power output was about 2watts; $129.95. (1)

**F ◊ VHF ENGINEERING PA-4010H** VHF Engineering was located in Binghamton, New York. Their PA-4010H amp boosted a 10 watt 2 meter transmitter or transceiver up to 40 watts output. It was useable with rigs running 2–12 watts. The resulting output was in the 25–45 watt range; $59.95 (kit)/$74.95 (wired), 1975. (1)

**G ◊ VHF ENGINEERING TRC SPECIAL AND SYNTHESIZER II** The TRC Special was a TRC-2 transceiver case with one of VHF Engineering's transceiver kit boards inside. It was available for the 50, 144, 220, and 432 MHz bands. The unit shown has the TRX144 board, and is a 15-watt 2 meter transceiver. It is complemented by a VHF Engineering Synthesizer II; $259.90 (TRC-Special)/$169.95 (Synthesizer II), 1977. A large part of VHF Engineering's product line consisted of circuit board kits. (1)

**H ◊ VOCOM 2C100** The VoCom Products Corporation was located in the Chicago suburb of Prospect Heights, Illinois. They made a line of 2 meter amps in a variety of drive and output levels. The 2C100's power output was 100 watts and it could be ordered for 2, 10, or 25 watt drive. A switch selected linear or Class C operation; $169.95, 1979. (1)

**I ◊ WESTCOM 2M15X90L** Westcom Engineering was located in San Marcos, California. Their 2 meter amplifier line included the 2M15X90L, which ran 90 watts out with a maximum 15 watt input. The linear amp could be switched to Class C for CW and FM. Its "Microstrip" design provided stable performance over a wide bandwidth. RF-sensed T/R switching was included. Other models in the line were FM-only, or FM/SSB with a receive pre-amplifier; $149.95, 1978. (1)

## What is the ARRL?

"ARRL" is an acronym for "American Radio Relay League," a name that refers to the original purpose of the ARRL in the earliest days of radio. Founded in 1914, the ARRL began as an organization devoted to promoting and enhancing ham radio's unique ability to "relay" information wirelessly using Morse code telegraphy.

Ham radio has grown tremendously since then. We still use wireless communication, but now the "information" can include voices, images and data. Today, the 154,000-member ARRL--The National Association for Amateur Radio--is still the only organization in the United States dedicated solely to the avocation of Amateur Radio in all of its many forms.

The core missions of the ARRL are:

### Public Service

The ARRL actively promotes the public-service aspects of Amateur Radio, a tradition that has earned respect through decades of service. The ARRL's legacy of public service began in 1935 with the creation of the Amateur Radio Emergency Service, better known as ARES, to provide communication support during natural and man-made disasters.

### Advocacy

The ARRL represents Amateur Radio in the halls of power at the local, state and federal levels. Thanks to the efforts of the ARRL, Amateur Radio has been able to thrive despite repeated attempts to restrict its growth. The ARRL serves as a voice for Amateur Radio before influential groups such as the Federal Communications Commission and the World Administrative Radio Conference.

### Technology

The ARRL promotes the advancement of new technology. Amateur Radio is an ideal environment for experimenting with telecommunications technology and the ARRL encourages this work through its publications and conference sponsorships.

### Education

The educational mission of the ARRL is twofold. (1) To recruit new amateurs, the ARRL publishes books and study guides for Amateur Radio license exams, maintains a mentor program for new hams and much more. (2) The ARRL also promotes ham radio in school classrooms, advocating its use as a tool to teach science and technology. To that end, the ARRL assists teachers with appropriate instructional materials and training.

### Membership

The majority of active amateurs belong to the ARRL, and for good reason! Membership in the ARRL brings a wealth of benefits, including...

• QST magazine, the ARRL monthly membership journal. QST is the authoritative source for news and information on any topic that's part of, or relates to, Amateur Radio. In each colorful issue you'll find informative Product Reviews of the newest radios and accessories from hand-held and mobile FM radios, to home-station transceivers, antennas and even shortwave radios. Each month's Coming Conventions and Hamfest Calendar columns show you who's getting together at hamfests, conventions and swapmeets in your area. Whether you're interested in contesting, DXing, or radios, accessories and antennas you can build at home, QST covers them all: New trends and the latest technology, fiction, humor, news, club activities, rules and regulations, special events and much more.

• Members-Only Web Access at www.arrl.org. Here you can read the latest Amateur Radio news, updated daily, along with a storehouse of helpful information that is literally at your fingertips.

• The ARRL E-Mail Forwarding Service, a great way to keep a central e-mail address that never changes, even when your home address does. Sign up for this service, and e-mail sent to your ARRL address ("your-callsign@arrl.net") will be forwarded to the e-mail account you specify.

• The Technical Information Service (TIS), where you'll find answers to questions on topics ranging from A (antennas) to Z (Zener diodes), and just about anything in between. Your ques-

tions will be answered by expert ARRL Technical Coordinators and Technical Specialists in the field and at ARRL Headquarters. Our Headquarters technical staff will help you over the phone, refer you to a volunteer ARRL Technical Specialist in your area, or send you the needed information from a growing collection of information packages. For really difficult questions, one of our Laboratory Engineers will research our technical library and send you an answer by postal or electronic mail.

• ARRL All-Risk Equipment Insurance provided at a substantial savings over other insurance plans.

• The Outgoing QSL Service where we act as your mail carrier and handle your overseas QSLing chores. The savings you accumulate through this service alone can pay your membership dues many times over.

• The ARRL Field Organization, where you can join a select group of ARRL Volunteers serving your fellow Radio Amateurs and the public.

• Exclusive operating awards that challenge you to increase your operating proficiency while you find out about the history and culture of places you've only dreamed of visiting.

### Join ARRL Today!

Join ARRL now by visiting us on the Web at www.arrl.org. You can also write or call:

ARRL - The National Association for Amateur Radio
225 Main St
Newington, CT 06111 USA
Telephone (toll free) 1-888-277-5289